BITT
THE STO

BITTERSWEET
THE STORY OF HARTLEY'S JAM

NI

First published 2011

Amberley Publishing
The Hill, Stroud
Gloucestershire, GL5 4ER

www.amberleybooks.com

British Library Cataloguing in Publication Data.
A catalogue record for this book is available from the British Library.

ISBN 978-1-84868-292-4

Typeset in 11pt on 13pt Minion Pro.
Typesetting and Origination by Amberley Publishing.
Printed in the UK.

To Isabel and William, the next generation

Contents

The Makings of a Fortune

In later years, when he was asked for the first twelve rules of success, William Hartley replied succinctly, 'Hard work repeated twelve times.' Hartley could look back with some satisfaction. The business that bore his name was one of the great success stories of Victorian Britain. Its abundant profits had not only allowed him to escape his humble origins, but to fund his plans to help the less privileged. At the time of his death in 1922, he had amassed a fortune of over a million pounds, and it was estimated that during his lifetime he had given away an equal amount to charitable causes. Hartley's was the leading name in a highly competitive industry, but its founder knew that, as much as hard work and intense ambition, the roots of his success could as easily be attributed to a single stroke of luck.

William Pickles Hartley was born in the Lancashire mill town of Colne on 23 February 1846. Now a quiet market town on the edge of Brontë country, Colne was once at the heart of the cotton industry. The town stood on a hill; a river ran beneath it. William was born in an area close to the river, known as Waterside. He was not born into poverty, as some would later claim, but the effects of poverty were all around him. Waterside was a heavily populated, working-class district of stone cottages, back-to-back houses and 'dandy shops' in which weavers lived on the lower floor and worked the handlooms on the floor above. Sanitation was poor and mortality rates high. Industrialisation had brought prosperity to the mill owners, but life for the workers was a constant struggle. In the mills, children toiled alongside their parents to help make ends meet. There was little else for them. People lived in cellars, families were large. There were too many mouths to feed.

William was more fortunate. The only child of his parents to survive infancy, he was afforded a greater level of freedom than might have been possible if there had been more mouths to feed. While other children took their place in the mills, he was educated at the newly built British School until

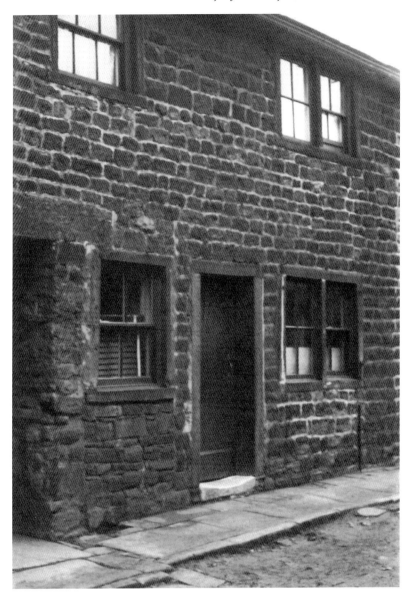

William's birthplace. (Lancashire County Library)

he was thirteen and followed it with a year at the local grammar school. The Hartleys were not an affluent family, but nor were their lives as harsh as those of many of the cotton workers and casual labourers, whose hand-to-mouth existence barely left them above the level of subsistence. William's father was a whitesmith; his mother, the former Margaret Pickles, ran a small grocery shop. In the neat order of Victorian society, his parents ranked higher than the mill workers who frequented their shop, but nevertheless were firmly part of the working class, even if by the standards of the time they were what might have been deemed a better class of working class.

William's grandfather, after whom he was named, was a schoolteacher and a Nonconformist preacher, first with the Wesleyans and then with the Primitive Methodists. His good fortune was to marry Christiana Lister, whose father owned the largest ironmongery in Colne. In 1846, when William was born, the couple were living on Colne Lane, a poor but respectable street in the centre of the town. The marriage produced four sons. The oldest, Robert Hartley, became a Primitive Methodist minister, serving in postings as far removed as Belfast, Bristol and the Channel Islands. In 1860, he sailed to Australia to establish congregations in the newly discovered gold fields of Queensland. William's father, John, was the second son and like his father was also a local preacher.

The family was intensely religious. William described his parents and grandparents as 'godly people'. In 1840, his grandfather was the first preacher to address the congregation in Colne's newly built Primitive Methodist chapel. Services had previously been held in the homes of members and in a rented room over a blacksmith's shop. At the age of fifty-nine, he became a town missionary in Douglas on the Isle of Man. He died when William was two, ministering to the needs of townspeople during an epidemic of typhus. It would prove a salutary lesson. 'I was always under the deepest religious impressions,' William would note, 'and I never remember a time when I had not an earnest desire to be good.'

A House with Two Windows

After the death of his grandfather, William and his parents moved into a house on Colne Lane, next door to his grandmother, who was living with her youngest son, Richard, a cotton manufacturer's clerk. A contemporary account describes 'a house with two windows; one window was filled with cakes and fruits, the other with tinware'. The family, like most traders, lived above. A short distance from the house was a forge, where workers went to

have irons put on their clogs, and there was at least one other grocer's shop on the street. William's new home was an improvement on his Waterside origins, but life remained hard. There is no record of how many children his mother lost, but her death in 1870, at the age of forty-six, and the loss of his siblings are symptomatic of the time.

What William grew accustomed to from an early age was noise. The town heaved to the sounds of industry, from the thunderous roar of the looms to the clatter of heavy horses pulling their loads up the steep hills. The railway reached the town in 1848 and developed steadily over the coming years, allowing swifter access to neighbouring cities such as Manchester and Leeds. With it came a rising population that grew from 3,000 at the start of the nineteenth century to almost 9,000 fifty years later. The town's streets bristled with shoemakers, saddlers, curriers, carpenters, hatmakers, booksellers, brewers and butchers. The streets were lit by gas lamp, and goods were transported by horse and cart, or up and down the nearby Leeds & Liverpool Canal. The arrival of the railway brought swifter transportation, but local people still travelled everywhere on foot or horseback.

William's childhood was centred on home and chapel. There was, it seems, little else. The one surviving photograph of him as a child, taken when he was fourteen, shows a round-faced little boy in stiff collar and jacket, a prayer book clutched in one hand. It is an archetypal image. The foundation of his

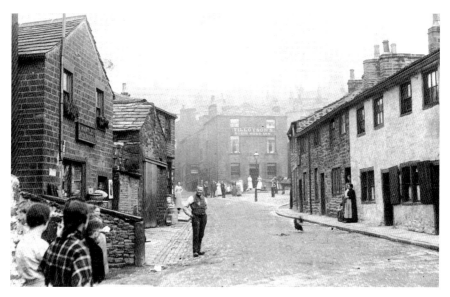

Waterside. The area was destroyed in the 1930s as part of a slum clearance scheme. (Lancashire County Library)

life was his faith, and from it sprang many of his richest ideals. As a child, he attended Sunday school and class meetings, which were the means through which members of his church followed the development of their faith. The values he espoused and the principles he upheld stemmed entirely from the tenets of his religion. His mother took him to his first class meeting when he was five, and at the age of thirteen – the earliest possible age – he offered himself for membership of his denomination.

Primitive Methodism was a predominantly working-class movement that grew particularly strongly among the disillusioned masses of the northern industrial towns. Its founders were Hugh Bourne, a carpenter, and William Clowes, a hard-drinking gambler and prize fighter, who spent much of his early life in 'the wildest dissipation', as one of the movement's early historians gingerly put it. The denomination grew out of Wesley's Methodist movement. Wesley defined a Methodist as 'one who lives according to the method laid down in the Bible', but following his death in 1791 the movement he had founded, torn apart by differences of opinion, had repeatedly divided. Primitive Methodism sought a return to the more traditional, or primitive, roots under which Wesley's movement had been conceived.

The Prims demanded a sterner form of devotion. To Wesley's children, the exhortations of the Bible and the rantings of its preachers were warning enough against the sinful and the profligate. One of the early qualifications for membership was an earnest desire to flee from the wrath to come. The Prims, like the Quakers, wore plain clothes and led plain lives. There would have been few possessions in William's home and few comforts. Thrift was considered to be a more fitting expression of God's word. Wealth was not frowned on, but the richness of a man's inner life was considered more important. The Prims eschewed the moral laxity associated with such 'vain and worldly' amusements as dancing and gambling. The use of profane language and the consumption of alcohol – the 'demon drink' – were considered equally repellent.

When it came to his faith, William seems to have ticked all the boxes of the perfect Prim. The one (and significant) exception was his inordinate ambition. The Prims, by and large, were an inward-looking faith, and an acute sense of how the outside world might view them made them cautious, particularly when it came to the very public matter of commerce. As such, ambition was severely censured, for it was felt that it would lead to financial ruin and worse, disgrace. The result was that, as businessmen, many Prims were held back by an innate inhibition; the same abstemiousness that ran through their private lives was evident in their businesses. To make a living was acceptable, but to make a fortune was an entirely different matter.

William, on the other hand, seems to have been far more independent-minded. In spite of his tender years, there was already something firm and resolute in his character. He was, it seems, an exceptional child, ambitious, determined and highly motivated. When he left school at the age of fourteen, his ambition was to become a chemist, but there was no opening in the town. So, faced by the demands to earn a living, he started helping in his mother's shop. It would prove a fateful decision. At fourteen, he suffered none of the health problems that would plague him in later life. He was young, energetic and eager to stake his claim.

The Fires of Ambition

William would describe Colne as the place where his 'ambitions were born', and he soon showed that he was not content to follow the well-worn path of his parents. Although the facts about John and Margaret are slim, there can be little doubt that neither of them possessed the same surge of ambition as their son. William's biographer, Arthur Peake, described his father as 'a kind, good man', but added waspishly that 'he had no special aptitude for affairs'. The essence of his life was to run a good business and to behave in a manner that would not shame either himself or his religion. William's mother similarly appears to have held no great aspirations other than serving God and in effect keeping her nose clean as far as the life to come was concerned.

William, by contrast, appears to have been guided by an instinct that far exceeded their narrow vision of the world. His natural talent, it seems, was for commerce. When a suitable shop became vacant in the town's main street, he urged his parents to take it. His parents unsurprisingly were firmly against the idea, the prospect of failure far outweighing the possibility of advance. Almost sixty years later, William's wife Martha, who was party to many of the conversations of that time, recalled his mother's 'gloomy forebodings' and her fears that his 'headstrong rashness would ruin them all'. It was all very well to praise God from the foot of the bed, or to sing his name from the hymn sheets, but to court wealth – the riches that exceeded daily need – was tantamount to a mortal sin.

There, his ambitions might have stalled had it not been for the intervention of a fellow tradesman, William Ayrton. Ayrton, as well as being a respected local businessman, was also a Primitive Methodist, and his approval of the plan seems to have been sufficient to persuade John and Margaret to set aside their worst fears, although they did so 'very much against their will'. At the age of sixteen, William was running his own grocery business and rapidly

added a wholesale department, the creation of which would inadvertently lead him into the manufacture of the preserves for which he would become so well known.

His path to prominence, however, was not without setbacks. In 1862, Colne was emerging from the longest strike in the history of the Lancashire cotton industry. The strike lasted eleven months and brought over one and a half thousand weavers close to starvation. There was worse to come. The strike was barely over when civil war broke out in America, which, following the North's successful blockade of the Southern ports, led to widespread shortages of cotton. As some 80 per cent of Lancashire's cotton came from the United States, Colne suffered in common with neighbouring towns and cities. There was widespread unemployment, and those workers who could not find employment were forced to accept reduced wages. Mills closed

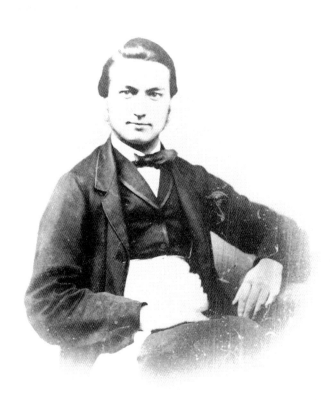

William, aged nineteen. A young man on the make.

and, by the time the war ended in 1865, over a thousand men, women and children, almost a ninth of the population, had left the town.

In 1909, when he accepted the Freedom of Colne, William looked back on that time in his life, recalling how he walked across the moors and dales, often leaving his home before five o'clock in the morning in order to call on his first customer at seven. 'I walked to Haworth, Oakworth and Keighley Station, so tired that I was very glad to sit down at the station,' he told an audience of his fellow townspeople. 'I walked about twenty miles. I had called on twenty customers and on many a journey I did not make a shilling. It took a great deal of resolution to keep that up.'

Disraeli described it as an age of 'infinite romance', but there was little romance in cold winter mornings and back-breaking labour. It was not unusual for William to put in as many as sixteen hours a day, and he worked every day, except Sundays, Christmas Day, Good Friday and the half holiday on Whit Monday. A photograph of the aspiring businessman shows an altogether more determined look than the more familiar image taken in later years. When he was older, one writer would note 'the benign tranquility of his eyes', but in the photograph his eyes exhibit a brashness that veers close to arrogance. His ambitions clearly will not be obstructed.

Marriage and Adulteration

At the age of twenty, William married his childhood sweetheart, Martha Horsfield, the daughter of a local grocer. It would prove an inspired match. A strong, capable woman, four years his senior, Martha possessed a keen intelligence and an innate understanding of his business that would prove invaluable to him. As a newspaper report later acknowledged, she 'brought to the young and rising businessman a caution and shrewdness that served as the balance wheel of her husband's enterprise'.

Martha was as hard-working as her husband. 'We were married on a Whit Monday morning,' William recalled. 'Holidays were then a very rare thing in our native town of Colne. Indeed, we scarcely knew that the word holiday was in the language. However, we were quite as happy with half a day on that Whit Monday as we have been since with a month's holiday. On that afternoon we spent our honeymoon processioning the town and I was at business as usual next morning as though nothing had happened.'

In April 1867, Martha gave birth to their first child, Maggie, named after William's mother. A second daughter, Pollie, was born in the winter of 1870 and a third, Christiana, in April 1872. A fourth child, Martha, was born

The Cloth Hall, shown on an invoice the year after William started to make his own preserves.

in November 1873, but did not live to see her second birthday. William's family blossomed, as did his business. In the years following his marriage, the business steadily expanded and he eventually moved into the old Cloth Hall, which had once served as a marketplace for the town's weavers to show their goods to merchants. The strike and its attendant troubles had, by one estimate, set the town back some twenty-five years in terms of growth, but there was still room for a man to make a living.

The Prims, like the Quakers, had a reputation for fair dealing. At the time, traders in general were held in low esteem, and grocers were not immune to accusations of dishonesty. The more unscrupulous regularly sold adulterated food and cheated customers on weight, either by selling short measures or by adding foreign substances. The leaves of hawthorn and sloe, for instance, were added to tea leaves, brick dust to cocoa, soap shavings and pounded rice to sugar. The practice was so widespread that an article in the weekly journal *Household Words* warned that 'whatever the British consumer may feel inclination to devour, let him devour it at his peril'.

The need to adulterate food arose not only from the desire of more unscrupulous traders to turn a quick profit, but also from the rising demand for foodstuffs resulting from the Industrial Revolution. The abandonment of the countryside in favour of the town had created a revolution in the manufacture and sale of food. In the countryside, householders traditionally prepared most of their own food, but in the densely packed towns, rural skills such as baking, brewing and preserving virtually disappeared. With less time

on their hands and ingredients less easily obtainable, people came to rely more and more on the new commercially produced foods that started to appear on the market. The result was that many cottage industries blossomed into large industrial factories, turning out mass-produced goods, which with the resultant economies of scale could be made and sold at lower prices.

William supplied many of the towns in the north that had grown rich on the profits of trade, and his reputation for honesty and probity, both of which were highly prized Victorian values, made him one of the rising stars in the industrial firmament. By the age of twenty-five, he owned several horses and had two apprentices and three travellers (salesmen) in his service. He was still in his early twenties when he became head of one of the largest wholesale businesses in Lancashire. But while he had built his reputation as a purveyor of goods, it was to be as a manufacturer that he would make his name.

The Greatest Good Fortune

William Hartley came to manufacture preserves – jam was a word reserved for a more inferior-quality product – more by accident than design. It was the single stroke of luck that would lead him to a fortune. In the mid-nineteenth century, the lower classes tended to eat very little fruit, either in preserves or on its own, deterred both by its prohibitively high price and, in the case of preserves, often its poor quality. Pots of jam invariably contained all sorts of 'rubble' and 'refuse', such as boiled turnips and apples, which helped to add weight and thus improve profit margins. The more imaginative purveyors added lurid dyes, to improve the colour, and wooden 'seeds' which served to create the illusion that the product contained an abundance of fruit. As a result, the growth in the consumption of preserves was slow and, to begin with, the business was little more than a cottage industry, with local suppliers satisfying local demand.

One of the most significant factors in the sluggish growth of the business was that the seasonal nature of the work meant that manufacturers could not rely on the sale of preserves to keep themselves afloat. (The larger manufacturers later turned to the production of marmalade, table jellies and other fruit-based products to keep workers occupied throughout the year.) The trade was equally hampered by the constant difficulties in obtaining supplies of fruit and sugar – one of the reasons, no doubt, that so many manufacturers turned to adulterants such as carrots, 'a vegetable whose sweetness', it was observed, 'spares the manufacturer's sugar barrel and whose mild flavour is lost in that of almost any fruit with which it is combined'.

One of the products that William sold as a wholesaler was preserves, which were made for him by a local manufacturer. When the manufacturer defaulted on their agreement, William decided to make his own. It was a decision that would shape his life and with it the fortunes of his family. At a time when food adulteration was raising hackles across the nation, he foresaw the demand for a pure, unadulterated product, and from the outset he vowed that his preserves would be made solely from fruit and sugar, with no adulterants whatsoever.

William was one of the first manufacturers to take the product and give it a more wholesome reputation. In a deliberate attempt to escape from what he saw as little more than subterfuge, he marketed his products as containing no pulp, glucose, preservatives or artificial colourings. His formula was simple. He would provide a quality product at an affordable price. The idea was bold, ambitious and almost uniformly drew scorn from friends and family alike, who believed he would not last in business long enough for consumers to discover the excellence of his wares.

A number of factors conspired in his favour. The protectionist policies of successive governments had ensured that high duties were charged on imports such as tea and sugar, but the introduction of free trade, following the repeal of the Corn Laws, meant these duties were steadily lowered and in many instances removed altogether. In 1872, the Adulteration of Food, Drink and Drugs Act made it an offence, punishable by heavy fines, to sell a mixture containing ingredients for the purpose of adding weight or bulk unless its composition was declared to the purchaser – the beginnings of modern-day food labelling. The branding of products, together with the steady growth of advertising, similarly allowed consumers to more accurately identify what they were buying, or at least to associate it with a name they could trust.

The success of William's business was equally enhanced by a steady growth in the amount of fruit that was available in the market. Until the late nineteenth century, farmers largely grew wheat and barley. The import of cheaper grain from the plains of North America, however, created an agricultural depression at home and, instead of using the protectionist policies of their predecessors, the government allowed the free market to dominate. The availability of cheaper food was widely seen as a vote-winner, and with more voters in the towns than the countryside the needs of agriculture were ruthlessly sacrificed in favour of the new urban environment.

The result was that, in order to survive, many farmers were forced to turn parts of their land over to dairy farming, market gardening, or fruit growing. In Kent, Herefordshire, Hampshire, Somerset, Worcestershire, Norfolk, Gloucestershire, Essex and Middlesex, vast tracts of land were turned over

to the production of soft fruits. As a result the price of fruit fell, and when, in 1874, the duty on sugar was repealed, the door was opened to a massive expansion of the business. Sales were particularly buoyant in the northern industrial towns, which formed the predominant part of William's market. Preserves provided the poor with a sweet, palatable product that was cheaper than butter and added taste to the stodgy, soggy bread that many of them were forced to consume. In the north, bread and jam became the main food for children for two out of three meals.

No record remains of the exact date that production commenced, or the speed with which production moved from cottage industry into a larger concern. However, when full-scale production began in the summer of 1871, the date commonly taken as the birth of the business, William had in his service a dozen workers, who between them made around a hundred tons of preserves. He could not have known that by the turn of the century his output in a single week would be ten times greater and his employees would number in the thousands.

'That Stirring Period of My Life'

William's business went from strength to strength. There are no indications of the extent of his wealth (his later success tended to overshadow all that preceded it), but by 1874 he was faced with a stark choice: either to continue trade as a wholesaler, or to move wholeheartedly into the manufacture of preserves. The business, and indeed his energies, could not sustain both. In 1874, he was living on Lord Street with Martha and the children, along with two apprentices, Nicholas Shields and Caleb Duckworth. (Duckworth and his brother, Joshua, would later take over William's business in the town.) His father had moved to Colne Field on the edge of the town with his younger brother, Richard, and at the age of fifty was working as a cotton weaver.

In the end, William decided to leave Colne and build a factory in Bootle at the mouth of the Mersey. The decision was not easy. With a young family to support and a successful business up and running, he was in effect trading substance for shadow, a point which his friends were quick to acknowledge. There was, it seems, no end to the criticism. As he later explained, all of them believed he was 'making a fatal mistake without any possibility of remedying it'.

There was a sense that his decision amounted to little more than 'an expression of vaulting ambition', and among his friends – many of whom were fellow members of his chapel – he was scorned for what seemed to be a

shameless pursuit of wealth. William appeared to represent all that his faith opposed. His overweening ambition, his appetite for wealth, his insistence on moving far from the security of home and chapel, were all signs of a man hell-bent on defying the word of God. In the chapel, the talk was of little else. He had, he confessed, 'never felt so alone'.

The spectre of divine wrath hung over him once more. 'They all believed I was flying in the face of providence and prophesied disaster,' he recalled in later life. 'There was no exception to the adverse criticism. Whenever I look back upon that stirring period of my life, I often think how careful we should be in forming adverse views as to the conduct of others for fear that our criticism should prove to be wrong. It was so in my case.'

William might easily have settled for the life he had made for himself in Colne, but he was, it seems, guided by a stronger impulse. The rapid growth of his business, coupled with his own unfailing instinct, urged him forward. In June 1874, he opened his new works at Pine Grove in the oldest part of the town. The site had been well chosen. Pine Grove was about a mile from the docks and close to the main railway line, which allowed him to benefit from the lower cost of sugar from the nearby refineries in Liverpool, and to improve the distribution of his finished products. In the surrounding countryside, farmers grew fruit in marketable quantities, while the proximity to the docks enabled William to obtain supplies of oranges at reduced rates to make into marmalade and other products, such as candied peel. The number of workers at the factory when it opened has not been recorded, but in 1881, when the census was taken, the number of permanent workers was 120 women and 30 men.

When he moved to the town, William took up residence at 12 Park Street, not far from the works, and he lived in at least two other houses in the town: one on Merton Road, described as 'one of the best addresses in Victorian Bootle', the other at Peel Villas, a semi-detached house that was of a sufficient size to hold his fast-growing family. In December 1875, six months after the death of little Martha, another daughter, Sallie, was born. She was followed in May 1877 by the birth of William's only son, John William, who would follow him into the family business, and in 1879 by a fifth daughter, Clara. In 1880, the family moved to 22 Sussex Road in nearby Southport and was sufficiently well off to engage the services of a servant and a nursery maid. There, two more children were born: Martha in April 1882 and Connie in the summer of 1884.

The move to Bootle, however, was plagued by difficulties. William would later note that he had arrived in the town 'in great fear and trembling'. He went on: 'In our early days we had great difficulties and our first struggles

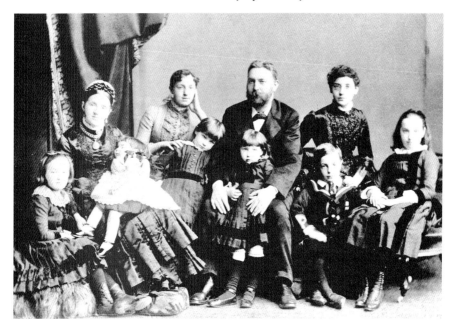

The aspiring businessman and his family, *c.* 1885. From left to right: Sallie, Martha, Connie (the baby), Maggie, Clara, Martha (with her father), John William, Pollie and Christiana.

were severe indeed.' The construction of the new works had taken all his capital and he had arranged a loan for the purchase of fruit and sugar. At the last minute, the lender threatened to withdraw the funds unless William made him a partner. William refused and the loan was withdrawn. As a result he was forced to borrow the money on the most onerous terms. The loan ran for seven years and the interest rate was so high it absorbed 75 per cent of his profits. No records remain of the amount he borrowed, but it must have been substantial. In 1877, for example, the firm made a profit of around £350. Four years later, once freed from the restraint of its debts, the figure rose to over £2,000.

In later life, he would date many of his health problems to those early years, when anxieties about his business hung over him, seemingly without respite. He pushed himself relentlessly. In a tribute to him written a few months after his death, Arthur Peake listed many of his qualities, among them his precise, methodical mind and 'cool, balanced judgement', his 'resourcefulness', his 'quickness of mind' and 'untiring industry'. All seem to have been present in the nascent man of commerce. His aim of producing a high-quality item at an affordable price made his products popular, particularly among the working classes, and sales duly boomed. 'Our aim has always been to win

the confidence of the public by making the best possible article and selling it at a fair price,' he would declare, 'and on that principle our business has gone from strength to strength.'

William had staked his future on the venture and, in spite of the doubts of his friends, he prospered. His was one of the 'sunrise industries', which included the mass production of biscuits by firms such as Huntley & Palmer, Jacob's and Carr's; chocolate and cocoa (the forte of Cadbury's and Fry's); tea (Horniman's, Lipton's) and a host of other products that benefited from advances in science and technology. In the twelve years he was at Bootle, William twice enlarged his premises to cope with demand. In 1884, after a summer when fruit was abundant (and therefore cheaper to purchase), the firm's profits exceeded £18,000. The following year, William Hartley & Sons Ltd was incorporated with nominal capital of £100,000.

William swiftly proved himself adept as a man of commerce. In 1886, flushed with wealth and buoyed by success, he decided to make a defining statement. The works at Bootle were too small to accommodate his fast-flourishing business. He therefore decided to move his firm to a site that would not only reflect the purity of his products, but which would also enable him to pursue his ideas for a more enlightened form of commerce. A short distance from Bootle stood the quiet village of Aintree, whose main claim to distinction was the steeple chase that annually drew crowds from nearby Liverpool, and it was there that William opened what would become one of the largest preserves factories in the world, in the middle of rolling fields and open countryside.

An Industrial Eden

Industrialisation had sparked a revolution; but while its supporters touted its every success as a sign of progress, critics were as swift to condemn its worst excesses. In the towns and cities, industry was held responsible for a multitude of sins, from the pollution of rivers and streams to the virulent spread of disease. Mass migration to the towns had caused innumerable difficulties. While working conditions in the countryside were poor, workers nonetheless benefited from the provision of fresh food and open spaces. The towns, on the other hand, were little more than fetid pools of stench, grime and grit, where 'the factory smoke pollutes the air and the dye-houses poison the streams; where streets cannot well be described than as canals in wet weather; where it is difficult to get air at all and impossible to get it untainted by the chimneys and sewers; where the refuse of a thickly-populated district lies rotting in the open streets and the gutters do duty for more than surface drainage.'

The heavily industrialised landscape produced a marked decline in health. 'There is no doubt of the degeneracy and deterioration of the masses in our town bred population,' the *Lancet* recorded in 1900. 'It is saddening to see the pallid, stunted, ill-set up lads and girls, many of them married, streaming out from the factory gates at closing time and still more saddening to see the puny infants, of perhaps a few months old, with emaciated faces and the weary careworn look of old age, who are brought by their ill-developed mothers to the out patient rooms of our hospitals.'

The effects of a poor diet, the lack of clean water, and poor sanitation were all too evident. When men were recruited for the Boer War, 40 per cent of those who took the King's shilling between 1897 and 1902 were rejected as physically or medically unfit. By 1910, the figure had risen to more than 50 per cent, and in 1916, at the height of the First World War, recruiters were horrified to discover that 66 per cent of conscripts were of inferior health. A

survey of boys aged between ten and twelve at private schools found them to be on average 5 inches taller than their counterparts in state schools. The well off, it seemed, could look down on their supposed inferiors in a literal as well as a metaphorical sense.

Britain was an economic miracle and a social disaster. In the towns, workers sweated long hours in poorly lit factories that had few amenities and few comforts. There were no medical facilities and, if a worker was forced to stop work as a result of accident or illness, he had no recourse to his employer. Workers had few rights and little representation. A succession of Acts of Parliament were passed in an effort to reduce working hours and to ensure better treatment for workers, but more unscrupulous employers constantly found means to circumvent the law – and since workers were in plentiful supply, there was little to stop them.

The threat of losing employment was so severe that most workers submitted to the harsh conditions imposed on them, merely to put food on the table and keep a roof over their heads. It was a decision forged by necessity. In the factories, workers were subject to dismissal without notice and often faced the most arbitrary forms of discipline. 'There is no security for them,' wailed Maud Pember Reeves, a member of the socialist Fabian Society. 'Any work which they do may stop at a week's notice. Much work may be, and is, stopped with no notice of any kind. The man is paid daily and one evening he is paid as usual, but told that he will not be needed again. Such a system breeds improvidence, and if casual labour and daily paid labour are necessary to society, then society must excuse the faults which are the obvious outcome of such a system.'

The Victorian era had created a host of problems that few had foreseen in its heady youth when the exultations of industry served to mask its most shameful effects. There were, however, signs of change. The urge to cultivate a common humanity provided the impetus for a revolution in which factory reform, improved housing, public health and education formed the backbone. It had once been possible to shelve the problems of the working class out of sight and out of mind, but throughout the nation there was a growing sense of flux and a widening conception of a new order.

A Factory in a Garden

The revolution had no distinct leader, but its most ardent followers included a number of the nation's leading industrialists, among them George Cadbury, Joseph Rowntree, William Lever and William Hartley. William had made his

name as a manufacturer at Bootle, but it was at Aintree that he developed a reputation as one of the nation's more enlightened entrepreneurs.

The Aintree works was one of the early garden factories, which sought to take industry out of the harsh environment of the towns and to place it in cleaner, brighter surroundings. When it was built, it drew visitors from miles around, who were stunned both by the beauty of its rural location and the contentment of its workers. 'Hartley's, in selecting the site and designing the works and garden village adjoining, have paid particular attention and made special efforts to secure both beautiful and healthy hygienic surroundings for their workpeople, as well as for the perfect production of their jams and marmalades,' a piece of advertising puffery proclaimed.

The works covered seven acres (it was later extended to ten) and was built on Long Lane, a rough, narrow track that ran across the fields, with scarcely enough room for two carts to pass. The site had been carefully chosen. In 1886, Aintree was a small, rural village with a population of less than three hundred. The village had its own blacksmith and wheelwright. The pace of life was slow. Modern life has encroached on the works to such a degree that what remains of it is hemmed in on all sides by houses and factories, but for many years it stood alone in the middle of green fields and open countryside. The scene was almost picturesque. A reporter guided to the works for an interview was told to follow 'the private path leading direct from the station across the fields'. It is an image more reminiscent of long summer afternoons than the heady strains of industry.

The exact location of the works was determined by the railway line. William had learned at Bootle that delays in the delivery of fruit allowed it to deteriorate to a condition in which it was impossible to make it into high-quality preserves. He therefore positioned the factory at the junction of two main railway lines, the Cheshire Line and the Lancashire & Yorkshire, to facilitate both the delivery of vast amounts of fruit and sugar, as well as the distribution of the finished products. At the same time, he constructed his own sidings and two maroon-coloured engines, *Martha* and *Maggie*, were purchased to shunt the wagons in and out of the factory.

Hartley's was a huge business. The imposing works dominated the skyline and became a well-known landmark for travellers heading in and out of Liverpool. The factory was built of red brick and was entered through fortified gates surmounted by castellated turrets, which lent it the appearance of a modern-day castle. The addition of an iron portcullis and a crenellated parapet added to the illusion. When it was opened, the works was a series of long, low buildings in which production moved from one phase to the next, but by 1891 the first of three great six-storey warehouses had been

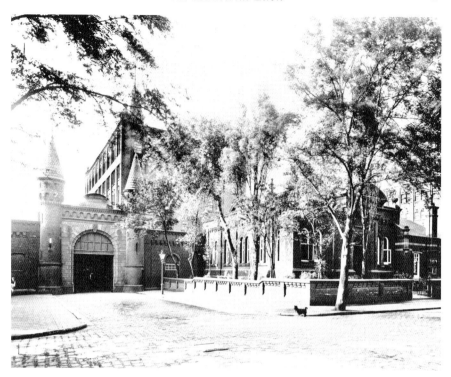

The front of the works was like a castle. The streets were paved and lined with trees, giving it the feel of an early garden village.

added. A second was opened in 1899, the last in 1923, a year after William's death.

William had selected the site for its railway links. He had also given careful consideration to its isolation. The factory was therefore largely self-contained. The works had its own generating plant to supply electricity, and water was pumped from an underground supply. The firm employed its own coopers, coppersmiths, joiners, fitters and engineers. It had stable lads to look after the horses that pulled its wagons, and when motorised lorries were introduced, the company employed its own mechanics to maintain its fleet of vehicles. It had its own box-making department, where most of the apprentices started at the age of fourteen, turning out the wooden crates in which the finished products were dispatched. There was a printing works that used the latest lithographic and letterpress equipment to make its labels, a laundry for washing the workers' overalls, and a clog shop for the repair and fitting of the clogs that were worn in the Boiling Room and the Filling Room. The works also had its own small fire brigade from at least the end of the nineteenth century.

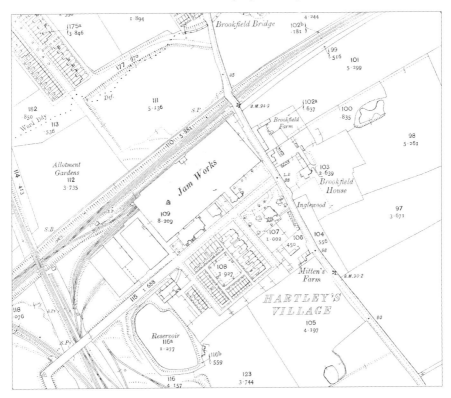

Map showing the factory and the village. (Reproduced from the 1908 Ordnance Survey map)

In 1888, William added a model village at the side of the factory and the construction of a house for himself and his family two years later completed the image of rural domesticity. Tree-lined avenues welcomed workers from across the fields, and next to William's office at the front of the works was a well-tended garden surrounded by a low wall. An article in the *Philadelphia Record* noted that the distance from Liverpool 'is not so many miles, yet it lifts you entirely away from the busy whirl of industry and sets you down amid the peaceful surroundings of a locality where the interest of its inhabitants centres about the Hartley Jam Works'.

Model Village, Model Lives

In the mid-nineteenth century, a growing interest in the nation's health had encouraged the construction of a small number of what came to be known as model villages as part of a healthier working environment. The growth of industrialisation had been matched by an explosion of working-class housing,

much of it near factory gates, which allowed workers to secure employment that was invariably handed out on a first come, first hired basis. The houses were often built from the cheapest materials and were placed together in courts and tenements that had little ventilation, no fresh water and scarce amounts of natural light. Landlords, in turn, filled them with as many families as would fit, and the explosive combination acted like brushwood to the fires of disease.

In 1850, Titus Salt, the owner of one of the world's largest textile mills, presented Bradford with a 61-acre park so that people could escape the pollution of the factories. He then built the model village of Saltaire close to his mill and provided his workers with their own school, hospital, chapel, almshouses, public baths and washhouses, library and temperance institute. Model villages were also developed next to Price's Patent Candle factory on Merseyside, whose workers had been relocated from south London, at Akroydon on the outskirts of Halifax, and beside the factory of Quaker shoemakers Cyrus and James Clark at Street, near Glastonbury.

The construction of model villages was as much pragmatic as it was philanthropic. In providing accommodation for workers, employers guaranteed themselves a ready supply of labour. In 1878, cocoa manufacturer George Cadbury and his brother purchased fourteen acres of meadows and woodland at King's Norton, four miles south of Birmingham, on which to build a new factory. The success of their business had prompted the need for larger premises, and beside the factory the brothers built sixteen semi-detached houses for key workers.

Although opponents suggested this was little more than a shameless exploitation of workers, it soon became clear the brothers were in pursuit of a more enlightened ideal. In 1895, construction began on a model village that was not solely for workers at the factory. The village was named Bournville after the stream beside which it was built (the Bourn) and the French for town. Within a year, more than 200 houses had been built, and the project was crowned by the addition of an elementary school and night school, a recreation ground, church and meeting house, swimming pool and gymnasium, almshouses and shops.

Meanwhile, at Port Sunlight on the banks of the Mersey, fellow industrialist William Lever had started his own community. In December 1888, he instructed a local architect to prepare plans for twenty-eight cottages next to his soap manufacturing works. Work began the following spring and the village expanded as Lever's fortune grew. His aim was to build houses in which his workers would 'know more about the science of life than they can in a back to back slum and in which they will learn that there is more enjoyment in life than the mere going to and returning from work and looking forward to Saturday night to draw their wages'.

Port Sunlight was noted for its low mortality rates – recorded at the turn of the century at 70 per 1,000, compared to 140 per 1,000 in nearby Liverpool – and for the general morality and sobriety of its inhabitants. Between 1889 and 1914, more than 800 houses were built and were enhanced by a cottage hospital, a school, an art gallery, shops, a concert hall, a library, a recreation ground and an open-air swimming pool. Public houses were forbidden.

William's model village at Aintree was on a far smaller scale than Port Sunlight and Bournville, but ranked alongside them both for its pursuit of an ideal and its contribution to a solution to the great housing problem of the late nineteenth century. At the time, housing in nearby Liverpool was poor. The construction of narrow, closed courts had been banned in 1864, but by the close of the Victorian era there were more than a thousand that were still inhabited. In 1883, the success of Andrew Mearns's penny pamphlet on the plight of London's poor, The Bitter Cry of Outcast London, *prompted the editor of the* Liverpool Daily Post *to print a series of articles entitled 'Squalid Liverpool'. The aim was to arouse 'the inhabitants of Liverpool to a sense of the seriousness of the existing situation and of the imperativeness of their duty toward a huge population which lives at their very doors under conditions of life so horrible as to well nigh defy description'. The articles, as intended, provoked a public outcry.*

The shock was not that poverty existed, but that it existed on such a scale. In the city's labyrinthine passages and alleys, human existence was reduced to its most basic form. A special commission sent into the slum areas in response to the articles noted that 'here resides a population which is a people in itself, ceaselessly ravaged by fever, plagued by the blankest, most appalling poverty, cut off from every grace and comfort of life, born, living and dying amid squalid surroundings of which those who have not seen them can form a very inadequate conception'.

Liverpool was a city of contrasts. On the one hand, it was a monument to trade, whose commercial opulence was evident in its elegant houses, fashionable parks and grand civic buildings. On the other hand, the city's architectural luxuriance overshadowed the extremes of poverty and degradation that lurked beneath it. In 1884, on taking up his post at the Unitarian Church on Hope Street, Reverend Acland Armstrong, while excited to be living in 'the second city of the mightiest empire the world has ever seen', was appalled to find 'men and women in the cruellest grip of poverty' and 'little children with shoeless feet, bodies pinched and faces in which the pure light of childhood had been quenched'.

The poor huddled together in the same bed and bathed in the same water. Malnutrition was rife, and houses were often infested with lice, fleas and nits

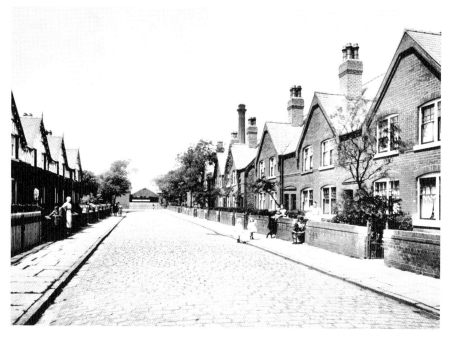

One of the streets in Hartley's Village.

– the 'bed bugs' of the night-time rhyme. The young were most at risk. In a healthy middle-class suburb, ninety-six out of every hundred infants survived their first year of life, but in a slum district one in every three died. Mortality rates in some areas were so high that one medical officer called them Herodian districts. In 1880, almost half the deaths in Liverpool were children aged under five. 'Grandmother, grandmother, tell me the truth, how many years am I going to live? One, two, three, four...' children chanted in a popular street game.

The needs of the city's poor had not been overlooked. Liverpool was one of the nation's pioneers in public health and social awareness. In 1841, the city introduced the first municipal washhouse in Britain, and by the end of the century the superintendent of its six public baths was calling for the installation of showers, or 'rain baths', which were designed to use less water, encourage more rapid usage and avoid the 'danger of drowning'. The city appointed the first Medical Officer of Health, the first District Nurse, the first slum clearance scheme, the first street cleaning department and the first society for the prevention of cruelty to children, formed in 1883.

The overwhelming weight of poverty, however, was hard to shift. The creation of a model village at Aintree was a means of showing a new direction in housing that would lift the poor out of the squalor of the towns and put them in more pleasant surroundings. In August 1888, the leading architectural periodical of

the day, The Builder, *published the results of a competition to build a model village next to the Aintree factory. The competition attracted eighty-five entries and was won by architects, W. Sugden & Sons of Leek. The winning design proposed the construction of seventy-one houses around a recreation green that extended to a little over an acre, with ornamental grounds, a bandstand and an ornate fountain in the middle. The houses were to be laid out in rows with names such as Plum Street, Pear Street and Cherry Row. There were to be five shops, and the arrangement of the village was intended to achieve 'a certain degree of picturesque effect without eccentricity'.*

In the event, the completed village was not as elaborate. At some point before construction began, William opted for a more modest design in which the number of houses was reduced to forty-nine. The exact reason for his change of heart is not documented, but it is possible that he simply did not have the funds to complete the larger project. In January 1890, he noted in his pocketbook that he had repaid the loan taken out with National Provincial Bank in order to build the works: 'I have been looking forward to this day for three and a half years, since I built the Aintree works and am much pleased to see it.'

The end result, nonetheless, was a utilitarian vision that attempted to remove some of the stain of back-to-back houses, cramped living conditions and poor

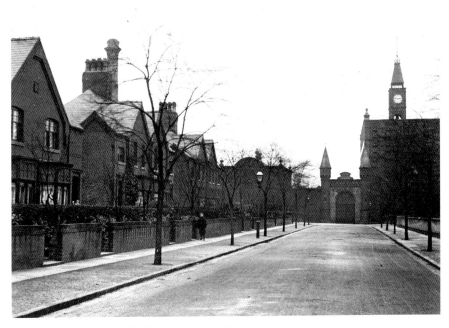

The front of Hartley's works from the model village.

sanitation. When the village was built, residents would have looked out of their windows across open fields and countryside. The streets were paved, and while in the 1891 census the houses were known as being simply 'off Long Lane', the village became known as Hartley's Village, the name it still retains. In contrast to the more widely accepted tenement courts, each house had its own front garden, and William ensured that a lane was preserved at the rear that was some three feet wider than the minimum legal width prescribed at the time by Liverpool city regulations. Trees were planted to give the area the feeling of an early garden suburb, and every house had its own supply of fresh running water, a rarity at a time when many households had no indoor plumbing.

The houses were arranged around a central square, with a separate row of eight smaller houses for newly married couples and pensioners. A bowling green, which was later converted into two tennis courts, was situated in the middle of the square. There was also an ornamental lake close to the houses that provided a haven for rest and recreation. As William did not seek to make a profit from them, the houses were let at 'very low rentals', which varied from two to three shillings a week, well within the reach of most of the male employees, who at that time were earning between twenty and twenty-five shillings a week. A number of the houses were sold to workers at favourable rates of interest.

The number of properties in the village did not equate to Bournville, but at the turn of the century William built another sixty-two houses on Cedar Road, a short distance from the factory. These houses were available to all those who could provide 'evidence of steady employment and good character'. He built a Primitive Methodist church in Aintree that was opened in 1891, and in 1895, when he was elected to the Walton School Board, he presided over the construction of a new school for the village at nearby Longmoor Lane. He also bought a large playing field opposite the works for the firm's football and cricket teams, which was enhanced by the construction of a pavilion around the turn of the century. The Aintree Institute too, while a short distance from the works, was part of William's vision and served as a 'counter-attraction to the public house', as he noted on its completion, which allowed him to further his ideas on those two more Prim-like habits, temperance and thrift.

William was one of a small handful of industrialists who built model villages. These villages in turn gave rise to the garden city movement, where developers sought to create 'slumless, smokeless cities' in which houses were 'spaciously laid out to give light, air and gracious living well away from the smoke and grime of the factories'. Tree-lined avenues, open spaces and well-designed, low-cost houses became the ideal. In 1903, work began on the creation of a model community at Letchworth that would serve as a blueprint to town planners

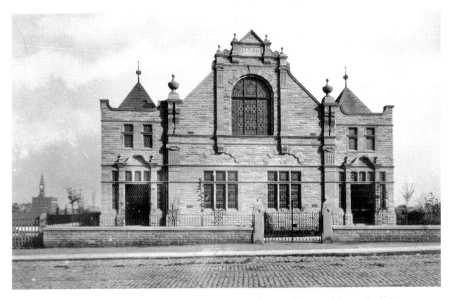

The Primitive Methodist church in Aintree. The Hartley works is visible to the left.

throughout the nation. The same year, confectioner Joseph Rowntree opened a planned community next to his factory at New Earswick on the outskirts of York.

The planned community was the architectural marvel of the decade. The railway companies ran excursions to Letchworth, and visitors to Port Sunlight and Bournville were legion. In 1905, a Cheap Cottages Exhibition, sponsored by the Daily Mail, *attracted more than 60,000 visitors. The exhibition proved so popular that in 1908 the newspaper launched its first Ideal Home Exhibition, the aim of which was to improve 'the comfort, convenience, entertainment, health and well being of home life'. There was to be no miracle cure for those who were living in squalor, but the seeds had been sown.*

An Enlightened Vision

The factory at Aintree was a monument to enlightened commerce, a pastoral image of an industrial Eden. It might have been a desire not to emulate the overseers in the cotton mills of his youth, whose rod-of-iron approach stifled the lives of so many workers, but William seems to have been determined to apply a more humane approach to commerce. A newspaper report noted that he was 'a pioneer in breaking down the class war between capital and labour'. He did not see his workers as sinews in the great industrial machine,

but sought to provide them with the kind of facilities that are now taken for granted, but which at the time were revolutionary.

The Hartley works was well lit and well ventilated. Workers were provided with free medical treatment, and a benevolent fund was started for all those who through sickness or accident were unable to work. A pension fund was introduced for those workers 'who had passed the best days of his or her life' at the firm, and in 1889 William became an early proponent of profit sharing, which he started 'not because I think it pays commercially, for I never ask myself that question, but because it seems to me right and doing as I would be done by'. The total amount distributed in profit sharing by the time of his death was £145,000 – the equivalent of more than £3 million in modern terms.

In September 1895, he opened a dining hall for his workers and such was its novelty that he invited a party of guests to its inauguration, laying on a special train to collect them from Liverpool's Exchange Station. At that time, workers either heated their food on pipes and boilers, or ate sandwiches. Workers at Hartley's, by contrast, had a choice of potato pie, sausage and mash, soup, fresh fish from Grimsby on a Friday, hot pot, cheese, mineral water, milk, lemonade or tea. A report noted that 'enough fruit is eaten at the works'. The Dining Hall, which replaced an earlier, less ornate building, was divided into separate rooms for men and women. It had its own bakery and served up to 4,000 meals a day, which were sold at cost price in line with William's determination that no profit should be made from them.

The following year, he built a temperance hall and social club, the Aintree Institute, which was constructed a short distance from the works at a cost of £12,000. The institute was opened on 3 November 1896 and was designed not merely as a social club for his workers, but also as a place which, as William described it, would unite men of all faiths 'from the Roman Catholic Church and the Church of England down to the very smallest mission room'. It comprised a hall that accommodated 650 people and could be converted into a gymnasium, classrooms and a lecture room. There was a recreation ground, tennis courts and bowling greens, two billiards rooms, private dining rooms and a workman's restaurant.

There were those who believed that 'labour was just a factor in production, a commodity to be bought and sold'. William was more forgiving. These were not his workers, his employees, or even his staff, but his 'people', as he called them, a vaguely biblical allusion reminiscent of Moses leading his people into the Promised Land. As far as he was concerned all of them had embarked on a great venture together and he knew each of them by name, moving among them in a manner that was largely at odds with those owners whose rule

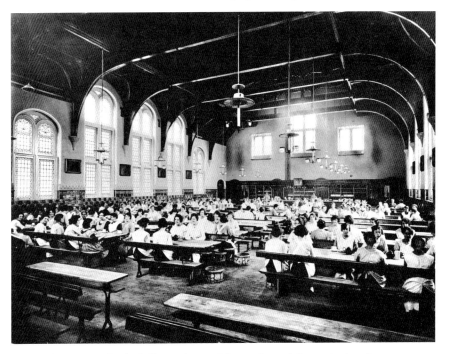

The Girls' Dining Hall. The hall was also used for parties and dances in the winter.

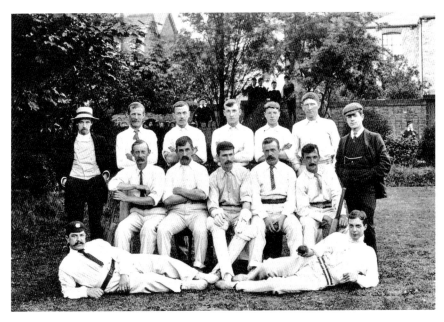

The firm's cricket team, 1905.

tended to be more despotic. 'Our interests are mutual,' he announced at one of the firm's annual profit-sharing distribution ceremonies. 'I cannot carry on the business without your co-operation and I venture to think that in my capacity as your employer I render some service to you.'

At a time when many employers were more interested in profits than people, William was constantly at pains to present himself as a humble servant and not a forbidding master. He did not stand apart from his people, but worked alongside them, as is evident from his system of profit sharing, which he personally calculated, not as a percentage of their wages, but based on a constant observation of their work and effort throughout the course of the year. 'This means that I must be in personal touch with practically every one of my workpeople,' he explained, 'and I am sure it works well. They all feel that they are not lost in the size of the business, but are in direct contact with me, and they like this, while, of course, it stimulates them to do their best.' It was a task that was both time-consuming and laborious, but even at the age of seventy-three, three years before his death, he was still personally assessing the cases of more than 800 workers.

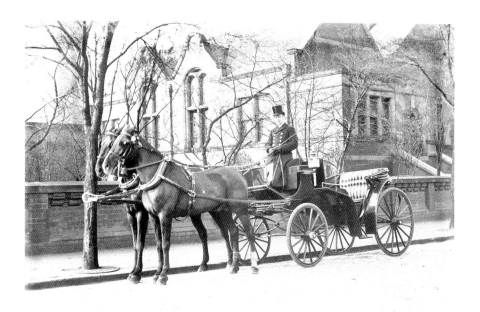

William's horse and carriage outside the Dining Hall.

'A Model to All'

The fact that William's business thrived is testament both to his abilities and to the unique relationship he cultivated with his workers. Charles Dickens wrote of 'the fusion of different classes, without confusion, in the bringing together of employers and employed, in the creating of a better common understanding among those whose interests are identical, who depend upon each other, and who can never be in unnatural antagonism without deplorable results'. William was one of its most natural exponents. The works at Aintree stood in stark contrast to the more oppressive factories in the industrial towns. At other factories it was not unusual for workers to be fined for such offences as swearing, spillages, lateness or loitering, but there were no fines at the Hartley works. William consistently paid his workers higher wages than his competitors – as much as 40 per cent higher – often increasing their pay of his own volition. He also took them on outings, the full cost of which he bore from his own pocket. One year, for instance, he took his entire staff who were over the age of eighteen for a five day trip to Glasgow and the Isle of Arran, paying their wages for the time they were away, as well as covering their hotel and travel expenses.

William consistently weighed his moral obligations against the need to sustain a thriving business. One of his favourite maxims was that work should be made attractive to the worker, and in view of the fact that women at the works outnumbered the men by a ratio of four to one, he gave particular attention to finding means of lightening loads and reducing strain. At Aintree, he introduced graduated slopes to ease the strain of pushing heavy loads and laid down over six miles of miniature tram lines inside the works so that the trolleys laden with stoneware pots or baskets of fruit could be pushed without difficulty. He also built special pits to ensure that the women did not have to stoop when filling pots of jam. All were signs of the intense desire of an employer not to extract all that he could from his workers – as critics were inclined to believe – but to improve their lives in immeasurable ways.

The factory became a showpiece for good industrial relations and was visited by social reformers, reporters and union officials seeking to learn the secrets of its success. 'With regard to Mr Hartley's factory, everything here is most perfect,' a representative of the Industrial Law Committee testified. 'I regret that the factory is not still larger so that even more hands could be employed under such excellent sanitary conditions.' A Board of Trade report presented to Parliament in 1891 was similarly glowing in its praise. 'The preserve factory of Mr W P Hartley of Liverpool has always sought

to maintain good relations with his workforce', its author concluded. 'His factory is a model to all.'

William did not believe he should exploit his workers. His was a Christian approach to commerce, and it was an approach that unfailingly succeeded. At the time he built the works there was increasing industrial unrest as business profits fell and unemployment – a new word coined to describe the effects of a slump – rose. In February 1886, an estimated 10,000 people marched through the streets of London in support of the unemployed. Two years later, the poorly paid match girls at the Bryant & May factory in the East End formed a union and marched out of the works, demanding higher wages, shorter working hours and improvements in working conditions. William by contrast suffered few difficulties with his workers. 'I have always had the happiest relations with my people,' he told an interviewer in 1898, adding with a distinctly biblical nod, 'If you ask me how it is to be accounted for, I can only say that it has been my aim from the first to do to them as I would wish to be done by.'

Generations of families passed through the Hartley works, their names recorded in the great ledger of carters, warehousemen, foremen, travellers, cashiers, clerks, stable lads, drivers and engineers. The esteem and affection in which William was held was recognised in numerous gifts to him and his family. In 1909, for instance, the workers presented him and Martha with a silver table-centre 'in acknowledgement of much kindness received by them during many years'. And in 1916, on the occasion of their golden wedding

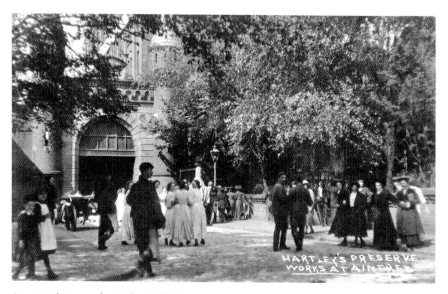

A pastoral image of an industrial Eden.

anniversary, the Hartleys were given a silver rose bowl and a Doulton tea set.

William's concern for his people similarly extended beyond the factory walls. On numerous occasions he helped his employees through difficult times in their lives with gifts of money (though noticeably not if their difficulties were caused by drink or gambling). And, at the end of his life, those who had served him the longest or who ranked highest in his estimation were presented with an unexpected reward. In 1923, when his will was read, it was discovered that thirty-seven of his workers at London and fifty-four at Aintree had between them been given almost £25,000 – more than half a million pounds in modern terms. The amounts included £1,250 for Richard Lambert, his right-hand man at Aintree; £550 for his private secretary, Thomas Handley; £500 for Charles Wardlow, his senior salesman; £250 for Works Manager Edward Eaton; and £110 for long-serving workers such as William Hill, James Llewellyn, William Rushton, Henry Bateman, Charles Eaton and William Trowler, the popular foreman of the Filling Room, who held the distinction of only being absent from work one day in thirty-six

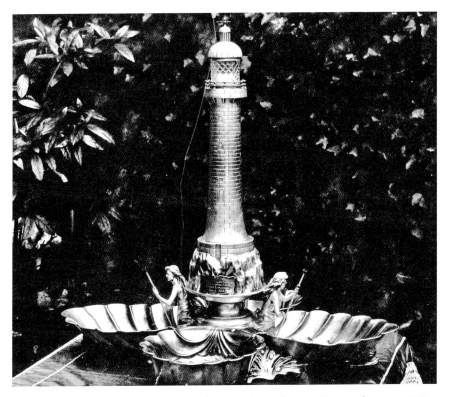

Silver lighthouse presented to William and Martha by workers at Aintree, Christmas 1909.

years. It was an extraordinary gesture, but one that was entirely in keeping with the unique relationship that William had forged with his workers.

Here was commerce used not merely to benefit its master, but as a clarion call to fellow industrialists, idealists, politicians and reformers. In the creation of a model village he addressed the need for better housing for the working classes, and in the factory that stood alongside it he demonstrated that it was possible to achieve the highest standards of working conditions while maintaining the fundamental aim of business, namely profit. At Aintree, and later London, he strived to create a harmonious relationship between himself and his people. It was an aim in which he almost entirely succeeded. 'In every detail pertaining to the happiness of the workpeople Hartley's have been pioneers in the movement for employees' welfare,' William Beable noted in his *Romance of Great Businesses*, published in 1926. William's was an enlightened vision, inspired by Christian principles and sustained by an absolute conviction that it was his duty to improve the lives of his workers and, by extension, all workers.

A Commercial Triumph

The Hartley works was an architectural marvel and an industrial masterpiece. William took a product that was traditionally made at home and produced it on a monumental scale. The firm used almost a quarter of the world's supply of Seville oranges and chartered its own ships to transport supplies from Spain. It had its own fruit farm at Henlow in Bedfordshire, which was bought around the turn of the century, and its own bonded warehouses on the docks at Liverpool.

The scale of the business was staggering. The factory was capable of producing over 600 tons of preserves a week (the equivalent of more than 1.3 million one-pound pots). And when the weather was warm and supplies abundant, special trains were laid on to collect the fruit from the fields. At the height of summer, trains laden with fruit crossed the nation from farms at Buxton and Martham in Norfolk, Wisbech, Ledbury, Evesham, Abernethy and Blairgowrie in the east of Scotland, where wagonloads of freshly picked raspberries were hitched to the back of the midnight train from Glasgow.

Hartley's purchased blackberries from Ireland that were sent by steamer to Liverpool, apricots from Murcia in southern Spain, and in the years before the First World War blackcurrants from 'three men in Boulogne'. It also turned fruit into a variety of associated products that were made throughout the course of the year, such as table jellies, sauces, candied peel – made from the surplus peels of oranges and lemons – and bottled fruits, 'made from fresh fruits direct from the orchards', as an advertisement proclaimed.

In the winter, the firm made marmalade, usually from early January, when the first Seville oranges arrived from Spain, but the bulk of its sales came from the manufacture of the preserves that were made in the short summer months. The firm boasted that 'fruit gathered at sunrise is Hartley's Jam the same evening', and vast numbers of women were employed to hull and stone, top and tail, or to work in the Finishing Room, where nimble fingers

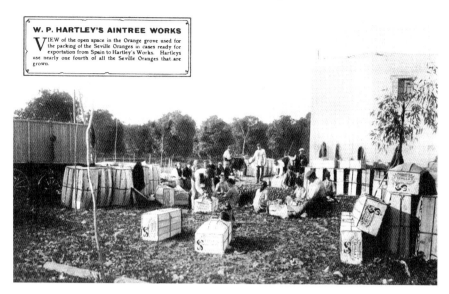

The packing space in an orange grove near Seville. Hartley's had contracts with growers in Spain who grew oranges exclusively for the firm.

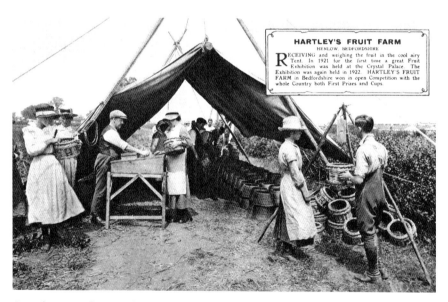

One of a series of postcards produced for the firm in 1923.

wrapped, labelled and tied over 100,000 jars a day. The Mayor of Liverpool, on a visit to the works, noted that a clergyman could not tie a knot as fast.

The works was the heart of the village. The firm maintained a permanent workforce of around 800, but in the summer, when the fruit came in from the fields, up to 2,000 workers were employed at the factory, the majority of whom were women. Women formed the backbone of the business, and the numbers assembled outside the factory gates at hiring time were so great that the firm engaged the services of a county police officer to keep order.

A Mystical Process

The need to employ so many women arose from the manner in which William made his preserves. At other jam factories, manufacturers pulped the fruit and preserved it with chemicals, which allowed them to make their products throughout the year. William's insistence on making his preserves from fresh fruit and sugar alone meant he had to make it as soon as the fruit came into the factory.

The whole process relied on speed. The season for soft fruits started, depending on the weather, in June when the first strawberries were gathered in the fields. The strawberry season lasted around three weeks and was followed by the arrival of French and then English blackcurrants, redcurrants (which were also made into jelly, primarily for the American market), gooseberries, raspberries, plums, damsons and finally blackberries, the last of which were picked in early October.

Hartley's had contracts with growers around the British Isles, known as its confidential growers, who grew fruit exclusively for the firm and sent it to the factory. At the height of the summer, more than 200 railway wagons of fruit were received at the works each day. As soon as it arrived, it was shunted into the Fruit Receiving Room, a large, airy room, whose sliding doors opened directly onto the train. The fruit was transported in wicker baskets and once it had been unloaded it was taken into one of the two Picking Rooms, where it was washed, sorted and graded by more than 900 women, whose hands at the end of each day were stained the colour of whatever fruit had passed through them. Gooseberries were topped and tailed, plums stoned, strawberries hulled.

The fruit then passed into the Boiling Room, where it was cooked in huge copper preserving pans with the addition of sugar, water and, in the early days, gooseberry juice, which acted as a setting agent. (The reason Seville oranges were preferred for the firm's marmalade was because they were

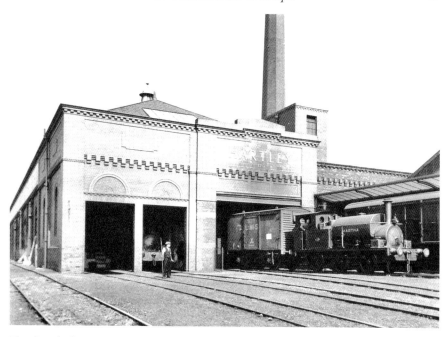

The firm had its own railway sidings. *Martha* (pictured here) was one of the two steam locomotives owned by Hartley's. *Martha* and her counterpart *Maggie* were sold for scrap in 1956.

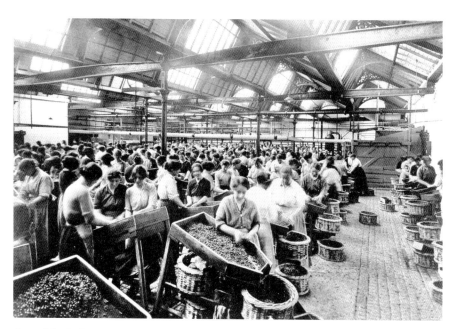

One of the Picking Rooms.

higher in pectin than sweet oranges and thus gave a good set.) The immense amount of sugar – almost 15,000 tons a year – came from the Liverpool refineries of Tate, Fairries and Macfies.

Nowadays, the process is computerised, allowing the firm's products to be made at the flick of a switch, but in the beginning the manufacture of preserves was an almost mystical process. William kept notes of each boil as scrupulously as a nurseryman and referred to them constantly, both as a means of eliminating mistakes and to remind himself of a successful formula.

An apocryphal tale credits William with personally examining every batch of fruit entering the works, which in view of the demands the business placed on him seems unlikely. He nevertheless kept close control over the quality of his products, and on the day after the fruit had been boiled he personally tested a sample of each boiling. At six o'clock in the morning nine jars at a time were placed on a stand and taken to his office. He would run his fingers over the paper covering of each in order to test the consistency of the jam and often examined as many as a thousand jars at a time. The results of his examination would then determine the formula to be used for the day ahead. In later years, a laboratory was opened at the factory to scientifically analyse samples of the firm's products, but in the beginning William's ability to gauge the quality of his preserves purely by touch was paramount.

In the Boiling Room, the pans were heated by steam, and according to a report the heat was so intense that it was 'impossible for anything to come out of them which was not perfectly sterile'. William worked hard to maintain his unique taste, and he often blended different varieties of fruit in order to improve the colour and soften the flavour. His favourite variety of strawberries, for instance, was Stirling Castle, which after the first five or six days of the season were blended with Paxtons, named after Joseph Paxton, the former head gardener at Chatsworth and designer of the Crystal Palace. William also mixed different fruits to create new products, such as Strawberry & Raspberry Jam, Raspberry & Redcurrant, Apple & Blackberry, and the unique, if not always popular, Gooseberry & Strawberry, made from the last strawberries of the season and the first gooseberries.

The recipes for each product were closely guarded secrets. There was good reason. Hartley's had created its own distinctive taste – and for a product as simple as jam, taste, coupled with price, was the defining factor for consumers in determining brand loyalty. In 1906, three eminent physicians visited the works and afterwards reported on the manufacturing process. 'We are pleased to testify that we have gone through the whole building and watched the processes of manufacture from beginning to end, and must say that we are exceedingly well pleased with the entire arrangements,' one of

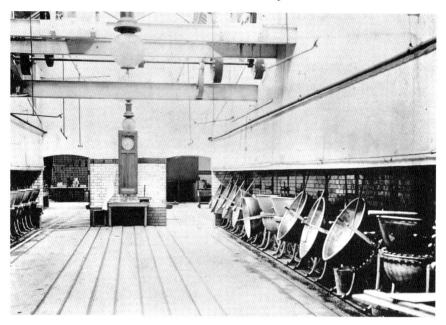

The centre Boiling Room.

its authors noted. 'The fruit was most excellent; its condition could not have been better, and everything used in the manufacture of the jam was all that we could desire.'

The firm's most popular product was strawberry jam. As such, it was made in the greatest amounts. In 1907, for instance, Hartley's made 970 tons and in 1911, when strawberries grew in abundance, it made 1,235 tons. The firm also made large amounts of raspberry jam, the second most popular flavour, and blackcurrant, the third favourite. The amount made was a careful balancing act, which depended largely on the prevailing conditions in the market. As the price of the fruit was agreed with the confidential growers at the start of the season, the firm had to pay the agreed price, whether or not it could achieve a lower price on the open market. The price of sugar was equally volatile. This combination inevitably affected profits. The amount of jam made was also affected by prevailing tastes. In 1890, for instance, damson jam was one of the most popular flavours among the working classes. Fifteen years later, it was plum.

After the fruit had been boiled, it was emptied into copper-lined trolleys and wheeled into the Filling Room. There, it was filled into the distinctive stoneware pots that were made at the firm's own potteries at nearby Melling. (Runners and riders in the Grand National annually cross the Melling Road, along which supplies were carried to the factory on the back of horse-drawn

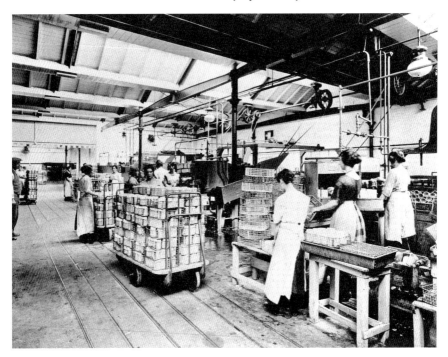

A big and busy department in which every jar was washed and sterilised before passing into the Filling Rooms. Some of the tramlines running through the works can clearly be seen.

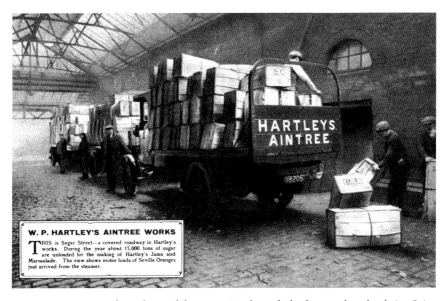

W. P. HARTLEY'S AINTREE WORKS

THIS is Sugar Street—a covered roadway in Hartley's works. During the year about 15,000 tons of sugar are unloaded for the making of Hartley's Jams and Marmalade. The view shows motor loads of Seville Oranges just arrived from the steamer.

Sugar Street was one of two thoroughfares running through the factory, the other being Spice Street.

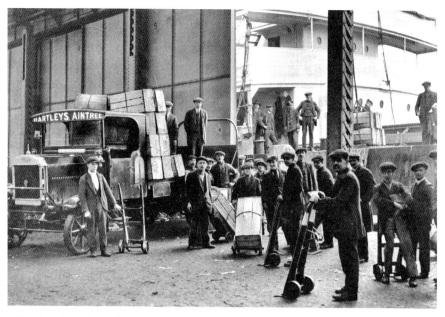

A Hartley's lorry being loaded with Seville oranges at Liverpool docks. The firm used almost a quarter of the world's supply of Sevilles.

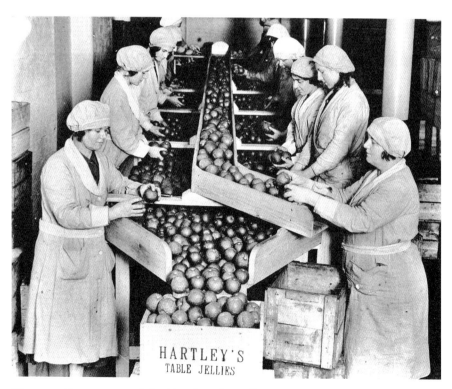

Women sorting oranges and checking them for quality.

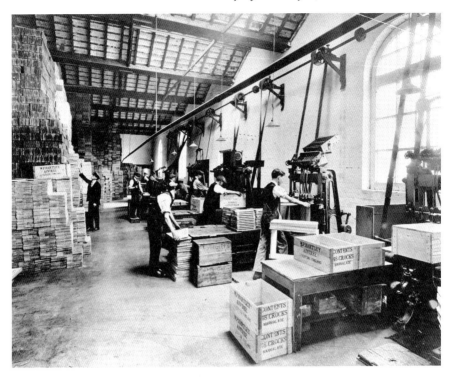

Many of the firm's apprentices started in the Box Making Room.

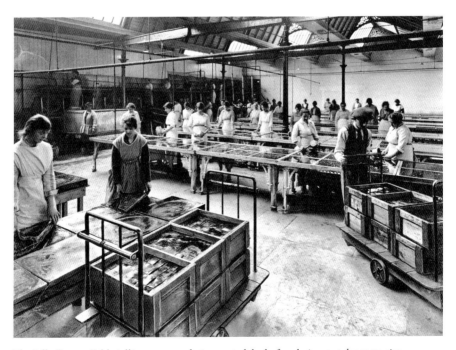

The Jelly Room. Table jellies were made in great slabs before being cut down to size.

carts in the late nineteenth century.) Pots were also made at the Caledonian Pottery at Rutherglen, near Glasgow, which William purchased in 1898.

The firm's trademark was a lighthouse and this was embossed on the base of the smaller earthenware pots in which the preserves were sold in one- and two-pound sizes. A larger seven-pound pot was made for corporate customers and for the corner grocers, who kept them on the shop counter and ladled out small amounts for customers using a wooden spoon. The lighthouse was a familiar symbol of trust and safety, both of which were important tools in the public relations war against adulterated products. It was also a Christian symbol of divine guidance and was probably first used when William moved to Bootle, the dual symbolism perfectly encapsulating his beliefs.

In the beginning, girls hand-filled the pots using silver-plated ladles, and it was not until the late 1920s that automatic filling machines were introduced. The pots were washed and sterilised before use. 'We do not use glass jars because our method is to fill the jam into the jars immediately it is boiled, so that glass jars would not stand the heat without constant breakages and most serious risk of pieces of broken glass getting into the jam, therefore

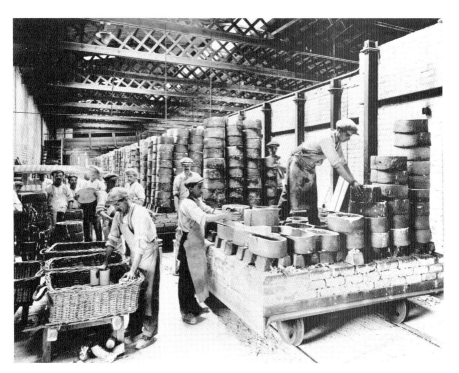

Melling Pottery. The heavy receptacles called 'seggars' containing the partially dried soft-clay pots are ready to be loaded into a kiln heated to a temperature of 2,300 degrees Fahrenheit.

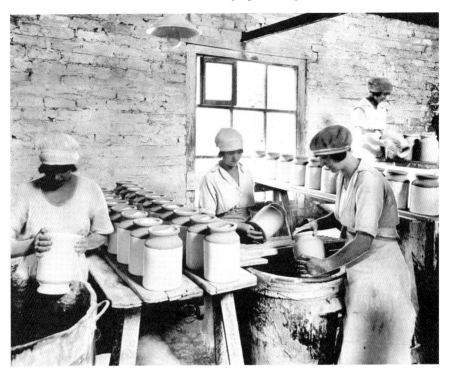

Melling Pottery. Seven-pound pots are being dipped in leadless glaze, the final stage in the preparation of the jars for burning.

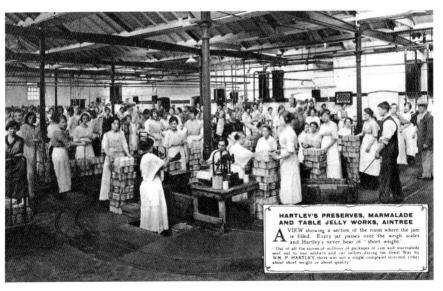

HARTLEY'S PRESERVES, MARMALADE
AND TABLE JELLY WORKS, AINTREE

A VIEW showing a section of the room where the jam
is filled. Every jar passes over the weigh scales
and Hartley's never hear of "short weight."

"Out of all the scores of millions of packages of jam and marmalade
sent out to our soldiers and our sailors during the Great War by
WM. P. HARTLEY, there was not a single complaint received, either
about short weight or about quality."

The Filling Room. Some of the women are standing in the special pits that were built to ensure they did not have to stoop when filling the pots with jam.

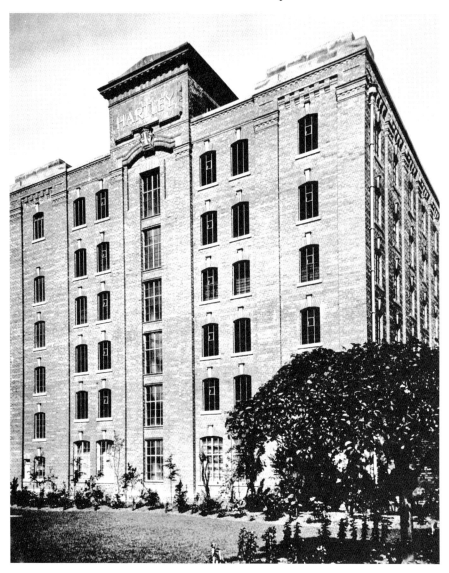

One of the three warehouses at Aintree. Each held around 15 million jars of jam and marmalade.

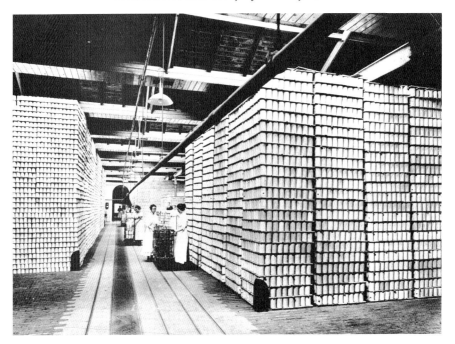

A small selection of some of the 15 million pots.

for twenty years we have practically used only the highly glazed stoneware jars,' William explained in 1901. In the Filling Room, the girls stood in the special pits that William had introduced to prevent them stooping, and the process of wheeling in the boiling jam and wheeling out the filled pots was as seamless as it was effortless.

After filling, the preserves were covered with a parchment cap and stored in one of the great six-storey warehouses, each of which held up to 15 million pots of jam and marmalade. Lesser manufacturers, who pulped the fruit, did not need storage space, as their products were made and sold throughout the course of the year. But as William's preserves were all made in the summer, he needed to store them before sale, and each of the warehouses to some extent represented the growth of the business.

The factory was a gargantuan machine, which in the summer absorbed and emitted the intense smells of the different fruits as they were cooked, allowing passers-by to know in an instant what flavour of preserve was being made. All roads seemed to lead to the Hartley factory. In summer, special trains were laid on to transport workers from Exchange Station in Liverpool, and hordes of women either arrived on train or on foot, crossing the fields in ones and twos. The roads were filled with the firm's delivery wagons, which

were fitted out in its distinctive colours of green and black, with its trademark lighthouse painted on the side in red. The factory even seemed to run on its own time. When the first warehouse was built in 1891, William added an ornate clock tower to it, which chimed the hours and became the means by which workers kept the time.

A Commercial Monolith

At Aintree, William turned flourishing industry into commercial monolith. The firm endeavoured to sell all its stock within the year, and its travellers covered the north of England, the Midlands, Northern Ireland and the Isle of Man. (It was not until the opening of the London works in 1901 that the firm conquered the nation as a whole.) The travellers were the public face of the business and were expected to be neatly dressed and well presented when promoting the firm's products. In spite of a growing taste for advertising, William was not keen on it, as it did not sit well with his religious principles. Advertising in itself was deemed to be a form of show and was avoided wherever possible. The early Hartley advertisements were little more than simple lists of products, whose only nod to self-promotion was to point out that they contained 'no pulp, no glucose, no preservatives, no colouring matter'. There were no slogans, no pictures, no gimmicks.

William made few claims for his preserves. He did not need to. The quality of his products was exceptional, and his religious refusal to charge consumers an unfair amount for them meant that Hartley's swiftly became one of the most popular preserves on the market. 'I trust that I may be pardoned for saying that in my own business I have tried to make the best possible article and to turn it out in the best style, believing that high-class quality will not only bring reputation, but dividend,' he revealed. His reputation soared and orders for the firm's goods flooded into Aintree.

In the offices at the front of the factory, staff worked round the clock to process the orders. There were no women office workers when the factory started, and all the clerical work was done by male clerks who sat in neat rows of desks that were arranged like pews in a church. The orders, once processed, were dispatched to the warehouse and the products then passed to the Finishing Room, in which each pot was individually labelled and wrapped in brown paper tied with string. A warranty attached to each pot guaranteed that the product was 'perfectly pure' and was signed 'W. P. Hartley', an individual touch that served to heighten the connection between manufacturer and consumer.

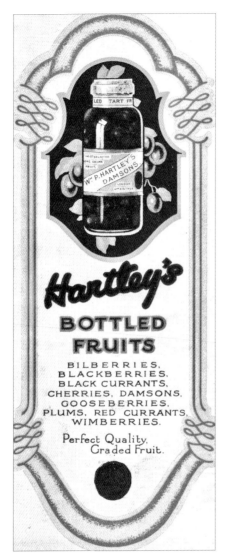

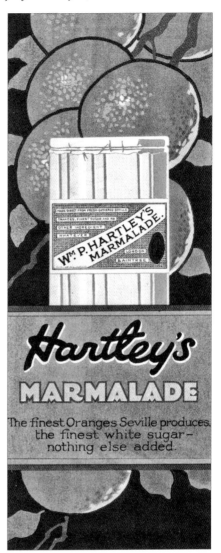

Labels for Hartley's Bottled Fruits and that perennial favourite, Hartley's Marmalade.

In the last stage of production, the products were taken to one of the two Railway Packing Rooms, where they were packed in wooden crates and loaded straight onto a waiting train. The firm sold its products to department stores, multiple retailers (the forerunners of the modern supermarket), corner grocery stores, institutions, restaurants, cafes and teashops, as well as the railway companies and shipping lines. The White Star Line, owners of the ill-fated *Titanic*, served Hartley's jams and marmalades on its fleet of ocean-going liners, as did Cunard and Union-Castle, the main shipping line to South Africa. Hartley's also made miniature pots of jam for Carr's of Carlisle, which were sold in its picnic hampers and provided the jam fillings for Jacob's to put in its biscuits.

The main market for Hartley's goods was at home, but in 1890 William appointed H. Kellogg & Sons of South Front Street as sole agent for his products in Philadelphia. Seven years later he signed an agreement with New York importer R. U. Delapenha to sell his goods along the Eastern Seaboard of America and into Canada. In 1908, miniature pots of Hartley's Marmalade could be found on the breakfast tables of trains on the New York to Chicago

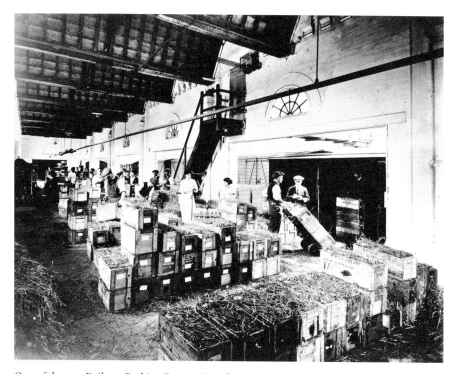

One of the two Railway Packing Rooms. Wooden crates of products are being loaded straight onto the back of a waiting train.

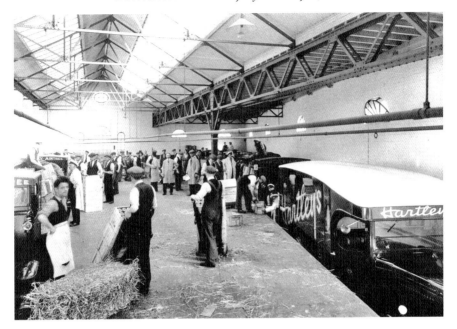

Loading lorries for distribution.

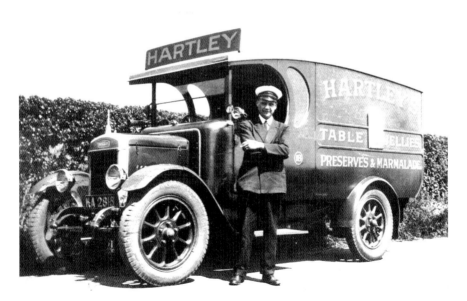

One of the firm's drivers, Bill Hill, on the road.

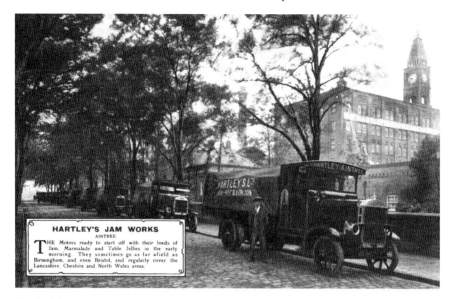

Hartley's lorries on Long Lane.

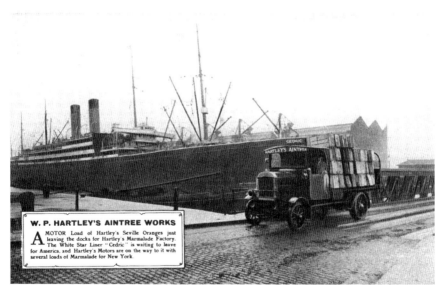

Destination: New York.

railroad and on those from Montreal to Vancouver. Marmalade was the most popular product in America, which at that time was a largely unexplored market, but the firm also sold a range of preserves that readily found favour abroad. William, however, was reluctant to lose control of production and, when he was approached with a proposal to open a factory on the outskirts of New York, he declined.

The Unrelenting Demands of Commerce

William oversaw the entire process with a practised eye, and he was an inspiring presence on the factory floor. A profile of him noted that 'Mr Hartley is a man to whom business is business in the best sense. It is the thing he is doing and to him the thing he is doing must be done with all his might.' In the summer months, he worked from early in the morning until late at night. 'No eight hours for me then,' he confessed to a reporter.

The manner in which he made his preserves, however, put an inordinate strain on both him and his workers. 'Those who make from pulp know nothing of the great strain we are under,' he complained in a letter to a friend. The summer months were a test of his nerve, an unyielding battle between the forces of nature and the unrelenting demands of commerce. William strived to make 'the best possible article', as he put it, but obtaining the best quality fruits was not as simple as it might sound. Fruit was a notoriously fickle crop that was susceptible to all the vagaries of the British weather – from late spring frosts to torrential rain. As a result, yields varied significantly from year to year, from paucity to glut. 'It is almost impossible to regulate the fruit supply,' William recorded. 'We have either too much fruit or too little and the weather is the great factor in arranging the daily supply. We never can work it to perfection and it takes all our time and temper to tackle the work in the actual fruit season.'

There were few certainties. William visited his growers in the spring in order to gauge the amount of fruit he might expect in summer, but even that did little to alleviate the constant worries about the season's crop. 'The strawberries are there, but the sun is not there, therefore they only ripen at about one-sixth the usual speed, and in a word the weather is so cold, wet and sunless, that the strawberry crop is now certain to be well below the average – indeed only the very best of the fruit can survive the weather conditions,' he wrote to a friend.

Troubles with his growers compounded his difficulties. William's correspondence is full of letters to those who failed to deliver their fruit to

him at the appointed time – leaving him with a factory that was not running at its optimum capacity – or those whose fruit was too small or not ripe enough, or whose delay in picking left the fruit in a condition that made it impossible for him to make jam from it. 'We are now exceedingly busy with English strawberries,' he explained in a letter to one of his growers. 'Then we have the blackcurrants to deal with and unless our strawberry growers and our blackcurrant friends keep us well informed we are absolutely powerless to regulate the work of the factory and if we are short of fruit then we are losing precious time; but on the other hand, if we have considerably more fruit than we can deal with, this is equally unfortunate, because of course the fruit is deteriorating and we cannot keep up our high class national reputation unless we make the best possible article.'

The pressure occasionally boiled over. 'We are on the eve of our season and it is necessary to work hard and long to make all preparations,' he wrote to the manager of his fruit farm at Henlow. 'I arrived home on Friday night at ten o'clock and at once noticed some strawberries on the table. Mrs Hartley and my daughters said these arrived from the farm at 11.30 and we are very sorry we had them. The fruit was wet, small, brown, sandy, and they said that if I made my jam from strawberries like these I had better give up making it, as it would be most unsatisfactory and of a decidedly brown, unsaleable colour. I was tired when I got home and to be met the very first moment I got into the dining room with a tale like this was enough to make me wish the farm was at the bottom of the sea.'

A Solemn Vow

The growth of the business was phenomenal, but by 1890, four years after the works at Aintree was opened, there were clear signs that the pressure of building and maintaining the business had taken a toll. In February, the family doctor was called to Aintree to attend William's father, who was described as being 'very poorly'. (John had followed his son, first to Bootle, and then to Aintree, where he lived in the model village opposite William's home, Inglewood.) In the course of the visit, John asked the doctor to examine his son. The doctor examined William's heart, and William wrote in his pocket book that 'I was calm and collected to a much greater extent than he could have imagined as compared with what I was two or three years ago'.

The business had expanded far beyond his expectations, and the strain of running it did not sit lightly on his shoulders. His pocket book, far from being a journal of everyday life, is a catalogue of his ailments. 'I sleep well,

but do not feel refreshed,' he wrote, 'and even if I have my breakfast in bed I do not feel ready to get up on three mornings out of four, and unless I exercise a strong will I am simply overcome by the tired feeling and lay down, feeling I have not the power to get up.' He was, he observed, 'tired beyond endurance'.

William was run down, exhausted and lacking the drive that had once sustained him. In December, he sought the opinion of three of London's most eminent physicians. The opinion of all three was the same. In his rooms at 5 Harley Street, Sir Oscar Clayton, an expert in neurological diseases, noted that he was 'suffering from serious nervous exhaustion' and recommended a three month break with 'no political, municipal or religious work'. Dr B. W. Richardson of 25 Manchester Square similarly stated that William 'must do work only of a pleasant character, must lead an active life, but have no mental anxiety'. He suggested a voyage to the Mediterranean, advice which William dutifully followed, travelling on at least two occasions to Menton in the south of France, where the sick habitually gathered to convalesce. He also became a regular visitor to the Hydro at Ben Rhydding, which became his bolt hole in times of trouble, and the Derbyshire spa towns of Buxton and Matlock, in whose dark chambers the well-to-do immersed themselves in a range of hydropathic treatments.

William's response to his fluctuating health was to have far-reaching consequences. In 1890, he sought to limit himself to what he knew he could achieve and not to proving, as he had so often in the past, that he could accomplish what others believed was impossible. 'I must do one thing at a time, the most important first and not allow myself to get over-faced, worried and nervous,' he noted on a sheet of paper, which was to be used as the first page of all subsequent pocketbooks, so that in those moments when he felt energetic and ebullient – ready to take on the world – he could remind himself of the darker side of success.

At the age of forty-four, he made a solemn vow to employ no new travellers, either at home or abroad, to make no new products and to limit the extension of his trade to his existing customers. The opening of the first warehouse at Aintree had been planned for the following year, but William determined to build no new warehouses unless he had been convinced of their necessity for at least three months, and even then their use was to be restricted to the needs of his existing trade. 'I have had these oppressive warnings for about ten years,' he concluded, 'and I now make this solemn vow to think of my health first and business second.'

William's fluctuating health is one of the reasons his business never developed to the extent of that of those other great purveyors of the

Victorian Dream, such as Lever, Lipton, Tate, Cadbury and Rowntree. In twenty years he had built his business to a position of prominence, but instead of pushing forward he was thinking more in terms of consolidation and restraint. At the heart of these self-imposed restrictions were concerns for his health.

While many well-known businesses exploited the commercial potential of the British Empire, or expanded into the fast-flourishing North American market, Hartley's was content to play second fiddle to competitors such as Chivers and Crosse & Blackwell, which moved overseas with greater ease. The opening of the London works in 1901 allowed the firm to dominate the market at home, but the overseas market, which for some firms contributed as much as 40 per cent of total sales, was never developed – and an opportunity, once missed, was not to return.

In the years that followed, William's health remained in a constant state of flux, the long periods of hard work offset by confinement to his bed, or one of his regular flights to Buxton or Ben Rhydding. Arthur Peake noted that William was 'subject to great fluctuations of mood and these tended to vary with his health. At times nothing could thwart his amazing energy or daunt his radiant optimism, but when his nerves were badly worn, or he was visited by the severe oppression on the top of his head, this buoyancy gave way to depression and weariness.'

At the same time, the decision to step back from business would lead him in an unexpected direction. The closing years of the nineteenth century would be for William a time for renewal, a time to establish his reputation in a wider sphere, a time to spread his wings. On New Year's Day 1877, while he was still struggling to build his business, he had taken a vow which he would describe ever after as 'one of the greatest joys of my life'. The vow was to devote a tenth of his annual income to 'religious and charitable objects' and it would pave the way for some of his greatest achievements.

As time went on, William increased the amount he gave away to first a quarter and then a third of his income, believing that the larger a man's wealth, the more of what he called 'the Lord's money' should be apportioned to religious and humanitarian needs. 'It is, so it seems to me, the primary duty of those who have money to remember in a liberal manner those who have not and to contribute to their needs as to make their lives more worth living,' he observed, articulating a principle that guided his life.

The fact that commerce did not and could not absorb him entirely enabled him to explore his wider interests – another reason his business did not expand to a greater degree. In the end, commerce was merely a device, and the broadening of his interest enabled him to satisfy a deeper desire. After all,

he had drifted into commerce more by accident than design, and the need to serve God always exerted a greater force.

William struggled to reconcile the demands of his faith with the increasing profits of his business, but the wealthier he became the more he sought to dispense his wealth in the service of a greater good. A man of commerce he might have become, but his innate 'desire to be good' created a man who did not seek wealth – the material riches so scorned by his denomination – but to serve and to be of use.

Private Conscience and Public Duty

The fate of William Hartley was to be remembered as a man of commerce, but in his lifetime he was as well known for his philanthropic deeds. In common with many of his fellow Victorians he felt a genuine compassion for distress, and throughout his long life he did all that he could to alleviate the suffering of the poor, the sick and the homeless. The range of his benefactions was extensive, from small gifts handed to individuals in times of need to the construction of almshouses, hospitals, churches, an orphanage, a sanatorium for consumptives, and a botanical institute.

William would long maintain that a businessman needed to find an escape from the monomania of commerce, and he found it in his unflinching pursuit of that great Victorian ethos, the common good. Wealth in itself held no allure for him. In the creation of a fortune that at times he was almost ashamed to possess, he showed that it was the use to which a man put his wealth that mattered, not its amount. In his paper, *The Use of Wealth*, published at the turn of the century, he outlined his ideas for systematic and proportionate giving, almost as a plea to others to help cure the nation's ills. The notion of the 'Lord's portion' became a familiar refrain in his speeches and formed the basis of an assault on the more traditional means of supporting charitable causes.

Here lies the significance of his vow. There were those who left their wealth in the provisions of their wills, or periodically donated an amount toward a good cause. The point at which William parted from many of these people was his promotion of a vision in which he systematically set aside a definite proportion of his wealth year in and year out. The idea of systematic and proportionate giving was central to all that he did. 'The real, deep, lasting and genuine happiness of my own Christian life began about sixteen years ago, when I was led to see how dishonouring to God it was to give money for His cause in a spasmodic manner and how much more satisfactory and

honouring to Him it must be to give help in the proportion He gave to me,' he acknowledged in 1892.

William was driven by what he called 'Christian principles' and 'Christ-like purposes'. His was a vigorous Christianity, a muscular faith that emboldened him to use his wealth in the name of a greater good – a greater God. Here was a Victorian voyage of idealism, equipped with wealth and propelled by faith. The pages of his pocketbooks, in which he recorded his smaller charitable gifts, bear witness to the depths of his sympathy. There is a payment of a pound to a 'poor woman, child dead' and ten shillings to a 'poor man'. There are payments to schools, missions, hospital funds, distress funds. In December 1893, for instance, he gave five hundred blankets to the poor of St Helens, who had been brought to their knees by the crippling effects of a colliery dispute.

All manner of human flotsam and jetsam float through the pages of his pocketbooks. He gave five pounds to the stationmaster at Aintree to purchase school books for his son – a significant amount at a time when many workers earned less than a pound a week. (The son later became Transport Manager at the Aintree works.) He bought coal for the poor of Southport and Colne to help them through the winter. He paid a widow's funeral expenses and looked after a minister's children after his death. He also established a group of trusted friends, known as the Secret Almoners, who were instructed to ask him for monies in connection with any deserving case that came to their attention. He never knew the names of the recipients. All he ever asked was whether the sum was sufficient.

A sense of unaffected goodness runs through his life. He did not promote himself as a paradigm of virtue, but he was inescapably an emblem of Victorian compassion. There were a host of philanthropists who made significant contributions to charitable causes, often to a greater financial extent. The idea of consistently assigning a definite portion of his income to the needs of the poor, however, called for a very different approach. In practice it was no simple task. As he acknowledged on numerous occasions, he faced a constant battle between what he termed the 'higher and lower self, between the money and the man', which broadly translated into the battle between selfishness and selflessness, the urge to keep what he had made and the desire to set aside 'the Lord's portion'. In later years the image of him that would become most familiar showed him in suit and tie, his open pocketbook in one hand, a raised pen in the other, poised to dispense his wealth. It was a simple image that belied the struggle behind it – the hours spent wrestling with the limits of his conscience and the limitations of his wealth. 'If a man has crushed his selfishness to any considerable degree, he has had something to do,' he observed.

William Hartley. A successful man of commerce and a well-known philanthropist.

The Uses of Wealth

Wealth and conscience were at odds. Industrialisation had created massive wealth, but its dazzling successes were overshadowed by the widening disparities between rich and poor. There was a deepening sense that the economic miracle had not benefited the working man and public debate increasingly focused on the responsibilities of the world's wealthiest nation towards its growing ranks of impoverished and undernourished citizens.

The Victorians developed a conscience, and the immense sense of guilt, often fuelled by the fires of religion, inspired a deep sense of public duty. In the conclusion of one of his lesser-known works, The Life of Our Lord, *written for his children, Charles Dickens promoted an orthodox view of Christianity that doubtless chimed with the views of parents around the nation:*

> *It is Christianity to do good always – even to those who do evil to us. It is Christianity to love our neighbour as ourself and to do to all men as we would have them do to us. It is Christianity to be gentle, merciful and forgiving and to keep these qualities quiet in our own hearts and never make a boast of them, or of our prayers or of our love of God, but always to do right in everything.*

The line of Victorians heading toward heaven's gate was seemingly without end. Textile magnates, newspaper barons, shipping tycoons and railway grandees all contributed to the pursuit of the brave new world. In 1892, Arthur Pearson, the founder of the Daily Express, *launched the Fresh Air Fund, which by 1909 had financed day trips to the seaside and countryside of more than 2 million disadvantaged children. Angela Burdett-Coutts, the nationally acclaimed 'Queen of the Poor', built schools in the poorest parts of London, and by her death in 1906, at the age of ninety-two, was said to have given away more than £4 million to charitable causes.*

William Booth, the son of an unsuccessful pawnbroker, created his Salvation Army and used its platform to promote better housing for the poor, training centres for the unemployed, and homes for abused women. (A lapsed Methodist, Booth condemned the acquisition of wealth but cultivated a number of wealthy donors, among them William Hartley.) Thomas Barnado likewise founded a string of homes for abandoned children, as well as all-night refuges for boys and girls, a labour house for destitute youths, and an industrial home for girls. By 1890, he claimed to have 'rescued, trained and placed out in life' more than 17,000 children.

The Victorians assiduously marched from the fires of eternal damnation toward a more progressive society in which citizens were morally elevated,

cultured, educated, civilised. The well-to-do and the well-intentioned built libraries, reading rooms, museums, hospitals, orphanages, almshouses, concert halls, art galleries and parks. In the New Jerusalem, the masses were expected to read (though not too much, in case it infected their minds with overweening ambition), to refrain from the evils of alcohol (which would assuredly lead them to an earlier grave than the one prescribed for them by fate), and to learn a trade that would be useful in the burgeoning empire, whose boundless limits were the chanting refrain of school children across the nation.

Victorian ingenuity had created vast fortunes, but while some chose to worship what Beatrice Webb called 'the Goddess of Gold', others chose a less triumphant approach. The urge to recreate society in a more Christian image prompted the establishment of a loose network of Christian Endeavour societies, Band of Hope unions, homes for delinquents, refuges for the destitute, medical missions, soup kitchens, institutions for reclaiming the fallen, rest homes and reformatories. In 1881, the Waifs and Strays Society (later to become the Church of England Children's Society) was formed to protect destitute and neglected children. A year later, a young curate, Wilson Carlile, formed his Church Army with the aim of elevating the lower classes to a higher standard of Christian morality.

At the same time, public lectures, penny pamphlets and periodicals spouted the language of hard work, thrift, neatness and cleanliness, the latter as an essential corollary to godliness. In Manchester, the Ladies' Health Society employed working-class women to visit the poor in their homes and to teach them the importance of hygiene. The Ladies' Sanitary Association similarly lent brooms and cooking utensils to poorer householders and distributed pamphlets on healthy living. One of its leading lights was quick to note that 'nasty air' was an anagram of 'sanitary'. 'Who'd have thought it?' she mused. 'And yet, after all, that nasty air is the breeze that has kindled the Sanitary Association into life.'

The critics of philanthropy claimed that too much charitable giving encouraged dependence among the poor, but Victorian prosperity created both the wealth to indulge in good causes as well as the will to improve the lives of the working classes. 'There is reason to think that the latter half of the nineteenth century will stand second in respect of the greatness and variety of the charities created within its duration to no other half century since the Reformation,' the Charity Commissioners Annual Report of 1895 concluded.

A Man of Genuine Goodness

William was thirty when he took his vow to devote a definite proportion of his income to the needs of the poor and the sick. As he grew older, the greater the scope of his benevolence became. In the closing years of the nineteenth century, he built a cottage hospital in Colne at a cost of almost £5,000, which was opened by the Earl of Derby in April 1900. And in October 1901, he presided over the opening of a sanatorium for consumptives at Delamere Forest, 30 miles outside Liverpool, his share of which came to £7,500. The construction of these august edifices came on the back of the continued success of his business, which in the summer of 1901 was consolidated by the opening of a factory in London. He also benefited from a number of shrewd investments, most notably in cotton mills, which significantly increased his income and thus the amount he was able to distribute.

At the time, cynics criticised some of his more munificent gifts as little more than shrewd advertising, but there is no evidence to support such an assertion. When it came to his larger benefactions, he devoted himself entirely to their pursuit, and the talents he applied to his business – his close attention to detail, his rigorous standards and refusal to compromise – readily found a home in his philanthropic work. He did not believe it was sufficient simply to hand over a sum of money to fund the construction of a building. Instead, he absorbed himself in every aspect of a scheme from the choice of brick to ensuring the adequate provision of light and ventilation. He was often as familiar with the plans for his buildings as the architect who drew them, and his involvement did not end when a building had been erected, but extended into the public support of whatever cause it represented.

William's reforming impulse prompted him to pursue a broad and uplifting vision of society. He might once have settled for a quieter life, and indeed others might well have expected it of him, but he was under no illusions when it came to the demands that his faith placed upon him. 'Religion,' he wrote, 'is not only a thing of the church, the prayer meeting, or holiness conventions; it is all these, but a very great deal more. It is a thing of the factory, the workshop, the mine, the office. In a word, it is a life to be lived.'

While he freely acknowledged its effect on his business in the sense that time spent in the interests of philanthropy was time lost in the pursuit of commerce, he was unapologetic when it came to the needs of those whose lives had been blighted by poverty, sickness, miseducation, a lack of education, or plain ill fortune. There were those who differentiated between the deserving poor and the undeserving poor, but William confined his interest to a solution that would favour all, regardless of religious or political persuasion.

He might have looked unfavourably on those who squandered their money on gambling, drink or a simple lack of thrift – the traditional marks of the undeserving poor – but when it came to the division of his wealth, his was a common humanity, a sense that all men were equal regardless of their circumstances.

Humanity First

Medicine ranked at the top of William's list of philanthropic priorities. It was the cause to which he devoted the largest, most consistent amount of his wealth. At a time when hospitals were kept afloat by endowments and subscriptions, he endowed beds to the sum of £30,000 in Liverpool's Royal Infirmary, Stanley Hospital, Royal Southern Hospital and Children's Infirmary, the latter made in thanksgiving for the life of his youngest daughter, Connie, who in October 1890, at the age of six, fell from a moving carriage in Southport. ('A policeman, who saw the accident, said the wheel went within an inch of her head and the deliverance was a miracle,' he wrote in his diary. 'I never felt so thankful before, as nothing short of providence could have saved her.') In 1916, at the height of the First World War, he divided £15,000 among hospitals in London and Liverpool. He donated £30,000 (over £1 million in current values) towards construction of the Liverpool Maternity Hospital, and £100,000 for Hartley Hospital in Colne, which replaced the smaller cottage hospital. He gave £6,000 to Manchester's Royal Infirmary and an unspecified amount to the Devonshire Hospital in Buxton. He also financed research into the cause and cure of cancer.

William was impelled by a moral compulsion that would not allow him to sit on his wealth. The opening of a sanatorium at Delamere Forest came at a time when consumption ravaged great swathes of the population. The great white plague was the scourge of the nineteenth century. When he laid the foundation stone for the sanatorium in October 1900, the Earl of Derby noted that losses from consumption in a single year in Liverpool amounted to more than the British Army had lost in the whole of the Boer War.

The victims of the disease were not limited to the poor, but it was the poor who suffered in greater numbers. The disease struck at all levels. A lack of financial assistance meant that when a male householder was too sick to work, his wife and children, as like or not, were forced onto the bread line – and when the rent was not paid, onto the streets. It was part of the unending cycle of poverty to which the lower classes were subjected. 'The victims are left to struggle and to suffer, dragging into destitution and disease

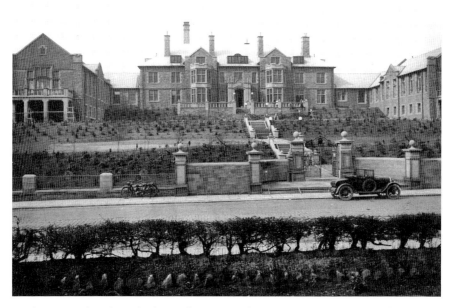

Hartley Hospital, Colne. The hospital was opened in 1924 and became part of the newly created NHS in 1948. It was subsequently abandoned, but has since been converted into apartments. (Lancashire County Library)

their families and friends, and only too frequently multiplying the evil by the propagation of delicate and tuberculously disposed children,' an editorial in the *British Journal of Tuberculosis* proclaimed.

In 1898, the National Association for the Prevention of Consumption was formed. Its aim was 'to educate the public in the prevention of the disease, to influence Parliament and other public bodies, and to stimulate action at a local level'. The same year, William Hartley and Lady Willox, the wife of one of Liverpool's more prominent politicians, each pledged £7,500 towards the construction of an open-air sanatorium at Rough Hill, Delamere, overlooking the Cheshire plains and the Welsh hills. The sanatorium was one of the first of its kind in Britain and was heralded by the Earl of Derby as 'the forerunner and guide to others'.

William's interest in medicine broadened as it deepened and rapidly became enshrined in the dictum 'humanity first'. In 1901, the same year the sanatorium at Delamere was opened, work commenced on the construction of the Hartley Botanical Institute at the University of Liverpool as a centre for research into the medicinal properties of plants. The institute was not his

first contribution to the university. In 1889, together with the Earl of Derby, Sir John Brunner, whose chemical firm formed the nucleus of ICI, and the Liverpool banker Alexander Hargreaves Brown, William contributed £4,000 toward the endowment of a Botanical Lectureship. In 1892, at a cost of £1,000, he presented the university with a magnificent clock, whose five bells were each inscribed with a line from Tennyson's *In Memoriam*: 'Ring out the old, ring in the new, ring out the false, ring in the true, ring in the Christ that is to be.' Three years later, he funded construction of a new physics classroom.

The Hartley Botanical Institute was established, as an inscription above its entrance noted, 'for the study of nature and the service of man'. A towering edifice, five floors in height, it was equipped with laboratories, a library, museum, herbarium, research rooms and a lecture theatre capable of seating 150 students. William purchased a set of botanical works for the library and presented the institute with a collection of plant specimens, which he bought from the estate of William Lomax of the city's Northern Hospital. The total cost was £14,000.

The institute was formally opened in the spring of 1902 by Sir William Thiselton-Dyer, the Director of the Royal Botanical Gardens at Kew, and it soon came to be regarded as one of the most modern facilities in the country. (The building remains in use, though no longer as a botanical institute.) At the opening ceremony, William declared that he wanted Liverpool to be 'a city of light and learning'. He went on to voice his hope that the city would be 'distinguished by a love of all that appertained to knowledge – to the discovery of truth and to the encouragement of science – knowledge that not simply made their wealth more and their comforts greater, but which also cultured the mind and developed the higher functions of the soul'.

The Higher Functions of the Soul

Wealth brought William comfort, but there were no pretensions about him, no sense that fortune and fame had changed him. It could scarcely have been otherwise. The tenets of his faith had taught him to disdain show and ostentation. At the same time, the preachers – and as a friend of so many ministers he could little afford to ignore them – were swift to remind him that wealth was transient and that what mattered more was the hereafter. 'My daily prayer is that God will show me what he wishes me to do,' he wrote. 'I only want to see clearly his guiding hand and I am daily asking him to lead me. I see my responsibility more and more, and I often picture what account we shall give at the last if the judge shall say that he was aware we had gone

to church, to the class, to the prayer meeting, but when it came to sacrificing our money to his cause we let our lower self prove the master.'

The search for God's guiding hand inevitably led him to the needs of his denomination. In 1884, two years before opening the Aintree works, he launched the first of his great challenge offers under which the stimulus of a large donation prompted others to support a cause. The cause was the eradication of the debts of the Primitive Methodist Missionary Society, which after years of financial mismanagement had risen to over £5,000. William's contribution was £1,000, and in spite of the opposition of leaders of the Church, who did not believe its members would be persuaded to part with their money in sufficient amounts, within a year he was able to report the entire debt had been wiped out.

William faced much of the same opposition within his denomination as he did in the early days of his business, but he nonetheless pressed forward undaunted. In 1890, he created the Chapel Aid Association, which effectively rescued the Primitive Methodist Church from the immense debts (almost £1 million) that had been incurred in the construction of its chapels, churches, schools and meeting rooms. The association was an overwhelming success, and by 1922, the year William died, the total paid off the debt was £1.3 million. It also proved to be his longest-lasting legacy, which still operates to this day from its offices in York. A brass plaque in the company's boardroom commemorates William's vision.

The Primitive Methodist Church was traditionally a poor denomination, but William consistently supported it with gifts that defied imagination. In 1896, at a cost of £12,500, he funded an extension to the movement's theological college in Manchester, which doubled its size. Ten years later, a second extension, at a cost of £20,000, made it one of the largest theological colleges in the British Isles. It was renamed the Hartley Primitive Methodist College in his honour. He funded the appointment of additional tutors at the college and created an annual lecture. He founded scholarships for needy students and paid the fees of those students who wanted to take arts and divinity courses at nearby Manchester University. 'He must have spent not much short of £40,000 on the college since I came,' Arthur Peake, who he lured from a comfortable sinecure at Oxford to be the college's senior tutor in 1891, wrote in 1916, adding 'it may be more than that'.

There seemed to be no limits. William became one of the movement's best-known figures, who was described by one of his supporters as 'a God-sent man to the denomination'. He gave £7,500 to the Missionary Jubilee Fund, which he inaugurated in 1892, £5,000 to the African Missions Jubilee Fund, and £2,000 towards the construction of a new mission in Africa. He funded

the training of the movement's first medical missionary in Africa, who took up his post in the Congo in 1915. William also subsidised the purchase of theological books for ministers, augmented their salaries and donated £10,000 to the Preachers' Friendly Society, which paid their pensions.

In 1902, he donated 5,000 guineas to the Wesleyan Million Fund and five years later contributed £15,000 to the Church's Centenary Fund. As the Prims were not as prevalent in London as in other parts of the country, William funded the work of three ministers charged with creating congregations in the capital and put £15,000 towards the eradication of the debts incurred by a number of the city's chapels. In 1908, he built an orphanage at Harrogate, which housed forty-eight children. The same year, he acquired Holborn Hall in London, which he transformed into the denomination's new national headquarters.

Historians of the Church have not ignored him and with good reason. William became one of the Church's most prominent modernisers, who dragged its members – often kicking and screaming – into the new age that Victorian prosperity had created. He was a pivotal figure in the Church. In an article written shortly after his death, Arthur Peake described him as 'a man who struck with unexampled force into the stream of our denominational life, lifting its quality to higher levels, accelerating the pace of its progress, making possible otherwise impracticable enterprises'. An article in one of the denomination's journals similarly described him as occupying 'a position unique and altogether without precedent in the history of Primitive Methodism'. In 1909, he was elected President of the Primitive Methodist Conference, the highest distinction that his Church could bestow upon him and an honour that was rarely conferred on a layman.

The Start of Heaven on Earth

William continued to make his own earnest contribution to the divine. In 1909, he opened new buildings at the Liverpool Workshops for the Outdoor Blind (blind people living in their own homes) on Cornwallis Street. He contributed £5,000 towards the construction of the YMCA on Tottenham Court Road and £1,000 to the YMCA in Liverpool. He gave £1,000 towards a new arts building at the University of Manchester and presented Liverpool University with a Marconi wireless installation for experimental and research work at a time when the wireless was in its earliest stages. (The university became the only educational establishment in the north to possess such equipment, which received time and meteorological messages

twice a day from the Eiffel Tower and allowed experimental work in the new medium.)

Greater public recognition, coupled with greater financial resources, seems to have acted as an inducement to William to spread his philanthropic wings. On a summer Sunday in 1909, Louis Bleriot made the first ever powered flight across the English Channel. The *Daily Mail*, whose proprietor, Lord Northcliffe, had offered a prize of £1,000 to the first aviator to successfully cross the Channel, called Bleriot's historic flight 'an event which stuns the imagination by its far reaching possibilities and marks the dawn of a new age for man'. The following Tuesday, *The Times* reported that William had offered a prize of £1,000 to the first person to fly 'a heavier than air machine' between Liverpool and Manchester. It was another gesture in an extraordinary and diverse litany of munificence which served to confirm his genuine desire to improve the world around him, not merely through the construction of edifice and monument, but through whatever means he felt would best serve it.

The scope of his ideas broadened. In February 1909, at the annual meeting of the Lancashire and Cheshire Band of Hope Union, he announced his intention to purchase 40,000 copies of a book entitled *Alcohol and the Human Body*. The book was distributed to each recognised speaker of the national Band of Hope Union, as well as Anglican, Free Church and Methodist ministers alike, in the hope that it would stir them to greater efforts in the campaign to eradicate the social evil of drink. A vice-president of the British Temperance League, William contributed £300 annually towards the cost of temperance education in schools in Liverpool, which was seen as the first step in eliminating the problems caused by alcohol at a time when children were as likely to be found in public houses as their parents and could equally be found drunk on the streets.

William ticked every philanthropic box. In 1909, at a cost of £1,000, he purchased Sir Frederick Leighton's *Perseus and Andromeda*, an allegory of the triumph of good over evil, which he presented to Liverpool's Walker Art Gallery. The same year he was back in the showrooms, laying claim to Paolo Veronese's *Feast in the House of Levi*, a traditional depiction of a well-known biblical scene. The painting was purchased at Christie's and presented to the Walker Art Gallery in 1914.

Faith and fortune combined in natural harmony. In 1911, William built twenty almshouses in Colne. The Hartley Homes were built at a cost of £13,000, and William provided an endowment for their maintenance in perpetuity. (The homes remain a feature of Colne, the one benefaction that retains its original purpose.) Two years earlier, he had been made an

Honorary Freeman of Colne, becoming only the second person in the town's history to receive the award.

The Hartley Homes were laid out in three sides of a quadrangle, the open side facing the surrounding hills. In the middle of them was an imposing clock tower, a recurring theme in many of William's benefactions, as if the ticking of time should serve as a constant reminder of the shortness of life. In presenting the homes to the town, William declared that 'there will be no religious tests. Human need will be the only test.'

Human need had always been the only test. In a speech to mark the opening of the homes, the town's mayor hailed William as 'a noble example to young people to live up to the highest and best that was in them', adding that 'if a man wishes to be great he must have great benevolence, great charity in the heart and let the putting of them into practice be a part of his life'. He expressed his hope that 'the earnestness and sincerity with regard to duty which Sir William has always shown might influence public men and private citizens, and teach them to try and make life more beautiful, more happy, the world more lovely and heaven to begin on earth'.

The full scale of his benefactions would never be known, but on his death in October 1922 some estimated it to be as much as £1 million, because while the newspapers carried stories of the grand edifices that bore his name, there was no means of quantifying the amounts given to less prominent

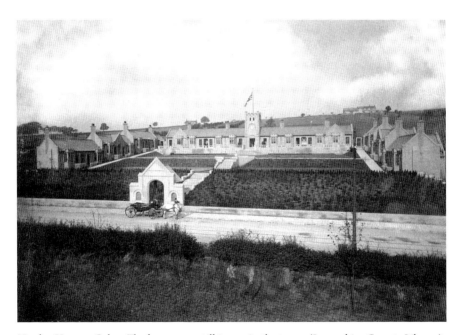

Hartley Homes, Colne. The homes are still in use in the town. (Lancashire County Library)

causes – the small acts of kindness distributed through his secret almoners, or the payments made to the individual poor, sick and homeless. There were also the additional costs, such as those associated with the sanatorium at Delamere Forest, which, while his initial outlay was £7,500, had in the end, after extension and renovation, cost closer to £20,000. The sum given in perpetuity for the maintenance of the Hartley Homes in Colne similarly went unrecorded in the great balance book of his benefactions.

William married a beguiling vision of commercial progress with a fixed and unalterable belief in the essential goodness of human nature. He was both benevolent employer and unpretentious man of God, a dazzling combination of discipline, determination and unremitting devotion. In 1908, he was awarded a knighthood, not for his contributions to commerce, important as these were, but 'for his many princely acts of beneficence and philanthropy rendered to his country'.

The scale of his munificence was staggering. 'The memory of Sir William Hartley will be cherished, not because of his wealth, or even his commercial genius,' Arthur Peake wrote, 'but for the lofty use to which his wealth and his genius were consecrated. His deeds of splendid generosity are impressive when taken singly, they are overwhelming in their mass.'

A Leap of Faith

William had turned his attentions to philanthropy and religion, but he did not lose sight of the needs of the business that funded them. In the summer of 1901, he opened new works in London, the success of which ultimately enabled him to become the leading preserves manufacturer throughout the United Kingdom. The factory was situated at Green Walk in Bermondsey and was built at a cost of £100,000, more than £5 million in modern values.

In 1890, William had vowed to restrict his business to his existing customers, but eleven years later he was opening a new works in London. In a speech to mark its opening, he explained his reasoning. By the late nineteenth century, he told an audience of reporters and invited guests, demand for the firm's products had soared. The reason, he explained, was twofold. On the one hand, new customers from the south of the country had discovered Hartley's wares while holidaying in northern seaside resorts such as Blackpool and Southport. There was also a significant increase in the number of his existing customers, who on moving south wrote to the firm requesting details of where his products could be purchased.

In the last years of Victoria's reign, William bought an existing business in London and opened a small office through which the firm sold its goods. The exact date it opened is not recorded, but in 1892 the December edition of the *Primitive Methodist Magazine* listed the names and addresses of six dealers in the London area where supplies of 'Hartley's English whole fruit preserves and Seville orange marmalade' could be obtained. Similarly in June 1895, when his daughter Sallie married George Gibbens, the couple received among their wedding gifts a barometer from 'the London office staff'.

Demand continued to soar. In 1899, William opened a second warehouse at Aintree, but the growing popularity of his products left him with a stark choice: either to expand his existing works or to open a factory in the south. The same year, he bought an old leather tannery and a linoleum factory on

William's only son, John William.

Green Walk, which were demolished to make way for the new works. And from the ashes and rubble rose a modern factory that was well equipped and well designed. A number of his senior men were sent from Aintree to help start up the factory. And at the age of twenty-four, his son, John William, or Will as he preferred to be known, was appointed to run it.

The Rise of the House of Hartley

When the factory was officially opened on 25 June 1901, Will conducted a party of reporters around it. The works was entered through a pair of wrought-iron gates, which led into a spacious courtyard. The offices stood next to the entrance and beside them was a row of cheap working-class houses that ran the length of Alice Street. A public house, The Jolly Tanners, stood at the end of the row. There was a stable block near the entrance, which was later converted into garages, and above it was a works canteen, which although not as grand as the Dining Hall at Aintree was nonetheless a welcome addition for workers for whom canteens were a rarity in the years leading up to the First World War.

The factory was a tour de force of modern working practices. The production facilities were spread over six storeys, which were divided into sections as protection against fire. Automatic sprinklers, a novelty at the time, were fitted throughout. And the works was powered by a medium so new that, in a souvenir booklet produced to mark its opening, it was noted that 'the agency for distributing light and power throughout is electricity'. Ventilation was good and there was plenty of natural light through the abundance of windows that ran the length of the main buildings. As at Aintree, miles of miniature railway track ran through its innards to make it easier for the trolleys to be pushed from one department to the next. Graduated slopes with steady gradients minimised the amount of exertion. There were five electric lifts, and the great boilers in the bowels of the machine were fitted with the latest equipment designed 'to minimise the escape of smoke to the greatest possible extent'.

The site covered two acres, about a fifth of the size of the Aintree works, but whereas at Aintree production moved from left to right, at Green Walk it ran from top to bottom. The fruit was sorted on the top floor of the factory (on the roof itself on the hottest days) and was carried downward through the Boiling Room and into the Finishing Room on the fourth floor, which was also used for labelling and packing. The three lower floors were used to store the products, and on part of the third floor was the Jelly Room in which

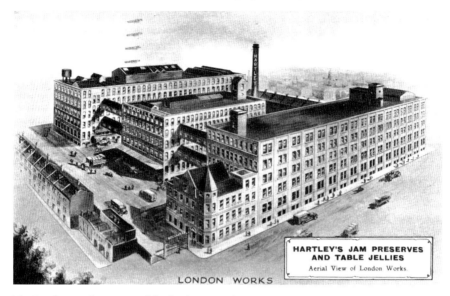

HARTLEY'S JAM PRESERVES
AND TABLE JELLIES
Aerial View of London Works

LONDON WORKS

The London works on one of the firm's postcards.

table jellies were made. When the factory was built there was one production block, but in 1908 a second six-storey block was added, which was connected to the first by a series of bridges. A third was built five years later, necessitating the demolition of the houses on Alice Street. The Jolly Tanners was retained.

There was no railway line into the factory and so all the fruit was transported from the nearest goods station about a quarter of a mile away. The stoneware pots were transported by rail from Melling and from the Caledonian Pottery, while sugar came across the Thames on lighters from riverside refineries such as Tate's at Silvertown. Hartley's had its own wharf on the south bank of the Thames, opposite the Tower of London, shown on maps as Hartley's Wharf, and from it goods were transported along Tower Bridge Road into the factory, at first on horse-drawn wagons, later by motorised lorries.

The firm's assault on the south was no half-hearted attack, but full-blooded war. William did not construct a small works and then expand. Instead, he put up one of the largest factories in London and ruthlessly promoted the quality of his goods. 'The supreme object will be to turn out the purest and best article which the most advanced science and art of preserve-making can command,' he told reporters at the opening of the works. He added, 'Hartley's makes only one quality – the best.'

The works had a production capacity of over 400 tons of jam a week, which, together with the 600 tons produced at Aintree, allowed the firm to make over 4,000 tons of jam a month in the season. The word soon spread

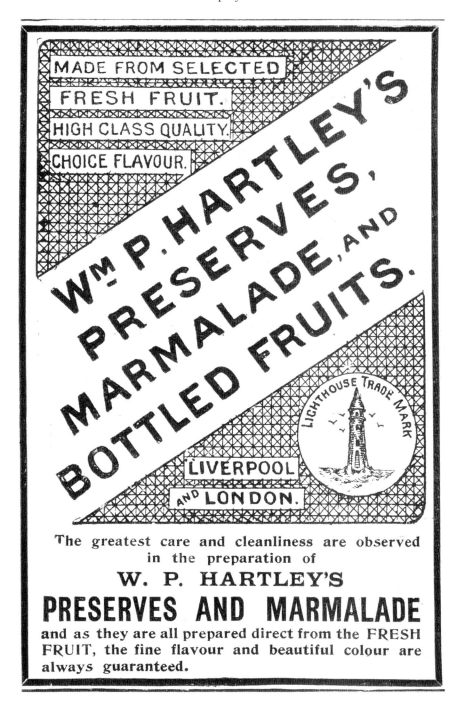

Advertisement from 1901, the year the London works officially opened.

that Hartley's paid higher wages than its competitors, and with better working conditions, together with the promise of a share of the profits, the firm proved a beacon for workers in the area, who flocked to be part of the House of Hartley, as it became known.

An Area of Intense Poverty

The crowded streets of Bermondsey were very different from the open fields at Aintree. In the late eighteenth century, Bermondsey had been a popular health spa to which middle-class Londoners flocked in their droves to enjoy its pleasure gardens, tree-lined walks, orchards and springs. The arrival of industry, however, had transformed it into a warren of factories, breweries, tanneries, wharves, workshops and riverside warehouses. The population grew rapidly, from less than 30,000 in 1851 to almost 140,000 in 1891, and its more pleasant origins were subsumed beneath 'the smoke of close built, low roofed houses' and 'rooms so small, so filthy, so confined, that the air would seem too tainted even for the dirt and squalor which they shelter'.

Green Walk, on which the Hartley works was built, was far from green. In a letter to Angela Burdett-Coutts, the 'Queen of the Poor', Charles Dickens described the area as 'the last and hopeless climax of everything poor and filthy'.

Industry dominated. Bermondsey was outside the central district from which offensive trades were excluded, and its open fields had provided ample scope for development. The area was home to a varied mix of chemical works, starch factories, rope-making works, beer makers, sack makers, bottle makers, glue factories and tanneries. The district had for many years been the centre of London's leather industry and, although by the end of the nineteenth century the trade was on the decline, it still employed over 6,500 workers in 1901. Bermondsey was also home to a large number of food manufacturers, which led to it becoming known as 'London's Larder'. Biscuit makers Peek Frean had works on Drummond Road, which by the turn of the century employed over 2,000 workers, custard manufacturers Pearce Duff were on Spa Road, and Jacob's Biscuits was on Wolseley Street. Courage had a brewery near Tower Bridge, and Sarson's vinegar yard was nearby at Brunswick Court.

There were jam makers too. The area played host to a number of William's competitors. The firm of Charles Southwell, 'manufacturers of high class jams, jellies, marmalade and candied peel', had works at Dockhead, not far from the river, while Crosse & Blackwell, which made jam and marmalade

as well as pickles and sauces, was at Crimscott Street. E. & T. Pink, which billed itself as the largest marmalade manufacturer in the world, was on Staple Street, a short distance from the Hartley works, as was the works of Scottish entrepreneur Thomas Lipton, who in 1892 opened a factory on Rouel Road, promising to 'make things hum' in the trade by selling his jams and marmalade at a fraction of the price of other manufacturers.

The hum of industry filled the air, as did its intense smells. 'In one street strawberry jam is borne in on you in whiffs, hot and strong; in another, raw hides and tanning; in another glue; while in some streets the nose encounters an unhappy combination of all three,' a writer recorded in 1890.

Bermondsey was also pervaded by 'the sharp stink of poverty'. In his *Inquiry into the Life and Labour of the People of London*, Liverpool shipping magnate Charles Booth called it 'this black portion of Central South London' and noted that of its inhabitants 'sixty per cent are poor'. There were few trees and few open spaces. (It was no accident that in 1926 Bermondsey became the first area in London to open a municipal solarium, the Sun Cure Institute, to help prevent and cure tuberculosis. The following year, new public baths were opened at a time when less than one home in every hundred had its own bath.) After payment of rent, burial insurance, provision for coal and light, cleaning materials, clothing and food, most workers had little left for themselves. The less skilled took seasonal work on the docks or in the jam factories and pickle works. The less fortunate took poor relief – or worse, went into the workhouse. 'Those who can afford it move out and those who cannot escape crowd in,' Booth concluded.

Working conditions were poor. In 1911, Clementina Black, founder of the Women's Trade Union Association, investigated conditions for women in Bermondsey's jam, pickle and tea-packing industries. The average wage, she noted, was between seven and eleven shillings a week, well below the poverty line, which Seebohm Rowntree defined as the minimum amount needed 'to secure the necessaries of a healthy life'. A report published four years later noted that women worked ten and a half hours a day, 'pushed and urged at utmost speed, carrying a cauldron of boiling jam on slippery floors, standing five hours at a time, and all this often for about eight shillings a week'.

There had been opposition to the new Hartley works. When he was invited to open the works, the local Member of Parliament, Henry Cust, said that he had 'hesitated as to whether it was wise to bring another big industry into Bermondsey, from the point of view of the housing of the working classes'. His reservations had been overcome by fellow MPs, who, in pointing to Hartley's concern for the welfare of his workers at Aintree, had convinced him 'that such an employer might be welcomed in any part of London'.

The Mayor of Bermondsey expressed his opinion in a less conciliatory tone, noting that 'jam makers ought to carry on their trade where the fruit was grown', but added grudgingly that 'perhaps Bermondsey was the right place when the industry was conducted on a large scale'.

A Revolution in Trade

The opening of the new Hartley works was an extraordinary leap of faith. In 1901, the number of William's competitors had expanded considerably from when he had entered the business thirty years earlier. The competition was severe. In 1864, Marion Robertson, the wife of a Paisley grocer, had turned a barrel of bitter oranges into a transparent jelly marmalade that she called Golden Shred. It sold so well that shortly afterwards she rented part of a cloth-finishing works, using the surplus steam from the processing to heat the preserving pans. In 1890, Robertson's moved south of the border, opening a factory at Droylsden, near Manchester. Ten years later it established a second factory in Catford and, in 1914, a third at Brislington on the outskirts of Bristol.

Keiller's had also started in Scotland when another grocer's wife, Janet Keiller, made a coarse orange marmalade that sold so successfully in her husband's shop in Dundee that she started to make it for a wider market. In 1857, Keiller's opened a marmalade and confectionery works on Guernsey to avoid paying the tax on sugar, and by the late 1860s one of its directors was boasting that its products were sold to 'the whole British Isles'. When the duty on sugar was repealed in 1874, the firm opened works in Silvertown, not far from Tate's refinery, which opened four years later. (In 1882, Abram Lyle opened a refinery about a mile from Tate's to make his Golden Syrup, but the two businesses did not merge until 1921.)

Hartley's nearest rival, Chivers, was also rapidly expanding. The Chivers family, whose business like that of Hartley's was bought by Schweppes in 1959, had made their first batch of jam on their farm at Histon near Cambridge in 1873 with the help of a relative who was a cook at nearby Pembroke College. Within two years, the firm had built a factory at Histon, later named the Orchard Factory, and in the years that followed it extended its range to include table jellies (the production of which it claimed to have pioneered), bottled fruits, lemon curd, custard powder and Christmas puddings, which it first produced in 1890. In 1907, the firm launched Olde English Marmalade, a thick-cut marmalade, which was marketed as 'The Aristocrat of the Breakfast Table'. It was an instant success.

The Victorian taste for preserves had created a manufacturing revolution. In the south-east, fruit fields were the only land that retained their value and even increased in price. Landowners were quick to recognise the benefits. At the end of the nineteenth century, the acreage of small fruit near the Chivers factory had risen to almost 2,000 acres, most of which was used in the production of jam and associated products. Cambridgeshire followed a national trend. In 1888, the acreage of small fruit in England stood at 36,724. By 1904, it had more than doubled. The jam makers were by all accounts the 'backbone of the fruit industry', and growers and manufacturers were interdependent.

The preserves market had accordingly filled with new suppliers, each of them anxious to take a share, either at a local or national level. In 1903, Frank Cooper, a grocer who sold his wife's marmalade in his shop in Oxford, opened a purpose-built factory on Park End Street. By then he was making all kinds of homemade jams as well as his celebrated Oxford Marmalade, the favourite of dons and undergraduates alike. In Leeds, the firm of William Moorhouse & Sons, which together with Hartley's and Chivers was later bought by Schweppes, started trading in 1886. The firm specialised in the manufacture of its high-quality lemon cheese, but also made plum puddings, mincemeat (another by-product of the trade, also made by Hartley's), bottled fruits and jams. The list of companies also included Scott's of Carluke, John Moir & Sons (which opened its head office in London in 1880), W. R. Deakin, Duerr's of Manchester (which opened a factory at Old Trafford in 1890) and J. T. Morton's on the Isle of Dogs, whose workers formed a football club in 1885 and named it Millwall Rovers.

The multiple retailers were also swift to get in on the act. The Co-operative Wholesale Society started manufacturing its own jams in 1897 and was followed by a number of other retailers, among them Home & Colonial Stores, which introduced the sale of jam in twelve of its shops in 1906 and extended it shortly afterwards to all its outlets. There was also an increasing number of what were known as 'orchard firms', which began as fruit growers and steadily moved into the production of their own preserves. The orchard firms included T. W. Beach & Sons of Pershore, Wood Brothers of Swanley in Kent, which sent its best fruit to Covent Garden and made the rest into jam, and Wilkin's of Tiptree, which in 1901 included among its customers Windsor Castle, Osborne House and 'a large proportion of the nobility and country houses throughout England'.

The demand for preserves showed no signs of diminishing, and as supplies of fruit increased it resulted in lower costs to manufacturers, which when passed on to consumers stimulated further demand. By 1901, a number of

smaller manufacturers were attempting to muscle in on the market, but by then the conditions that had favoured the smaller man thirty years earlier had largely disappeared. The railway rates favoured the larger firms, who moved the largest amounts of fruit, while unstable seasonal prices made it harder for smaller manufacturers to absorb the increased costs. As the market became more centralised, so the business blossomed.

The Multiplication of the Multiples

The retail trade, too, was in the midst of a revolution. The emergence of the multiple retail stores had led to unprecedented growth. In 1870, Walton Hassell & Port became the first firm to have more than ten branches in the grocery and provisions trade. Ten years later, it had more than fifty branches.

As food came down in price, the more enterprising opened new shops to meet the rising demand. In 1871, at the age of twenty-one, Thomas Lipton opened his first shop in Glasgow. A second was opened three years later, and through a combination of clever advertising, winning gimmicks and sheer hard work, he rapidly expanded his empire. The speed of his expansion stunned the retail trade. In 1881, he opened his first shop south of the border in Leeds, and by 1888 he was at the gates of London. Ten years later, he had over 240 shops in the United Kingdom, and at his London headquarters he employed over 1,000 workers.

The success of Lipton's was emulated by multiple retailers such as the Maypole Dairy Company, which went from 185 branches in 1898 to 958 in 1915 (the firm claimed to have opened a shop a week in many years), the Star Tea Company, the International Tea Company, and Home & Colonial Stores, which by 1906 had over 500 branches. The multiples appealed to the working classes and succeeded by purchasing goods cheaply and selling them direct to the public without the need for a middle man. In such a manner, costs were kept to a minimum. The writer H. G. Wells, whose parents ran a shop in Bromley, accused the multiples of 'sucking away the ebbing vitality of the local retailer', but the public seemed to like them. In the six years to 1896, Lipton's profits averaged £96,000, and in 1898, when the company was floated on the Stock Exchange, its value was placed at £2.4 million.

At the same time, the price of bread plummeted. In 1901, the price of a London loaf was as low as it had been for more than thirty years, and the working classes, as like as not, covered it with jam, which was cheaper than butter and more palatable than margarine. In his study of poverty in York,

published in 1901, Seebohm Rowntree, the oldest son of confectioner Joseph Rowntree, found that even the poorest families made or bought jam, because children ate more bread if there was jam on it, particularly strawberry jam, which would long remain a children's favourite.

The price of tea, a natural accompaniment to bread and jam, similarly tumbled. Tea, which had been heavily promoted by the temperance societies as an alternative to alcohol, had suffered like many products from accusations of adulteration. However, the introduction of packet tea, which could be purchased without recourse to individual grocers and at a fraction of the cost, had led to a surge in sales, the like of which had never been seen. As a consequence, sales of Mazawattee, Hornimans and other well-known brands rocketed.

In 1889, the great self-promoter Thomas Lipton, or Tom Tea as he became known, started trading in tea and quickly became the most famous tea retailer in the London area. In his first year he sold four million pounds of tea and the following year more than six million. He was swift to see an associated form of profit and in 1892 opened his factory on Rouel Road, promising to 'make things hum' by selling his two-pound jars of jam for the normal price of one. The factory was extended twice, a reflection of the immense demand for his products, which, while made from pulp – unlike Hartley's fresh fruit preserves – were undoubtedly popular with consumers.

A Summer of Discontent

In August 1911, over 15,000 workers in Bermondsey went on strike for higher wages and better working conditions. The strike started in the works of E. & T. Pink on Staple Street and drew in workers from as many as twenty factories in the area, including Hartley's. 'One stifling August morning, while the transport workers strike was at its height, the women workers in a large confectionery factory in the middle of Bermondsey, in the black patch of London, suddenly left work. As they went through the streets, shouting and singing, other women left their factories and workshops and came pouring out to join them,' George Dangerfield wrote in The Strange Death of Liberal England.

The strike lasted about ten days and drew in trade unionists, such as Mary Macarthur, founder of the National Federation of Women's Workers, Clementina Black and Ben Tillett, leader of the Transport Workers Federation, who had helped to lead the successful London Dock Strike in 1889. The women had come out on strike in a largely spontaneous gesture. 'Most of them regarded the conditions of their lives as in the main perfectly inevitable and came out on strike to ask only 6d, or 1s more wages and a quarter of an hour for tea,' a

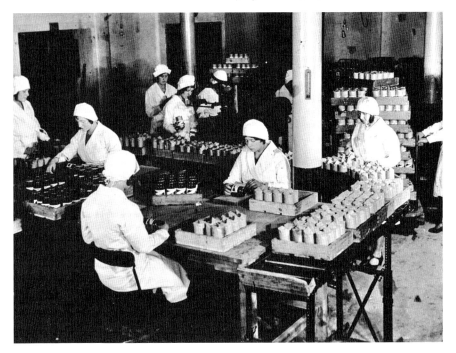

The Finishing Room.

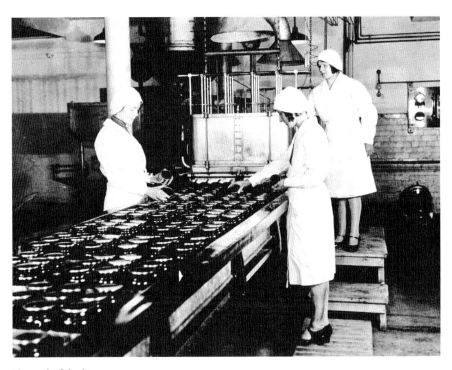

The end of the line.

member of the Fabian Women's Group recorded. The trade unionists helped them to organise and to formulate their demands.

It was a summer of discontent. On 1 August, dockworkers went out on strike in London in support of higher wages. The dockers were joined by hundreds of carters, who in turn were supported by the railwaymen and transport workers. Industrial action brought the docks and the railways to a virtual standstill. On 10 August, William wrote from Aintree that 'during the past two or three days there has been a serious strike in London by carters, dock men and all kinds of men, and this morning there are about 50,000 packages of fruit at Gravel Lane, and the strikers will not allow them to be touched; therefore we have had to take about 2,300 halves of greengages in order to relieve London, otherwise they would have gone bad at Gravel Lane the same as other people's are doing. The greatest difficulty was experienced in getting hold of them at Gravel Lane. Indeed, under the circumstances it is almost a miracle that they could get hold of them.'

Liverpool did not escape the worst of the troubles. In mid-August, employees of the Lancashire & Yorkshire Railway walked out, precipitating a national rail strike. The strike escalated and rapidly turned violent. Trains were set on fire, and after a mass meeting of transport workers more than 200 people were injured in violent clashes with the police. In response, the government sent troops into the city and positioned a warship at the mouth of the Mersey, its guns trained on the city. The unrest continued. On 15 August, soldiers opened fire on a crowd of demonstrators who had pelted them with stones. Two men were killed.

The working class increasingly vented its fury. H. G. Wells declared that 'the new fangled strike is less of a haggle, far more of a display of temper', but it was clear that he had missed the point. Technological innovation was transforming the nation, but it was largely the comfortable classes who benefited. It was the comfortable classes who could afford to install central heating and running water in their homes, or to purchase one of the new two- and four-seater cars that flooded onto the market. The working class, by contrast, remained in a state of flux, trapped between the desires of a world that promised them the moon and the demands of a society that held them at arm's length.

'If the poor were not improvident they would hardly dare to live their lives at all,' Maud Pember Reeves observed darkly in her treatise, Round About a Pound a Week, which lifted the lid off the poor of Lambeth.

The nation was on the move, on the march. 'Working people all over the country are not content that their lives should remain an alternative between bed and factory,' Winston Churchill acknowledged, articulating the hopes of an entire class. 'They demand time to look around them, time to see their homes by

daylight, time to see their children, time to think and to read and to water their gardens – time, in short, to live.'

All around there was change. The generation that came of age in the early twentieth century witnessed the advent of the motor car, the dawn of motion pictures, the beginnings of powered flight, the rise of the popular press and the birth of radio. Towns and cities pulsated to the rattle of electric trams and the hum of motorised lorries and buses, which for a time mingled uneasily with the traditional horse-drawn traffic.

The nation reeled to the shock of the new. In 1909, Joseph Lyons opened his first Corner House to cater to the influx of shoppers from the suburbs, as well as the increasing number of women who were employed as switchboard operators, shop assistants, typists and clerical staff. The Ritz opened its doors to the upper classes, Selfridges to a less monied but no less indulgent class. 'You know why they come here?' Gordon Selfridge remarked as he watched the crowds pouring into his store. 'It's so much brighter than their own homes.'

There was a gradual shaking off of the old ways, which showed itself in lighter, brighter fashions and changing ideas about ethics and morality. The fight for women's emancipation had been brewing for many years, but under the darkening clouds of Edwardian England it erupted. The creation of the Women's Social and Political Union and the rise of the suffragettes – a word coined by the Daily Mail to distinguish them from the less militant suffragists – signalled a less conciliatory tone. In order to draw attention to their cause, women set fire to railway carriages and chained themselves to railings. The orchid house at Kew was smashed, and the house of the then Chancellor of the Exchequer, David Lloyd George, was bombed – an attack orchestrated by Emily Wilding Davison, who in the summer of 1913 threw herself in front of the King's horse on Derby Day.

A number of employers attempted to downplay events in Bermondsey, blaming the action on a handful of hard-line militants, but there was no disguising the depth of resentment. Women poured out into the streets from the jam and pickle factories, biscuit makers and tea packers. The Daily Chronicle called it 'strike fever'. The unrest was exacerbated by record temperatures in the capital, which climbed to over 100 degrees Fahrenheit. The women, incongruously dressed in their Sunday best, marched down Tooley Street singing the strike marseillaise 'Fall In and Follow Me'. George Dangerfield noted that the women were 'oddly light-hearted', adding that 'many of them, dressed in all their finery, defied the phenomenal temperature with feather boas and fur tippets, as though their strike were some holiday of the soul, long overdue'. At the Pink's factory, which was known locally as the Bastille, girls carried banners inscribed with the slogan 'We are not white slaves, but Pink's slaves'.

The women's cause drew widespread support. A series of open-air rallies attracted supporters from outside the borough, who were 'infected by the Bermondsey spirit'. A public meeting held on 14 August, at which the speakers included Mary Macarthur and Ben Tillett, was attended by more than 10,000 women. Mary Macarthur, who turned thirty-one in the middle of the troubles, established her headquarters in the offices of the Bermondsey Independent Labour Party and ran a press campaign that was designed to draw the maximum sympathy for the women. 'Many thousands of women are on strike,' she told the Daily News, *'many more are locked out, the pawns shops are closed.' Within a week, more than £500 had been raised.*

After ten days, victory was assured. A meeting held on 19 August marked the strikers' triumph. There was widespread celebration. At Hartley's, Pink's, Lipton's and Charles Southwell, wages were increased from nine to eleven shillings a week. Working conditions in the majority of the factories were improved. Mary Macarthur announced the creation of twenty unions in Bermondsey, converting it, she said, from 'the black patch of London' to a centre of women's trade unionism. In September 1911, the Trade Union Congress passed a resolution congratulating the Bermondsey women trade unionists for the successes that had been achieved in 'this great revolution'.

The revolution continued. In 1912, an editorial in The Times *warned that 'the public must be prepared for a conflict between Labour and Capital, or between employers and employed, upon a scale as has never occurred before'. Workers became more militant, less restrained. In March 1912, over a million miners came out in support of the 'five and two' (five shillings a shift for men and two for boys), while a second dock strike in London brought out over a quarter of a million more workers than the first, bringing trade to a standstill once more.*

The message was clear. In April 1912, when the White Star liner Titanic *sank on its maiden voyage, some called it divine retribution for the upper class, even though the number of wealthy passengers on board was far less than the mass of ordinary men and women crammed into the lower decks. Although there was little desire for a radical overhaul of the system, it was clear that a confrontation was coming. In the years before the war the grievances of an incensed working class multiplied, and there was talk of a general strike in support of a national minimum wage.*

The lower classes had cause to complain. In 1909, a survey conduced by the newly created Women's Fabian Group concluded that there were 8 million people in England who were 'underfed, under-housed and insufficiently clothed'. There was much, it seemed, which had not changed.

The Path of Most Resistance

The competition was fierce, but William determinedly adopted the path of most resistance. 'We have great competition,' he told his workers, 'and very properly the house that makes the best article at the most reasonable price should win. I want us to be that house.' In the years before the outbreak of the First World War, the works employed around 450 permanent workers. The number, as at Aintree, rose to more than 1,000 in the summer months.

At first, sales were sluggish. William had borrowed heavily to finance the new works, and the additional expense of stock and working capital, coupled with the high rates and taxes in London, meant the works did not show a profit for many years. In January 1905, he wrote to a friend, stating that 'we have made no money in London yet'. He nevertheless remained quietly optimistic, adding that 'we shall make some profit I hope after another year or two, because we are gradually getting the ear of the London buyers, who will in time know the quality of our stuff'.

His words proved well founded. On 20 July 1908, the night before he received his knighthood, William met his senior salesmen at the newly built Kingsley Hotel in Holborn. 'All the London travellers said that our goods were gaining in public estimation and that the multiple shopmen such as Hassell & Port and other such were stocking our goods,' he noted. William identified his main competitors as Chivers, Keiller's and Crosse & Blackwell, but was pleased to report that according to one of his salesman 'they were not to be considered real competitors, but were a good way behind'.

It might have been salesman's hype, but there was some truth to the statement. The quality of the firm's products continually outshone the best its rivals could offer. The public's estimation grew. Hartley's distinctive taste eventually captured the market, and its reputation in the south soared as it had in the north. The combination of unbeatable price and unbelievable quality took Hartley's preserves and marmalades, table jellies, bottled fruits and candied peels into households up and down the nation.

The works at Green Walk supplied customers southwards from a line drawn across England at Northamptonshire, while Aintree met the requirements of the north, the Isle of Man, Northern Ireland and Scotland. In a few short years, the firm became the fastest-selling brand in the nation. Hartley's West End Marmalade was said to stand on the breakfast table of King Edward VII, and in 1911 Hartley's Gooseberry Jam was packed into the supplies Captain Scott took with him on his expedition to the South Pole. (The jam, stored in a cache for use on the way back from the Pole, was discovered by a group of American explorers in 1957. When sampled by Scott's son, Peter, the jam

was found to be in as good a condition as when it had been made over forty years earlier.) Hartley's preserves were also taken to the Pole by Shackleton's expedition.

In the years before the outbreak of the First World War, the market for the firm's goods grew at an alarming rate. 'We are able to make a very large quantity of jam and we can sell all that we can make,' William wrote to one of his suppliers, not as a boast but as a simple statement of fact. Profits rose, and, having established its reputation throughout the nation, the firm moved forward at an ever-accelerating speed. There was little, it seemed, that could contain it.

CHAPTER SIX

The World in Eclipse

In February 1906, William celebrated his sixtieth birthday. At such an age he might have been expected to lessen his commitments, but there were few signs that he was slowing down. When his health allowed, he continued to work long, rigorous hours, even though he conceded that such a strenuous life was 'a sin against light and knowledge'.

His life was full, fraught. 'My life is very full because with my large business in Liverpool and London, together with my public and charity work, I have double the amount of work any man ought to attempt,' he confessed in a letter to John Bowran, a Methodist minister and successful novelist. He added tellingly, 'I make dozens of resolutions that I will lessen it, but for some reason I am unable to do it.'

William struggled to divorce himself from the life he had created. In a letter to a friend concerning a proposed extension to the sanatorium at Delamere Forest, he noted that 'while I am immensely interested in the whole affair and able to talk to you on the matter when I am at Delamere, my difficulties at once begin when I come to business and find so very much to do'. At the same time, he accepted that many of the restraints on his time were of his own making. 'One of the faults of my make-up is that I go into these things much too closely,' he told John Bowran.

William's wife Martha persuaded him to devolve at least some of his responsibilities to his senior men, but he found it hard to loosen his grip. His private secretary, Thomas Handley, regularly accompanied him on the train so that he could keep up with his affairs, and on at least one occasion went with him to Menton in the south of France when William was supposed to be resting, but during which time he maintained a healthy flow of correspondence.

'With a brain teeming with new ideas – commercial, architectural and philanthropic, the marvel was that he could bear the strain,' his friend Joseph

Ritson recalled. 'He found it difficult to relax. He liked a good story and would often be jovial or hilarious over dinner or tea; but even there business and philanthropic schemes would be discussed with his family.'

William was at the forefront of those merchants and manufacturers whose fortunes had brought them fame. At the same time, he had broader concerns. In the appointment of his son as head of the works, he had expected to lessen his workload, but it rapidly became clear that Will had not inherited his commercial instincts. Will was not at all like his father, either in looks or temperament. At the age of sixteen William had been running his own business, but at the same age his son had still been tied to the family home opposite the works, half dreaming, half dreading the moment when he would take over its running.

Will had been a sickly child, and the immense weight of following such an earnest, devout and successful father almost crippled him. He suffered chronic ill health throughout his short life (he died at the age of forty-six, nine months after his father) and was frequently absent from the works, whether by intention or design. There were also rumours that he turned to drink, either to deaden the pain of his illness, or to dull the memory of all that he felt so singly unable to achieve.

The frequent absences of his son meant that William was forced to take a more prominent role in London, which in turn created more problems with his frail health. In 1904, he moved back to Southport, as much for the bracing sea air as a means of removing himself at least one step from the intense pressure of living so close to the works. The house overlooked the sea and came to be as much a place for him to entertain as to recuperate.

All through 1904 he was unwell. 'I very much regret to hear you are not enjoying the best of health, but sincerely trust you will be able to take the change your doctor recommends,' one of his growers, Harry Bickham, noted in the first of a series of letters in a similar vein. The following summer, Bickham, a nephew of the writer Rider Haggard, wrote, 'I was very sorry to hear from Mr Riley that you have been unwell for some time, but hope you will soon recover your health and strength.'

The demands on him were unremitting. William did not divide his life into neat blocks of commerce, philanthropy and religion. To him, it was all part of an indivisible whole. 'Mr Hartley has not hours for commerce and hours for philanthropy and hours for worship in his life,' a reporter acknowledged. 'The three are one, from morning till evening, from year's end to year's end.' William's office at Aintree, which acted as his headquarters for both business and benevolence, was stacked with papers that ran from desk to chair to floor. 'I have so many matters to attend to even in my slack season that it

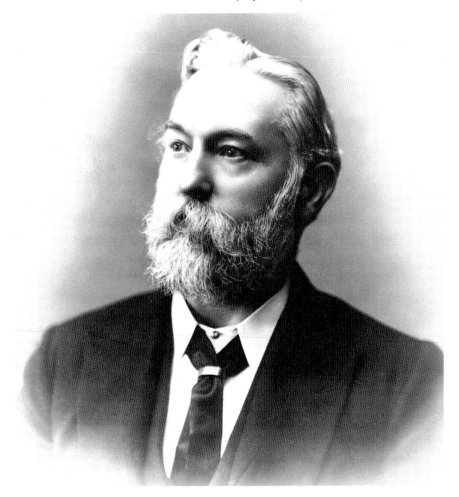

The pressures of work were a constant strain on William.

takes all my ingenuity to fit everything in and get comfortably through,' he confessed to a reporter.

There was no respite. At Seaview, his home in Southport, he and Martha entertained a continuous stream of ministers, politicians, reformers and fellow industrialists. William Booth, the founder of the Salvation Army, was a guest, as was David Lloyd George, William Lever, Arthur Peake and minister turned novelist John Bowran. His work for his denomination was similarly all embracing. In 1890, he became chairman and treasurer of the Chapel Aid Association, posts he held until his death and which took up a large slice of his time. The same year he was appointed Treasurer of the Primitive Methodist Missionary Society, a post which involved travelling

around the country raising funds, and he was closely involved in the progress of the movement's theological college in Manchester. At the same time, he faced a constant round of public engagements. 'I am constantly asked and pressed to go here, there, and do this and that,' he complained in a letter to a friend.

The sheer volume of work overwhelmed him, but while the collision of commerce and benevolence would prove awkward, there was never any suggestion that he would turn his back on one in favour of the other. In March 1908, he was back in Menton, recuperating once more in the south of France, where winter was as warm as an English summer. Six months later, he presided over the laying of the first bricks of the new warehouse at Green Walk. The balance, it seemed, was strangely elusive.

The Formidable Hartley Girls

Hartley's was a family business in every sense. Martha was as familiar a figure at the works as her husband, and was his closest confidante and most trusted adviser. William's daughters also took an active interest in the business and from an early age were encouraged to express their opinions on all matters. When it came to his children, William was no Victorian tyrant. He might well have laughed at the tale of the Reverend Sabine Baring-Gould, author of 'Onward, Christian Soldiers' and father of sixteen, who once asked a small child at a party, 'And whose little girl are you?' only to have her tearfully respond, 'I'm yours, daddy,' but he certainly would not have recognised himself.

The centre of William's life was his wife and children. In many ways he was the antithesis of the archetypal Victorian. He did not sit neatly in a box, whether in terms of his wealth (or its disposal), his role as an employer and more pertinently his attitude to women. The Victorians wrote at length about good character, but strenuously denied the rights of women. William was less restraining. At a time when the opinions of women were frequently silenced, or at best unacknowledged, he encouraged his girls to soar. 'I have been brought up in a home of puritan ideals, where there has been a broad outlook on life and yet where the women of the household were freely consulted and their views and opinions loyally respected,' his daughter Christiana recalled in later life.

The Hartley girls were a formidable lot. The accepted role of Victorian women was to make a good marriage and to run the home, but William's daughters were rarely content to defer to their husbands, or to be chained

to the house. The girls had been educated by a governess and then at private schools. William equally had not cosseted them from the harsher side of life and deliberately included them in discussions both about the business and the division of his wealth – the how and where of its disposal. With independence of mind came independence of spirit. The girls by and large married men who in terms of their finances might have been considered beneath them.

The oldest, Maggie, was first to leave home, settling down with a high-minded, impecunious preacher. The son of an engineer, Joseph Barkby (known as Holy Joe for his staunchly evangelical views) entered the Primitive Methodist ministry at the age of twenty-three after a year's training at the Manchester theological college. His early postings took him on the Northern Circuit from Blackburn to Harrogate and the Isle of Man. In 1906, when William built a new church on Derby Road in Southport, Holy Joe was appointed its minister. By then he and Maggie had three children, the oldest of whom, Gladys, was born in January 1892, three weeks before the death of William's father. The oldest boy, Hartley Barkby, who was born in June 1897, was to have taken over the running of the business, but was killed in the First World War (see 'A Boy of Exceptional Promise' below).

Sallie's marriage to George Gibbens, who worked in the Patents Office in London, similarly was not one of financial equality. The couple met on a tour of the Holy Land in the winter of 1894. Sallie, aged eighteen, was accompanied by her mother, her brother Will and her three older sisters. George and Sallie married the following year at the Primitive Methodist church in Aintree. Holy Joe officiated. In honour of the occasion, workers at the factory were given a day's holiday and many of them stood outside the church to catch a glimpse of the happy couple. At thirty-two, George was thirteen years older than his bride, but it was Sallie who provided the lavish homes in the fashionable suburbs of Redhill, Reigate and Richmond, the latter of which was named Aintree Lodge.

The one marriage that was more equal in terms of finance was that of Pollie, who in 1899 married John Sharp Higham, the owner of a prosperous firm of cotton spinners in Accrington. John, like George Gibbens, was thirteen years older than his bride. At the time of the wedding, he was serving the first of two terms as Accrington's mayor. In 1904, he entered national politics, taking his seat in Parliament as the Liberal Member for the Sowerby Bridge division of Yorkshire. A staunch advocate of social change, he was a devout temperance reformer and like William a long-term supporter of the Lancashire and Cheshire Band of Hope Union. He was also a benevolent employer, who in 1906 took a party of his workers to Paris and Geneva.

Reverend Barkby married William's oldest daughter, Maggie, in September 1890. The couple had four children. The oldest, Hartley (right), was killed in 1916.

Higham was a man of deep religious convictions, unbounded energy and great intellectual curiosity. In 1906, when the Liberals won a landslide victory, he was re-elected and served in government for the next thirteen years, becoming firm friends with, among others, David Lloyd George. At the time, the Liberals were seen as the most progressive force in politics. To many, it was the party of reform. The Liberals presided over the introduction of labour exchanges, free school meals for 'the necessitous poor', an 8½-hour day for miners (the first time that government intervened in limiting the working hours of men), old age pensions, at least on a limited scale, and new legislation on health and unemployment insurance, culminating in the National Health Insurance Act of 1911, one of the most influential documents of the Edwardian years. Higham served in the government throughout the First World War, but after losing his seat in 1918 he went to work at Hartley's. In 1922, at the age of sixty-five, he became its chairman. He was joined at the firm by his oldest son.

Within the space of thirty years, William had raised his family into the ranks of the aspiring middle class. In February 1903, two months before her twenty-first birthday, Martha married the son of a colliery owner at the Primitive Methodist church in Aintree. The following month, at the age of twenty-five, her brother Will married Jessie Port. The marriage took place at King's Weigh House church in Grosvenor Square and doubtless drew a small crowd of onlookers, as the son of one of the nation's foremost preserves makers emerged from the church with his bride on his arm. In February 1904, Jessie gave birth to a son, Lister, and sixteen months later to his brother, Rex, my grandfather.

In 1904, when William moved back to Southport, three of his children were still living at home: Christiana, who that year turned thirty-two; Clara, who was twenty-five; and Connie, the youngest at twenty. The Hartley girls were undoubtedly a good catch. In 1913, Connie and Clara were married within three months of each other. Connie was first. On 3 September, she married John Cant, the son of a Glasgow timber merchant, at the church William had built on Derby Road, known locally as the Jam Chapel. William by then had given away four of his daughters, but he was no less proud as he walked his youngest to the altar. His wedding gift to the couple was a house in Kilmacolm in Ayrshire and a cheque for an undisclosed amount.

In 1913, William and Martha were presented to King George V at Southport, and the year was crowned by the marriage of his daughter Clara, who in December married Percy Gabbatt, Professor of Mathematics at Christchurch University, New Zealand. The marriage had a distinct air of romance about it. The wedding was held in Colombo, Sri Lanka, which was chosen as a point

John and Pollie were engaged in 1899. He was forty-two, she was twenty-nine.

approximately equidistant between London and Christchurch. In the first week of November, Clara left England, accompanied by her sisters Maggie, Chrissie and Sallie. William and Martha did not attend. The bride travelled on the Orient Line Steamer and arrived in Colombo on 29 November, three days before the wedding. The groom sailed from Melbourne on 12 November and arrived two weeks later. At Aintree Lodge, Sallie's children tracked their progress on a large map attached to the wall, with flags to represent the two ships. At the exact time the marriage took place, they drank the couple's health, even though in England it was 2.40 on a cold winter morning.

The Descent into Flames

On the eve of the First World War, both William's public and private lives were flourishing. In his advancing years, he took on the look almost of a biblical figure, with his neat white beard and long white hair, which one commentator noted was 'white as snow'. He might have been Moses or Methuselah. An article in the *Primitive Methodist Magazine* noted his 'rare brightness and spirit' and 'the dancing light in his eyes'. There was an aura about him, and in spite of his problems with his health (or perhaps because of them) there was a sense that somehow he and the business he had created were invincible.

When Britain declared war on Germany on 4 August 1914, there was a sense of shock across the nation. The shock was followed by scenes of intense jubilation. In the early days of the conflict, hordes of idealistic young men rushed to enlist for what was widely seen as 'The Great Adventure'. There was, it seemed, no time to lose. At a crowded meeting in Liverpool's St George's Hall, the Earl of Derby invited the city's clerks to form their own battalion with the promise that 'those who join together should serve together'. Within three days, there were enough volunteers to form three battalions.

The idea spread and the formation of Pals battalions became a popular means of recruitment in towns and cities across the country. In Manchester, 20,000 men enlisted in the first month of the war, many of them from the same offices and factories, while in Accrington, where John Higham had his cotton works, it took a mere ten days to raise a complete battalion. There was a sense that to remain out of uniform was a sign of timidity – or worse, cowardice. 'If I had twenty sons,' the Earl of Derby told a public meeting, 'I should be ashamed if every one of them did not go to the front when his time came.'

The common cause of war united the nation. In the autumn of 1914, as refugees of the fighting headed across the Channel, George and Sallie Gibbens took a Belgian family into their home in Richmond. The following December, George and Sallie organised a concert to raise money for the YMCA camps in northern France that served hot coffee to troops near the front. Sallie's younger sister Martha was among the performers, singing 'I Love Thee Life', which concluded the first part of the concert, and closing the show with 'Ships that Pass in the Night'. In 1916, George Gibbens was appointed Examiner of War Inventions at the Munitions Inventions Department (one of his own inventions was a typewriter for armless men), and at the age of fifty-four he was digging trenches and defending supply depots in Richmond as a member of a part-time unit of older men, who in fighting for King and Country rejoiced in the name of the Gorgeous Wrecks.

In the early days of the conflict, William served as an adviser to the Chancellor of the Exchequer, David Lloyd George. The war would test his faith, but his support of it was unwavering. In January 1915, he agreed to contribute £100 for the duration of the war to the *Times* Fund for the sick and wounded. He gave £10,000 to the War Relief Fund and £5,000 each to the Red Cross, the French Fund and the Belgian Fund. He also gave financial support to the families of those members of his staff who enlisted in the services, which Martha delivered to their homes in discreet brown envelopes. In 1916, he added £10,000 to the firm's pension scheme.

While other manufacturers profited from rising prices and the uncertain conditions that the war had produced, he steadfastly held to the principles of fairness on which his business had been founded. 'We could have made a much larger profit in the past year had we taken advantage of the rise in sugar when war was declared,' he explained to his workers at the profit-sharing distribution of 1915, 'but as our soft fruits – raspberry, strawberry and blackcurrant – had at that time nearly all been made, we decided that we would not advance the prices of the soft fruit jams, although as a matter of business we were entitled to do so. We were resolved – I was very firm on it myself – not to make a profit out of national necessities.'

National necessities were clearly at the forefront of his mind. In February 1916, he publicly paid tribute to those men from the works in London and Liverpool who had 'responded nobly to the national call'. His remarks were made at a celebration of his seventieth birthday in St George's Hall on Old Kent Road, an event that was commemorated by the division of £15,000 among hospitals in London and Liverpool, as well as £5,000 among trade charities. In his address to his workers, William noted that the entire jam and confectionery trade of the United Kingdom had raised more than £7,000

for the British Red Cross Fund. The Hartley works, he added proudly, had contributed almost half the total amount.

'A Boy of Exceptional Promise'

In 1916, H. G. Wells set out his thoughts on the war. 'The first most distinctive thing about this conflict,' he wrote, 'is the exceptionally searching way in which it attacks human happiness. No war has ever destroyed happiness so widely.'

The most profound effect of the war on William was the loss of his oldest grandson. Hartley Barkby was born in Nelson, near Colne. He was, Arthur Peake wrote, 'a boy of exceptional promise and great personal charm'. In August 1914, when the war broke out, he was seventeen. A product of Southport's University School and the Nonconformist Mill Hill in north London, he had been instilled with many of the same virtues of duty and honour that impelled thousands of young men to defend a cause that in some quarters was likened to the defence of civilisation.

A few months earlier, he had passed the entrance examination to Trinity College, Cambridge, but his belief in a greater good was such that when war broke out he underwent an operation in order to have himself proclaimed medically fit. In 1915, he joined the Royal Field Artillery and within a few weeks was appointed a lecturer and sub-instructor of gunnery at Bettisfield Artillery School in Shropshire. The following year he was sent to northern France.

Barkby was a likeable officer. 'He was one I picked out to perform tasks requiring special vigour and talent on the part of the office undertaking them,' his commanding officer recorded.

In the summer of 1916, Barkby's regiment, the 55th West Lancashires, was part of the massive bombardment at the Somme that was designed to shatter the German front lines in advance of an infantry assault. The bombardment was so severe that it could be heard as far north as Hampstead Heath. The assault was followed by a series of attacks and counter attacks. Two weeks later, Barkby was positioned in an area known as Caterpillar Valley, which ran from Fricourt past Mametz Wood to the heavily fortified village of Guillemont. A stone's throw to the north, the South Africans were engaged in heavy fighting at Delville Wood.

In the days that followed, the British suffered heavy losses. One of those to lose his life was William's grandson. In the early morning of 2 August, Second Lieutenant Hartley Barkby was bringing his section of guns into action when a shell burst near him. In the same lingering moment one of his men was also hit. Barkby lived for another half an hour, but did not regain consciousness. His companion survived.

William's cherished grandson, Hartley Barkby.

A few weeks earlier, Barkby had sat with Reverend Fisher, the Primitive Methodist chaplain attached to his brigade. 'As he talked I had caught the promise of a fair future,' Fisher recorded in his memoirs. In a more personal letter written to Reverend Barkby, he noted that 'through all the infantry battalions of my brigade the news has caused sincere and general sorrow. As a father you may be proud in your sorrow for he did you credit and made your name beloved. I am glad I knew him.'

At home, a pall of grief descended over the family. In July, Hartley had celebrated his nineteenth birthday in the trenches. A letter to his parents from his former commanding officer was scant recompense. 'I was talking to my wife yesterday about your boy,' wrote Major Decker, 'and said to her that everything good such as I hope will be said of my boy when he grows up could be said of your son. He was truthful, cheerful, pure minded, able and brave. He never failed in his duty as a soldier and was an example to us all.'

The tributes to him were unsparing. 'He took his stand as a Christian very quietly and yet absolutely unswervingly,' his old headmaster at Mill Hill observed at a memorial service in Southport. 'He was also clever and his life was opening out before him in all its beauty.'

Hartley Barkby lost his life in what Wilfred Owen described as 'carnage incomparable and human squander'. On 30 July 1916, five hundred Liverpool Pals were killed in fierce fighting near Guillemont. A little over a week later, the Liverpool Scottish Regiment, which included men from the Aintree works, recorded the loss of ten of its twenty officers and ninety-six of its six hundred men, who were reported killed or missing.

On 9 August, two more Hartley's men were added to the list of casualties. Arthur Freeman had enlisted as a private in the summer of 1915. He was twenty-seven when he died. Bryce Thompson joined the regiment two weeks after Freeman. In his enlistment papers, he described himself as a jam boiler and resident at 7 Hartley's Village, Aintree. His name, like that of Arthur Freeman, is commemorated on the Memorial to the Missing of the Somme at Thiepval.

In the summer of 1917, William established a scholarship in perpetuity at Mill Hill in commemoration of his 'dearly loved grandson'. It was a small gesture and a stark reminder of one of the many promising young men who laid down their lives for their country. In the end it was a war without victors. An estimated 13,000 Liverpudlians were believed to have died in the Great War, and countless more were shattered by the experience. The men from Hartley's who lost their lives included Joseph Currie, who lived at 27 Hartley's Village, Reginald Eaton (whose father, Edward, was one of William's managers), Henry Rigby, William Watling, Albert Scotton, William Sumner and William Oldfield. In Southport, Hartley Barkby was one of 1,203 names engraved on a memorial in London

Square that was in part funded by his grandfather. A brass plaque erected by his parents in the church on Derby Road declared that he died 'fighting for God, for right and liberty'.

An Ill Wind

The war created difficulties at both factories. Women had long formed the predominant part of William's workforce and there was no shortage of women at either Green Walk or Aintree. The loss of men to the front, however, was so severe that as William confided in Arthur Peake, there were times when he feared he would have to close the works if he lost another man. In their absence, women took on many of their roles. Some roles were easier to fill than others. Women readily adapted to the posts of timekeepers, checkers, foremen, office clerks and warehousemen. The posts of lorry drivers, engineers, carpenters, joiners and fitters, however, were not as easy to fill.

The firm's difficulties were manifold. In the early days of the war, one of its shunting engines, *Maggie*, was commandeered by the newly created Ministry of Munitions. There was a shortage of timber to make the boxes in which the products were packed and a reduction in the number of stoneware pots from the Melling works, which was similarly affected by the loss of men to the front. There was a shortage of sugar, much of which had previously come from Germany, Holland and parts of the Austro-Hungarian empire, leaving a sugar-hungry nation turning to its colonies in the West Indies for supplies. The business was also impaired by the reluctance of banks to lend working capital, even to such a large, well-established firm. 'We are short of labour, short of sugar, in a word short of everything,' William fumed in a letter to his travellers in July 1916.

The firm also faced severe difficulties in finding enough fruit. At the outbreak of hostilities, farm workers enlisted with the same enthusiasm as those in the towns. Matters were not helped by the requisitioning of huge numbers of horses, mules and donkeys that were shipped off to the front to pull guns and wagons instead of carts and ploughs. The result was that farms were deprived of many of their best workers, in many cases the strongest and fittest.

At Holwellbury, his fruit farm in Henlow, William faced difficulties of a different sort when the young son of the farm's manager, who effectively ran the farm, was imprisoned as a conscientious objector. In order to keep the farm afloat, William called on one of his growers, Harry Bickham, to advise

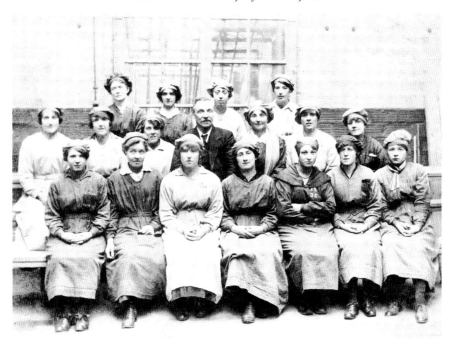

Workers in the Dining Hall, 1916.

its manager on planting and cultivation. Bickham, who turned forty in 1915, was pleased to help 'as a small return for the many acts of kindness' William had shown him over the years.

At the same time, new directives from the Ministry of Food led to a decrease in the acreage and output of fruit farms, as ministers were keener to stimulate production of more essential crops, such as wheat. At the start of the war, the government was unwilling to intervene with regard to food supplies, as the idea of state control did not sit well with politicians devoted to free trade. Instead, the authorities were more content to call on citizens to self-regulate through 'meatless days', or by reading royal proclamations in church on successive Sundays urging restraint. The shortages caused by U-boat activity and the huge demands of the armed forces, however, forced the government to take more drastic action. In December 1916, when he became Prime Minister, Lloyd George immediately established two new government departments to control the production and distribution of food supplies.

In 1917, Hartley's became one of eight government-controlled jam factories. The others included E. & T. Pink and Maconochie Brothers Ltd, which also produced potted meats, tinned fish and canned vegetables. The brief to the

factories was to increase output, and armies of statisticians were employed to monitor progress. Government officials also intervened in the production process, which created friction between manufacturer and bureaucrat. 'We know it can't be made in that way,' William fulminated to Arthur Peake when officials sought to instruct him how to make his jam, even though he had been making it successfully for over forty years.

The strain was unbearable. At the beginning of 1917, William went to Harrogate to recuperate over the winter months, and in August correspondents to Aintree received a note in response stating that he was 'in the doctor's hands'. His return to the works did little to relieve his anxieties. By 1917, he was adding new products to his list in order to skirt the difficulties caused by the lack of fruit. In June, the Bermondsey works made Lemon Marmalade. The same month, Aintree produced 435 tons of Rhubarb & Preserved Ginger, principally for the War Office, which supplemented the more traditional favourites.

The Hartley ethic, nevertheless, remained the same, and in spite of the difficulties the works at both Aintree and Bermondsey continued to make products of the highest standard throughout the conflict. Sylvia Pankhurst, who opened a jam factory to create jobs for pacifist women, observed that there were girls in other factories whose job was rubbing pieces of wood into seed shapes that could be added to raspberry jam. Harry Bickham similarly noted that 'one of course never knows what proportion of turnips, mangold, swede, beetroot and marrow constitutes a pound of extra special strawberry jam'. William's conscience, however, would not allow him to make an inferior product. In his memoirs, an ex-serviceman, Frank Richards, wrote that William 'gave the fighting Tommies his very best jams'. Hartley products, he added, 'never lost their civilian quality'.

The strain of the war, however, took its toll. In February 1919, on a cold winter afternoon, William travelled to Holwellbury Farm to hand out bonuses to his workers. After frosts and heavy snow, walking was hard work, and, as Harry Bickham observed in a letter to a friend, 'The poor old boy had had quite enough of it by the time he had a brief look around.' A few days earlier, William had turned seventy-three. His eyesight was failing and he had difficulty in hearing. To compound his woes, he had started to suffer attacks of angina, which seems to have been brought on by the slightest exertion.

His health continued to deteriorate. In 1919, in a concession to his advancing years, he and Martha moved from Seaview to an altogether less prepossessing house at 11 Oxford Road in the smart suburb of Birkdale. William's daughter Christiana moved in with them in order to look after

them. The same year, John Higham started work at Aintree in order to relieve some of the burden on William, who became a less frequent presence at the great works which for so long had loomed over his life. When he was invited to become Mayor of Colne, he declined on the grounds of ill health. The years had at last caught up with him.

Uncharted Waters

The war had been hard on William, but its aftermath was perhaps worse. An economic boom at the end of the war was followed by a downturn in trade as the nation plunged headlong into recession. In 1919, Wm P. Hartley (London & Aintree) Ltd was registered as a private company to take over the assets of the other Hartley companies. The same year, in an effort to inject much needed capital into the business, William sold many of his shares in the cotton mills that he had purchased twenty years earlier.

His troubles persisted. In the late summer of 1919, the Aintree works ran out of sugar and he was compelled to close down production of both plum and damson jam. The introduction of price controls meant that even when he was able to obtain sugar it was bought at a price which scarcely reflected the lower price consumers paid for his products. The result was that production costs soared and profits fell.

'Money is very scarce and the banks are very tight and have more or less considerable objection to lend money even for good purposes,' William wrote to Arthur Peake in March 1920, 'and now that sugar, fruit and everything we use is three or four times as dear as it was in pre war times, it takes an immense amount of extra capital, many hundreds of thousands to work the business.'

It was an age of lost certainties. In the aftermath of the war, many of the vestiges of wealth and privilege virtually disappeared. Income tax rose to 30 per cent for higher earners and death duties soared to 40 per cent on all estates valued at over a million pounds. 'Huge Estate Duties' declared the *Manchester Evening News* in its headline in February 1923 when William's will was proved and a sum of more than £300,000 was payable to the National Exchequer.

The well-to-do could do little more than watch the steady erosion of their capital. In London, many of the homes of the well-off were demolished to

make way for new flats and offices, while country houses such as Bryanston and Stowe, the former home of the Duke of Buckingham, were converted into schools. 'England is changing hands,' *The Times* recorded mournfully.

The old order was crumbling as fast as the grand houses in the West End. The effect of higher taxes and impending death duties meant that many families could no longer afford to retain vast ranks of servants. At the same time, a large number of men and women chose not to return to a life in service. The barriers were coming down. For instance, William's chauffeur, James Fairbrass, who served in the war as an RAMC driver, was bold enough to make his return conditional on an increase in salary to £5 a week.

In the election of 1918, the Labour Party's policy statement, drafted by Sidney Webb, called for a minimum wage and improvements in working conditions, a maximum working week and advances in health, housing and education. When the votes were counted, it soon became clear that large numbers of working men had transferred their allegiance from the Liberals to the Labour Party, which polled over 20 per cent of the vote. (John Higham was one of those who lost his seat.) In 1919, the discontented masses took to the streets once more. There were strikes on the railways, and in Liverpool rioters smashed shop windows and looted premises. Trade union membership rose to over six million and talk of a general strike reared its head once more.

'I submit that the day is past in which we could afford to compromise between the desires of the few and the needs of the many, or to perpetuate conditions in which large masses of the people are unable to secure the bare necessities of mental and physical efficiency,' wrote Seebohm Rowntree.

The Pilgrimage of Life

The fall in profits from his business, coupled with a post-war rise in building costs, affected William's larger benefactions. Indeed, after the war he only made two significant gifts, both of which were the fulfilment of commitments made before the conflict. The maternity hospital in Liverpool was one. The other was Hartley Hospital in Colne. On 19 November 1918, eight days after the signing of the Armistice, he purchased five acres of land adjoining the Hartley Homes, together with another four acres in front of the site, so that patients would have uninterrupted views of the surrounding countryside. The estimated cost of the hospital before the war was £25,000, but by 1918 the cost had soared to almost £100,000. William, nevertheless, was determined to proceed.

On 3 September 1921, he travelled to Colne to lay the foundation stone. He was accompanied by Martha, his daughter Christiana, Miss Lambert (the sister of his senior manager at Aintree), and Charles Wardlow, his senior traveller and one of the longest-serving members of the firm. His intention had been to secure a distinguished guest to perform the ceremony, but all those associated with the project insisted that it was fitting if the task fell to him.

After entertaining the press to lunch at the Crown Hotel, he joined a procession that formed outside the town hall and passed through the streets that were lined with cheering crowds and festooned with banners and flags. The town was triumphantly en fête. The procession was more than half a mile in length and included mounted policemen, members of the volunteer fire brigade, boy scouts, girl guides and governors from the Hartley Homes. At its head was a brass band. It was not a homecoming, but it must have felt like it. In 1912, the funeral of Wallace Hartley, the bandleader on the *Titanic* and a native of the town, had similarly drawn vast crowds, but there was no comparison.

At the site of the new hospital, an estimated 10,000 people gathered to witness the opening ceremony. A cameraman filmed events on a new device known as a kinematograph, which captured flickering images and later soundlessly conveyed them to an audience, which gathered that night in a local auditorium as much to see themselves on the screen as to applaud their illustrious benefactor. The ceremony commenced, like a vast open-air service, with hymns and prayers. In the autumnal still, the crowd raised their voices to sing 'O God of Mercy', which was followed by a reading from the parable of the Good Samaritan, which seemed particularly appropriate. William sat much of the time. He looked tired and frail. When he was called on to lay the foundation stone, he declared that he did so 'in the name of the Father, of the Son and of the Holy Ghost'. Inside the stone was a bottle containing a copy of the official programme of events, a plan of the building, a copy of the *Manchester Guardian*, a ten shilling note and some coins of the realm.

William's life, it seemed, had come full circle. He had assiduously marched through his life, but somehow he was always drawn back to the place where his 'ambitions were born'. At seventy-five, he might well have looked back at the path his life had taken from the first flowerings of ambition to his decision at the age of thirty-one to consecrate his wealth to the service of God. Dickens called it 'the pilgrimage of life', and there was a sense that somehow he had served a purpose – a divine purpose – in his ceaseless devotion to hospital, school, church, factory, mission, almshouse, orphanage: the full gamut of Victorian idealism.

William Hartley, toward the end of his life.

An Abiding Sense of a Life to Come

William's health continued to fluctuate. In November 1921, he was well enough to attend Christiana's inauguration as Mayor of Southport. He was joined by Martha and four of his daughters. In her inaugural address, Christiana announced that she was donating her official salary of £500 to unemployed ex-servicemen. It was a gesture typical of her father, who likewise matched it with £500 of his own.

The following Sunday, Arthur Peake 'spent several happy hours' with William. The two had not seen each other for some time and Peake was pleased to find him in good spirits. William's letters, he observed, 'had made me very anxious about his health. What he said was so ominous that I felt the end might come at any time. Yet he had again and again in the past shown such wonderful recuperative power that I hoped he would still be spared to us.'

In August 1922, at the height of the season, William went to Buxton for a short rest. He had kept the full extent of his illness from his children, so as not to alarm them, but his words revealed a more ominous tone. When he presided over the jubilee celebrations at the Wesley church in Southport the following month, he declared that 'I feel I am getting past public work. I did a lot of it in my younger days, but now I do not feel able to do it.'

The celebrations in Southport would prove to be his last public engagement. On 8 September, he was to have hosted a reception for the Southport Trades Union Congress, but did not feel well enough. Christiana deputised for him. At the end of the month, he and Martha were to have hosted a reception on temperance reform, but the state of his health once more prevented his attendance.

At the beginning of October, he drew up a guest list for the opening of the hospital in Colne, and he might well have felt that he could continue to hold the spectre of death in abeyance. There were, however, more telling signs. On 15 October, as he and Christiana knelt to take communion in the church he had helped to build in Southport, he was flooded with memories of his early life and broke out in tears.

On 24 October, his fellow industrialist George Cadbury died at the age of eighty-three. That afternoon William inspected progress of the War Memorial in London Square and on his return to Oxford Road worked at his papers until around seven o'clock. Winter was drawing in and the nights were lengthening. When he went to bed he felt unwell, and three times in the course of the night Christiana went to his room to attend to him. The signs were not good, but in the early hours he seemed to rally. He even

contemplated going to the works. It was as if the worst had passed and a sense of relief must have run through the house. But when he rose from his bed, he suffered a massive heart attack.

News of his death filled the newspapers and tributes to him were rich. In Liverpool, the *Daily Courier* noted the death of 'one of the most notable figures in modern industry, philanthropy and religion'. Edward McLellan in the *British Weekly* wrote that 'the life of the world is poorer by the death of Sir William Hartley. From very lowly beginnings he worked his way to a foremost position among merchant princes, philanthropists and religious leaders. In the achievement of this he owed nothing to favour or influence exerted on his behalf by others, but to a sound judgement, a daring and courageous initiative, and a passion for work which persisted to the very last.'

William was buried in Trawden Cemetery in the hills overlooking Colne. On a chill October afternoon, a sombre cortège passed through the streets of the town. A local reporter observed that 'Colne was a town in mourning'. The flag on the town hall flew at half mast, blinds were drawn and shops were closed as a mark of respect. The cortège was led by six of William's daughters (Christiana remained in Southport with her mother, who was not well enough to attend the funeral). The mourners included eight of the aging inhabitants of the Hartley Homes, staff from the sanitorium at Delamere, students from Hartley Theological College and representatives from the works at Aintree and Green Walk. There were delegates from the temperance movement, the Missionary Society, the Chapel Aid Association, the orphanage in Harrogate, Holborn Hall and the Aintree Institute, as well as leaders of the Primitive Methodist Church. There were also representatives from many of the philanthropic organisations that had benefited from his help and from the numerous trade associations with which he had been connected in a career that stretched over sixty years.

At the hour of his interment, a service was held in Aintree, attended by workers from the factory, who filed into the church in ones and twos to offer their prayers to a man whose concern for their welfare had always been uppermost in his mind. At the works, the great iron gates were closed and as the clock sounded the hours there was a sense of emptiness. The following morning, memorial services were held in Colne and Southport, while around the country, in church and chapel, congregations silently observed the loss of one of the nation's greatest men of commerce. In East London, a service was held to commemorate his life, together with that of George Cadbury. William Lever was among the congregation and listened impassively to the words of Reverend Scott Lidgett, founder of the Bermondsey Settlement, who noted that the two men had shown that it was 'possible to pursue a great

commercial enterprise without the tarnish and spirit of greed and without any of that narrowing of human sympathy which sometimes attends great success in life'.

William Hartley had led a remarkable life. His was an odyssey that had charmed and captivated the nation, the tale of a poor boy made good, who used his wealth in the pursuit of a common humanity. 'We do not claim that Sir William was a perfect man,' Reverend Holden Pickup observed at the service in Colne, 'but according to the light that was in him he saw the vision of God, he tried to do the thing that was right and surely no man can do more than that. He lived his allotted span. His life was crowded with activities and full of honour he went down to the grave. He now sleeps amongst his native hills which he loved and the hills over which he tramped in the days of his youth.'

The End of Romance

In 1926, William Beable published his *Romance of Great Businesses*, a triumphant roll-call of the nation's great commercial successes. The author described William Hartley as 'one of the great merchant princes of the country' and told the 'romantic' tale of his rise to fame and fortune. The prospects for the firm, however, looked uncertain. In the mid-1920s, trade was in turmoil. After the initial post-war boom, the north of England was plunged into economic depression. In the Lancashire mill towns, employers could not compete with cheaper imports from the Far East, and the great shipyards on the Clyde and the Tyne buckled under the weight of opposition from the new industrial giants, America and Japan. There was an equal decline in the iron, coal and steel industries, the heart of Britain's industrial strength.

At the same time, the development of new industries, such as assembly-line car manufacturing, aeronautics and electrical engineering, served to stimulate growth in other areas of the economy. The pace of change was rapid. The north had traditionally been the source of the nation's industrial strength, but manufacturers increasingly opened their factories in the Midlands and the South East, which became the fastest-growing areas in the country. At Cowley, near Oxford, the Morris group made almost half the total output of Britain's family cars, while within the space of ten years Dagenham grew from a small agricultural village to a vast industrial sprawl following the opening of the new Ford works.

There was also a significant growth in the production of new consumer goods, such as radios, refrigerators, cookers, heaters and vacuum cleaners.

In 1928, Selfridges opened the world's first television sales department. 'This is not a toy,' the store's flamboyant owner told reporters. 'It is a link between all peoples of the world. Great good can come of it.' The consumer society was born. In the West End of London, properties were demolished to make room for new car showrooms, cinemas, hotels, restaurants and retail outlets. In 1930, new retail giant Marks & Spencer opened its flagship store at Marble Arch. The following year, The Dorchester opened its doors. The poorer classes were shunted into new municipal housing estates and the suburbs were expanded, as developers pushed ever outward into the open fields and countryside, embracing vast areas of Kent, Essex, Middlesex and Hertfordshire.

'This is the England of arterial and by-pass roads, of filling stations and factories that look like exhibition buildings, of giant cinemas and dance-halls and cafés, bungalows with tiny garages, cocktail bars, Woolworths, motor coaches, wireless, hiking, factory girls looking like actresses, greyhound racing and dirt tracks, swimming pools, and everything given away with cigarette coupons,' wrote J. B. Priestley in his *English Journey*.

The impact on Hartley's was unexpected. In the north, sales fell as a result of rising unemployment. In the south, sales were affected by the growing demand for the new consumer goods, which were often bought on credit and left householders less to spend. The fashion for dining out, dancing and the cinema, which burgeoned with the advent of talking pictures, similarly left consumers with less in their pockets. 'All these wants, more or less unknown thirty years ago, are paid for from the common purse, leaving less to spend upon staple foods and the home,' John Higham noted at the firm's profit-sharing distribution ceremony of 1928.

At the same time, the growth of a less labour-intensive workforce led to significant changes in diet, which in turn impacted on sales. 'The industrial workers of London today are not the workers of Lancashire at the beginning of the century,' Higham observed. 'Their labour is for the most part less manual, more mechanised, and their hunger therefore diminished.'

Hartley's remained a formidable business, but it was a business beset by change. In the last years of his life, William had devolved more and more power to his senior managers, but by the late 1920s many of them were thinking about retirement and were less inclined toward resolving the challenges that the business faced. In 1928, Alan Rigsby, the influential Works Manager at Aintree, retired after a period of illness. Rigsby had joined the firm from the railway service in 1900 and brought with him an 'extraordinary precision in seeing that everything coming in and going out of the factory was of the very highest quality'. He was followed into

John Higham. Member of Parliament and, after William's death, Chairman of Hartley's.

retirement by Charles Wardlow, the firm's senior traveller, who had joined Hartley's in 1887, a year after the opening of the Aintree works. A year later, Richard Swift, who had helped to establish the works at Aintree, retired from the business, having spent the previous twenty-six years in charge of the Manufacturing Department at Green Walk.

The older generation was also affected by the inevitable onslaught of time. In 1923, William's right-hand man at Aintree, Richard Lambert, died, and in 1928 his former private secretary, Tommy Handley, died after a short illness. The same year marked the passing of Fred Davies, the most senior salesman in Liverpool, who had joined the firm in 1896, and William Trowler, the popular foreman of the Filling Room, who had been one of the fifty-four men at Aintree rewarded for his hard work under the terms of William's will.

The loss of some of the firm's senior and most experienced workers came at a significant time in its history and served to compound its difficulties. At the same time, a new untested generation came to the fore.

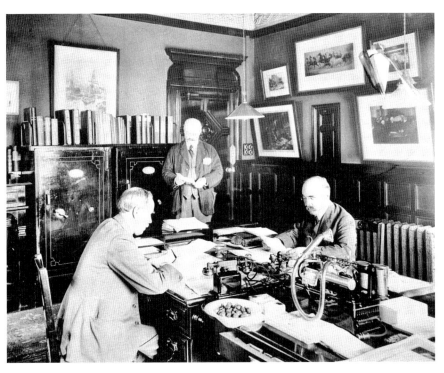

William's former office. From left to right: John Higham, Works Manager Alan Rigsby, and William's private secretary Tommy Handley.

A New Generation

By the mid-1920s, five of William's grandsons were working for the firm. The oldest was Will Higham, whose tenure at Aintree briefly overlapped with that of his illustrious grandfather. William Hartley Higham was born in June 1900 on the cusp of a new century. When he was younger his grandfather had taken him around the works, and when he was older he faced the difficult choice between a career at his father's cotton works or in the manufacture of preserves. The burden did not sit lightly on his shoulders. A shy, sombre figure, he did not have the same natural affinity with his workers that both his father and grandfather possessed. He would, nevertheless, turn out to be one of the firm's greatest assets.

In 1925, he was joined at Aintree by his more flamboyant cousin, Bobby Barkby, whose older brother's death on the Somme inextricably drew him into the business. Bobby was two years younger than Will, but there was a world of difference between them. A talented pianist, he had been a member of the Cambridge Footlights at university. After he was sent down for not doing his academic work, he formed his own band, which toured America. Bobby dutifully took his place at the works, but he never lost his taste for the bright lights. He was close friends with the bandleader, Carroll Gibbons, whose Savoy Orpheans was one of the best-known dance bands of the 1930s. He was also friends with Gertrude Lawrence and Noel Coward. In 1926, when he married Margaret Mabel McCormick Mitchell, the daughter of one of Liverpool's leading cancer specialists, her wedding gown was designed by couturier and court dressmaker Norman Hartnell, who was also one of the ushers.

The next generation were not all suited to lives in commerce. At Green Walk, Will Hartley's two sons followed in their father's faltering footsteps. The oldest was Lister. He was joined at the firm by his brother, Rex (see 'An Unfinished Life' below) but both were better known as sportsmen than men of commerce. The Hartley brothers were golfing sensations and until the outbreak of the Second World War were among the most notable figures in the game, notching up a succession of championship victories, both individually and as a pair. The brothers represented England in the Home Internationals for over ten years and competed in the Walker Cup, which at the time was the pre-eminent contest between America and the United Kingdom. In 1930, Lister married Lucila d'Alkaine, the daughter of a wealthy Argentinian landowner, in a grand society wedding at St Margaret's in Westminster. The wedding attracted a large crowd of onlookers, and afterwards a reception was held at the Grosvenor House Hotel on Park Lane.

Bobby Barkby.

Laurie Gibbens.

The Hartley brothers added a touch of glamour to the business and regularly appeared in the firm's in-house magazine, *The Lighthouse*. The brothers were joined at Green Walk by Laurie Gibbens, the second of George and Sallie Gibbens' five sons, who was born on 14 June 1901, eleven days before the factory opened. A less glamorous, more solid figure, he was educated at St Paul's in London and Trinity College, Cambridge. While three of his brothers pursued careers in medicine, he preferred to follow more closely in his grandfather's footsteps. (A younger brother, Alan, went to work at Holwelbury Farm in 1928 when he was twenty-one. The following year, he was killed in a car crash near Canterbury.) In May 1926, when the nation was convulsed by the long-talked-about General Strike, he was one of those who drove trucks and lorries through the barricaded streets. At Green Walk, Laurie Gibbens, like Will Higham at Aintree, would provide the platform of stability from which the business would press forward.

In the 1920s, Hartley's faced some of the greatest challenges in its history. William had guided the firm through the first fifty years of its existence, but his death, coupled with the downturn in trade, left the business in a state of disarray. When his grandsons took over, it was with the highest of hopes. In the wake of the war, attitudes were changing, as the nation shrugged off the constraints of its Victorian past, but the desire to uphold William's legacy, and to maintain the great business that he had started, remained firm. There was, nevertheless, much to be done.

An Unfinished Life

Rex Hartley was born into wealth. In contrast to his grandfather, whose hard work had created that wealth, Rex's childhood was one of privilege and advantage. He was educated at the prestigious Westminster School and for a short time attended Peterhouse College, Cambridge, studying economics. When he was still in his twenties, he became a friend and golfing partner of the Prince of Wales, the future Edward VIII. Rex went to the country house parties of the well-to-do and at the age of twenty-three was living in a grand house in Knightsbridge. In 1927, when he married the heiress to a vast steel fortune, it was like the union of two great dynasties.

His life is indicative of the increasingly blurred lines between trade and society, middle-class aspirations and lower-class origins. William's childhood in Colne had been one of struggle and strife. Rex and his brother Lister, on the other hand, did not need to work. While both became directors of Hartley's, neither had much of an inclination to follow either their father or grandfather when it came to business. There were other distractions. The brothers learned

to play golf at Chislehurst in Kent and at Cooden Beach on the Sussex coast, a fashionable club that was popular among members of the Stock Exchange, bankers, company directors and manufacturers. In 1923, at the ages of eighteen and nineteen respectively, they won their first major tournament, the London Amateur Foursomes at Sunningdale. The following year, they won it again. 'They play a foursome in a way that is a pleasure to witness,' the golfing correspondent of The Times enthused.

There followed a succession of championship victories. In 1925, Rex was appointed captain of the Cambridge University golf team. The same year, he was sent down for not working, the attractions of golf and society proving more powerful than the study of economics. In 1926, he was selected to play for England in the Home International against Scotland and represented his country for the next six years in succession.

At a time when there were few professional golfers, Rex and Lister Hartley were two of the nation's leading amateur players. In 1928, the brothers made the front cover of Golf Illustrated. 'A Triumph for Youth', its headline declared. Two years later, The Times noted of Rex that 'there is scarcely a better amateur golfer in Great Britain at the moment'.

Rex started at Green Walk shortly after leaving university. A life in business did not so much beckon him, as hold out its obliging hand to welcome him. The contrast between him and his grandfather could not have been starker. Rex had imbibed a set of values that were distinctly different to William's Nonconformist doctrines. Not for him the eternal notions of heaven and hell, or the virtues of temperance and thrift. Rex was part of a generation that consciously rejected its Victorian heritage and looked instead to the pleasures of gin and gambling, the Charleston and the Black Bottom. The shape of his life was dictated by a refusal to conform. And while the great business that bore his name had seeped into his life from an early age, he was content to work on its fringes, his interest largely confined to 'marketing', a universal term for the directors of many family-run businesses who had no set place within it.

In the wake of the First World War, the nation was rapidly changing. The 1920s was the era of pogo sticks and potato crisps, parties and postage-stamp-sized dance floors, fast cars and fashionable nightclubs, champagne breakfasts and Bright Young Things. Bobby Jones practised his chip shots on the roof of The Savoy, Gertrude Ederle swam the English Channel, and Suzanne Lenglen warmed up at Wimbledon in a white ermine coat. Women discarded their whalebone corsets and shrugged off their chaperones. Skirts were shortened and girls openly smoked in public in defiance of old rules and well-worn conventions. There were treasure hunts through the streets of the West End

and parties at which all the guests came dressed as babies with gin in their feeding bottles. It was the era of society hostesses, such as Ottoline Morrell and Emerald Cunard, whose affair with a black pianist scandalised society. The fashionable were photographed by Cecil Beaton and satirised by Noel Coward, while magazines such as the Tatler and the Bystander recorded the lives of a new class of celebrity, who ranged from sportsmen to novelists.

Rex's golfing prowess brought him celebrity status. In the 1920s, golf was rapidly gaining in popularity. As it was played by both men and women, it was considered one of the more social sports. Tall and slender, with cobalt-blue eyes and a mop of fair hair, Rex was invited to play in tournaments around the world and was frequently challenged by other golfers for the prestige of saying they had played against Rex Hartley. In June 1927, the Tatler announced Rex's engagement to Muriel Jane Stewart of Black House, Skelmorlie, a small seaside resort near Glasgow. The happy couple were married four months later at the fashionable Holy Trinity church, Brompton, in the centre of London, and in 1928 they moved into a house at 55 Hans Road, a stone's throw from Harrods.

The Stewart family fortune was in iron and steel. In 1903, Muriel's father had merged his business in Scotland with that of Birmingham steel-makers Lloyd & Lloyd Ltd to create one of the largest iron and steel-making firms in Britain. After the death of her older brother in the trenches and the disinheritance of her younger brother for marrying a showgirl, Muriel became the sole heir to her father's wealth. In 1934, Stewarts & Lloyds opened a new steel works at Corby in Northamptonshire and developed the town alongside it for its workers. The same year, Prime Minister Neville Chamberlain was taken on a tour of the massive new plant, which by the outbreak of the Second World War was employing over 15,000 workers. In the war, the company was best known for its part in the manufacture of PLUTO, the pipeline under the ocean which supplied fuel to the Allied forces after the Normandy landings in 1944.

The marriage of Rex and Muriel amalgamated two vast fortunes and the couple embarked on a life of unparalleled splendour. At a time when sports and society proved a compelling combination, their activities both on and off the course were consistently reported in the society pages. The pair were photographed at opening nights at the theatre, parties (Rex once danced with Fred Astaire at a party) and charity balls. At 55 Hans Road, they entertained the Prince of Wales and similarly were guests at Fort Belvedere, the Prince's home on the edge of Great Windsor Park. Rex's stated profession was as a director of the London works, but his name rarely appeared in connection with the business. In the society columns he was always referred to as 'Rex Hartley, the well-known golfer', whether he was partnering the Prince of Wales to victory at Sunningdale or walking the course with his wife at Westward Ho.

Rex and Muriel in happier times, at Prestwick in May 1928, at the British Amateur Golf Championship.

The couple were rarely out of the limelight. In May 1930, Rex was invited to take part in a unique match at Trent Park, the North London home of Sir Philip Sassoon, a cousin of the war poet Siegfried Sassoon and heir to a banking and trading fortune. Trent Park was a 1,000-acre estate with its own nine-hole golf course and private airfield. The match was between the Oxford University team and a scratch team that included the Prince of Wales, his brother the Duke of York, American socialite Charles Sweeney and golfing legend Bobby Jones, who that year won all four major championships. Two generations removed from the origins of his family in Colne, there was no suggestion that Rex did not belong. In January 1933, the Prince visited the Hartley works at Green Walk and was shown around by Rex, who guided him through the process of making marmalade. The same year, the firm was awarded the use of the coveted Prince of Wales feathers.

Rex might have fallen under socialite Dorothy Nevill's description of the sons of the well-to-do, who 'in several instances do not conceal their dislike for business and lead an existence of leisurely and extravagant ease', but in the late 1930s he showed that he was no idle socialite. In the spring of 1939, five months before the outbreak of the Second World War, he trained as an anti-aircraft gunner, rising to the rank of Second Lieutenant. When war was declared, he refused to move out of London to the relative comfort of the countryside. Instead he threw himself into work at the factory and in the Blitz took his place

A unique occasion. The Prince of Wales sits in the middle, clutching a checked cap. To his left is Bobby Jones. The Prince's brother, the future King George VI, sits next to Jones. Rex Hartley is in the front row second from the right.

Rex Hartley and the Prince of Wales at Green Walk, 1933.

The Prince is shown through one of the boiling rooms. His visit coincided with the manufacture of some of the year's marmalade.

in the defence of London. When the Hartley works was bombed in January 1941, he was one of the first to put himself forward to rescue survivors – and it was testament to his tireless efforts that a week after the bombing the works was back in full production. The strain, however, proved too much for him and at the end of the year he was admitted to a nursing home in Chobham after suffering a nervous breakdown. He died on 18 March 1942, after falling from a first-floor balcony. He was thirty-six.

A Radical Reshape

The new generation introduced fresh ideas into the business. In April 1928, the first edition of *The Lighthouse*, the firm's in-house magazine, was released as 'a visible bond between our factories, between our workpeople, our staff and management'. The magazine was edited by Lister Hartley and Bobby Barkby. Works magazines were a comparatively new feature in industry and *The Lighthouse* was 'a logical extension of our movement of cooperation in and out of business hours'.

The firm offered its workers a varied social life. In 1927, a Social and Welfare Club was established with the object of 'providing social activities, sports and recreation' within the firm. There were charabanc outings to Margate and Blackpool. A concert party named The Regals was formed, which performed shows in the Aintree Institute, as well as at public benefits for local hospitals and charities. There were dances that were 'exceptionally well attended', works picnics, fancy-dress parties – a common feature of the 1920s – and social evenings that brought 'more and more of our workers together'. The dances in particular proved popular venues for men and women from the works to meet and resulted in a number of marriages between couples from different departments.

In October 1932, William's former home beside the factory gates at Aintree was converted into a clubhouse and social welfare centre, replacing the old pavilion on the playing field opposite the works. The bedrooms became dressing rooms, and showers were fitted in the bathrooms – a notable improvement on the pavilion, which as it had no running water meant players had to wash themselves after a match in buckets of cold water. Meanwhile, two tennis courts were laid out in the garden, which were in addition to the two courts in the middle of the model village.

The creation of works' sports teams was encouraged. In October 1927, a ladies hockey team was formed at Aintree. There was a swimming club

The firm's football team in 1930. Goalkeeper Ernie Llewellyn attracted the attention of Huddersfield FC.

for workers at Aintree, tennis clubs at both factories (workers at Green Walk used courts at Half Moon Lane), a bowling club and a billiards club, which played at the Aintree Institute. There had been works football and cricket teams at Aintree from as early as 1908, but the intervention of the war had brought them to an end. The 1920s saw the revival of both teams. The men at Aintree played football in the Business Houses League against teams from companies such as Tate & Lyle, Bryant & May, Lever Brothers, British American Tobacco and the Liverpool Tram Company. Two of the team's players, Alfred Trowler and goalkeeper Ernie Llewellyn, attracted the attention of Sheffield Wednesday and Huddersfield respectively, who were eager to sign them, but both men preferred the more reliable employment that Hartley's offered. There was also an annual fixture against the works team from Green Walk, which took place at alternate locations.

A Benevolent Employer

Hartley's remained a benevolent employer. The firm continued to pay wages that were above union rates, and workers continued to benefit from profit-sharing, the company pension scheme, which was open to all employees between the ages of eighteen and fifty, and a benevolent fund. A company

doctor visited the works twice a week, and a scheme for sickness pay and convalescent treatment was open to all permanent employees. There was no trade union at Hartley's. Workers did not feel it was necessary. Work started at eight o'clock in the morning and finished at six, with an hour's unpaid break for lunch. In the years leading up to the war, both factories were open on Saturday mornings. Workers were allowed an annual holiday of two weeks, or ten working days, but no holiday was permitted either in the middle of the summer, or at the start of the year, when the factory was dedicated to the production of marmalade.

The firm also carried forward the charitable side of William's life, making regular donations to local hospitals in both London and Liverpool, convalescent homes, the Salvation Army, the National Temperance League, the British Christian Endeavour Union, London Homes for Working Boys and Bermondsey Medical Mission, among others. The payments continued throughout the Second World War and in many instances increased. The firm also responded to more immediate distress. In 1928, for instance, when coal miners and their families in the north of England were 'on the brink of starvation', the firm sent assorted cases of preserves that were distributed through local churches, as well as financial aid.

Hartley's remained a huge local employer and workers continued to flock to its doors. In 1928, the Aintree works was employing a permanent staff of around 1,000, while at Green Walk there were about 650. By then, the generation of workers who had started at Aintree in its early days was heading into retirement and in many instances were succeeded by their sons and daughters. William Trowler, for instance, had five daughters, all of whom worked at Hartley's, as did his three sons: Alfred, who became a traveller in the Birmingham area from 1930 to 1961, William Henry, who worked as an electrician from 1923 to 1964, and Herbert, who was a motor mechanic and garage foreman from 1925 to 1964. Herbert married a girl he met at the firm, Vera Maud Jones, and their two sons, Herbert and John Edward, in turn worked at the Aintree factory, as did a succession of cousins, uncles and aunts. The Trowlers were by no means unique.

Workers at Aintree benefited not only from the wide range of social and benevolent facilities, but also from the 'perfectly healthy surroundings' in which the work was carried out. In the mid-1920s, Aintree retained much of its rural character. The village was still surrounded by farmland and open countryside. An aerial photograph taken in 1923 shows the factory in all its isolated splendour. In 1914, Irish biscuit makers W. & R. Jacob had opened a factory on Long Lane next to the Hartley works, but industry had still to leave its mark on the area. The flat, cultivated landscape was 'scarcely broken

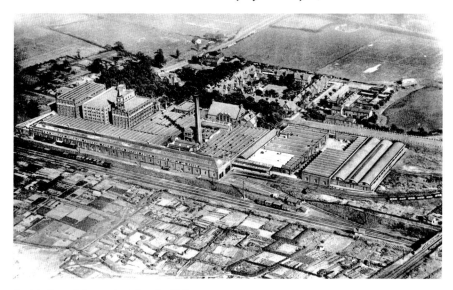

Aerial view of the works taken in 1923.

by even the smallest trees', and as far as the eye could see were scattered farmhouses. In the village itself, there were two inns and a school. There was no church, but the Primitive Methodist chapel that William had built in 1891 supported a thriving congregation.

There were, however, signs of change. In 1925, British Enka Artificial Silk (later Courtaulds) acquired an aircraft factory near Aintree racecourse that had been used to build Bristol biplanes in the war. The firm proceeded to build houses for its workers near the Blue Anchor inn. In 1929, Sefton Building Company also acquired land near the Blue Anchor on which it built more houses, and there was further development at the eastern end of the village, near the main road to Liverpool.

The Name is the Sample

In 1923, a third warehouse had been built at Aintree, a reflection of the post-war boom, but a fourth, started two years later, was not completed. Hartley's had risen on the back of industrial prosperity, but the decline in its traditional markets forced a radical reshape. In response the firm diversified. The core business remained sales of jam and marmalade, but by 1930 its product list included olive oil (which was exported from Calabria and bottled and sold under the Hartley name), salad cream, sauces, piccalillis, gherkins, blackcurrant tea (marketed as a medicinal drink for coughs and colds), lemon

Hartley's labels, 1928.

Above: Laurie Gibbens' daughter, Ann, photographed for an advert for Hartley's Strawberry Jam, the firm's most popular product.

Left: Hartley's advertisement, 1925.

cheese, lemon curd, kosher jam, glacé cherries for the confectionery trade, mixed fruit for the catering trade, mincemeat and Christmas puddings.

The competition remained fierce. In 1919, Keiller's was sold to Crosse & Blackwell, merging two of Hartley's strongest competitors, while at Histon the firm's closest rival, Chivers, continued to turn out a wide range of popular products. In 1932, Harrods' list of jams, which included 'almost every reputable make and variety', gave the names of eighteen different manufacturers. Hartley's was prominent among them, but alongside its long-term rivals were newer firms such as Crosbie's, Callard's, and Baxter's, which had expanded from its roots on the banks of the Spey in Scotland. At Aintree, a new firm, Nelson's Jams, opened a factory on Long Lane in 1923, not far from the Hartley works. The chain stores too were adding preserves to their growing list of products. Sainsbury's, for instance, which had moved out of London into the expanding consumer belt, introduced its own range of canned fruits and jam.

At Hartley's, a range of new products was introduced to excite the public palate. By the late 1920s, the firm had added grapefruit marmalade, ginger marmalade, pineapple conserve, rhubarb jam and blackberry and apple jam to its list. In 1928, Hartley's was selling three different orange marmalades: Seville Star, coarse-cut, and jelly. Sales of bottled fruits remained firm, but the range was extended to include bilberries, wimberries, red plums, loganberries, cherries and greengages. There were equally new flavours of table jelly, including lime, gooseberry, damson and the short-lived port flavour.

Tastes were changing. In 1930, the firm released Bittersweet Marmalade, which was marketed as 'a totally new idea in marmalade'. The new product was to have been called Baronial Marmalade, but it was decided the name did little to define the contents of the jar. The directors therefore agreed on the catchier name of Bittersweet, which came from Noel Coward's romantic musical of the same name, then in the middle of a successful West End run. Bittersweet was launched at the Savoy Hotel by the show's star, Evelyn Laye, and its release was accompanied by an extensive advertising campaign, both in newspapers and magazines. A short promotional film, *Morning Sunshine*, featuring Evelyn Laye, was shown in cinemas.

The release of Bittersweet and its more aggressive promotion reflected changing attitudes within the business. In his day, William had largely scorned advertising and publicity. In 1904, for instance, when a new salesman wrote to him requesting samples of the firm's goods, he replied in seven terse words: 'Dear sir, the name is the sample.' The changing market conditions produced a more vigorous approach. In January 1926, for instance, when Robertson's

Bittersweet Marmalade was launched in 1930 by the popular West End star Evelyn Laye.

Hartley's advertisement, *c.* 1924.

One of the firm's fleet of delivery vans, with the Prince of Wales feathers on the door and advertising slogan on the side.

announced price cuts across its range of products, Hartley's responded with a major advertising campaign that was designed to demonstrate the quality of its preserves in comparison with cheaper alternatives. It was the first blow in a long-running campaign.

'Hartley's is real jam' became a slogan that was used for many years and served to enhance the fact that in Hartley's jams there were no preservatives, no colouring matter, only fresh fruit and sugar. The genius of the business had long been its simplicity, but as consumer tastes changed it was necessary to continually find means by which to attract them. There was often little subtlety to the message. In 1930, for instance, a newspaper advertisement declared that 'for sixty years the people of this country have said that the one test of jam is … is it as good as Hartley's Jam?'

The firm went all out to win back the public. 'Are you getting fresh-fruit jam or pulp jam?' an advertisement questioned in November 1933. 'There's little difference in the price, but there's a world of difference in the contents of the jar.' The advertisements were designed to tackle head-on the 'pulpers' of the industry and were directed specifically at housewives, the keepers of the key to the family purse. 'Which do you buy for your children – fresh-fruit jam or pulp jam?' an advertisement in *Modern Woman* asked. 'Give your

children what is best for them. Give them Hartley's.' An advertisement in *Wife and Home* was equally direct: 'That is why more and more mothers are learning to ask for Hartley's by name. They know it's the best jam to give to children.'

Spreading the Word

A range of means was used to promote the firm's products. In August 1923, John Higham commissioned Clarke & Sherwell of Northampton to produce a series of photographs of the interior and exterior of the Aintree factory, the Melling pottery and the fruit farm in Henlow. (The Bermondsey works was so hard to photograph that the card was produced as an engraving – see page 82.) The photographs showed the business in all its glory and were made into a series of twenty-four postcards, which were handed out at trade fairs and sent to grocers to put on their counters for customers to take home. A total of two million cards were produced in the first batch, and in February 1924 another eight million were issued, which included twelve more photographs, five of which were taken in the orange groves of Seville.

The firm produced posters and colour showcards for its preserves and table jellies. In March 1930, for instance, 40,000 table jelly showcards of a pirate bearing the tag line 'some treasure' were purchased. The same year, 40,000 'Jamboree' preserves cards were bought, which showed a boy scout clutching a pot of Hartley's raspberry jam. The showcards were handed to customers and prospective customers. The cards were also for grocers to use in window displays, and prizes were awarded for the most imaginative (and business-producing) work. The newly created marketing department produced a list of guidelines: 'Showcards are not merely "to attract", but should form a close link with the rest of the selling policy. "Clever" display pieces are rarely successful. Simplicity should always be the first consideration.'

Marketing became an increasingly important weapon as the firm struggled to recapture its former glory. Hartley's was one of the first businesses in Britain to use a glass-sided display van to advertise its wares. The van was purchased in September 1931 for £366 and carried miniature jars of jam that were given away at women's meetings and other public functions.

As the nation became more mobile, so did the business. In June 1923, the firm purchased three Dennis 2.5-ton Box Vans. The following year, it added five more Dennis lorries to its fleet. The lorries were themselves advertisements for the firm's products and as such were kept scrupulously clean. At Green Walk, two men were employed five days a week from seven at night to six in the morning to wash and maintain the vehicles. The drivers were also advertisements for the

business and were expected to be neat and tidy at all times. In 1931, the firm purchased thirty coats and caps for its motormen, which were purpose-made at a cost of £3 3s a set.

Promotion was all. In April 1924, Hartley's took two stands at the British Empire Exhibition at Wembley, a triumphant celebration of trade and industry that attracted more than 17 million visitors. Its success encouraged the establishment of a designated team to run the firm's stands at trade fairs, which was headed by Fred Ainsworth and included Agnes Edwards, Alice Percival and Eric Coldwell, the son of the stationmaster at Aintree, whose father had been given five pounds by William Hartley to spend on schoolbooks. The new team took the firm's business on the road to trade fairs around the country and were joined by the firm's travellers for each area, who helped to cultivate new business. In 1926, the firm had fifty-two salesmen covering Britain, Northern Ireland and the Isle of Man. At the same time, the firm invited grocers to visit its factories as a means of encouraging them to drum up trade. In September 1929, for instance, parties of grocers who had travelled to London for an exhibition at the Agricultural Hall were entertained over a period of three days at Green Walk, where they were shown around the works and then taken to lunch at the Holborn Restaurant.

Hartley's advertised on the newly created Radio Luxembourg, which started broadcasting in 1933. The firm sponsored a show that featured the music of Carroll Gibbons and the Savoy Boyfriends, an offshoot of the Savoy Orpheans. Gibbons by then was at the height of his fame and the show attracted large audiences. As well as featuring Gibbons' music, the show included recipes for the firm's products, a technique that was adapted in the 1950s when commercial television was launched, allowing the marketing men to ply their trade under the guise of providing consumers with household tips and useful information. The shows featured the vocal talents of Anne Lenner, a regular performer with the Savoy Orpheans, but also included the less well-known talents of Rex Hartley and Bobby Barkby, who accompanied her on the piano. A record entitled On the Air for Hartley's Jam was released in 1980, after the bandleader's wife came forward with a pile of her husband's records, among them several long-lost Hartley's pressings.

The marketing men also introduced a host of ideas that in William's day had neither been considered, nor had been necessary. Recipes, for instance, were added to the packaging for raspberry jam, marmalade and table jellies, and consumers were exhorted to 'put this label in your cookery book'. In the late 1920s, 40,000 recipe books containing advertisements for Hartley's products were distributed in the Piggly Wiggly Stores in America, the world's first self-service stores. At home, there were competitions with cash prizes that aimed to

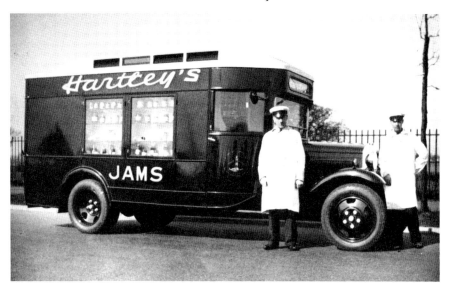

The firm's show van, photographed in 1932.

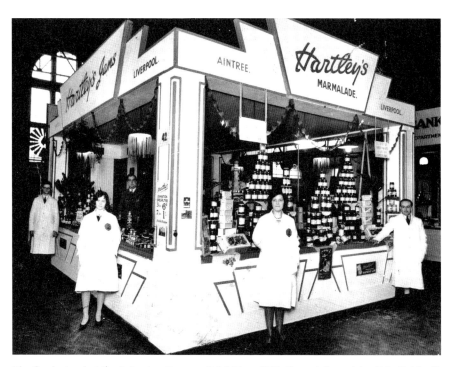

The firm's stand at the Leicester Grocery Exhibition, 1930. From left to right: Eric Coldwell, Agnes Edwards, Alice Percival, Fred Ainsworth.

increase sales by ensuring that all entrants returned their answers with labels from Hartley products. The firm also handed out silver-plated fruit spoons with the purchase of the relevant number of packets of table jellies. There were gimmicks too. A suitcase of Hartley products, for instance, was sold at Christmas for the 'amazing bargain price' of seven shillings. The case included New Season's blackcurrant jam, Aintree marmalade, Hartley's Special Mincemeat and a jar of Lemon Curd 'made as only Hartley's can make it'.

The firm did not create a memorable figure, such as Robertson's Gollies, which first appeared as badges in 1928, nor anything like the Ovaltiney Club, launched in 1935, but its products remained at the forefront of consumers' minds. Hartley's, as its wartime advertisements later proclaimed, was quite simply 'the greatest name in jam making'. Advertisements for the business appeared on railway platforms, walls, hoardings and plate advertisements on trams and buses. The firm produced miniature lighthouses, which were handed out to consumers. There was even a miniature advertising sign for Hartley's Jams that was made by Hornby for its model railway layout. At Aintree, the firm's products were emblazoned on the side of the works, and at Green Walk Hartley's literally declared its name from the rooftops, writing it in bold white letters on the 130-foot chimney that rose above the factory.

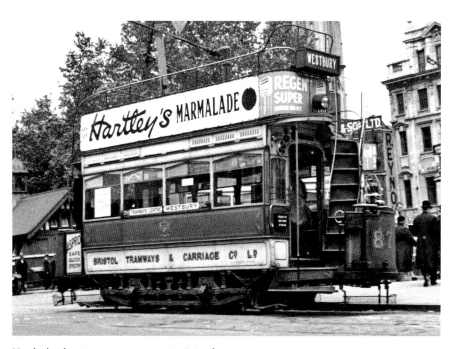

Hartley's advertisement on a tram in Bristol.

Evolution

The business evolved. By 1930, Hartley's was selling its products to the Grosvenor House Hotel, Selfridges, Harrods, Woolworths (for use in its restaurants), northern-based Irwin Stores (which in 1960 was bought by Tesco), Maypole Dairies, Meadow Dairies, corner shops, hospitals, institutions, ship chandlers, works canteens, bakeries, the railways and railway hotels. A number of the firm's rivals had supplied the railways with miniature pots of jam and marmalade for many years, and as trading conditions worsened it was felt all the more necessary that Hartley's should compete in this area, even though the manufacturing costs were prohibitive. It cost the firm almost seven times as much for a girl to fill miniatures as the larger pots. The benefit, however, was in the promotional value. The firm also supplied miniatures to restaurants and tea shops.

The loss of trade at home prompted the firm to expand abroad. In 1925, the directors agreed to spend $20,000 on a twelve-month advertising campaign in greater New York. The agreement was made with Robert Delapenha, who by then had been selling Hartley's products for almost thirty years. When William was alive, Delapenha had tried to persuade him to open a factory in America, but to no avail. In the mid-1920s, he tried again. In January 1927, William's grandsons Lister Hartley and Bobby Barkby sailed to New York to meet him. Delapenha was waiting for them on the docks and took them straight to his office on Jay Street. The following afternoon they travelled by train to Poughkeepsie, a journey of about 75 miles along the banks of the Hudson. There, they were shown Delapenha's factory. 'The site of the factory is remarkable,' Lister wrote home. 'Two railroads run practically through it and it has good sidings of its own. It is moreover right on the banks of the river and boats loaded at five in the evening can be in New York at eight the following morning.'

Delapenha explained his reasons for expansion in America in simple terms. There was, he noted, 'not a single brand of jams, jellies, marmalade or preserves being advertised nationally throughout the United States, nor is the consumer being told why she should eat jams, jellies, or marmalade'. He went on. 'I believe that there is a big field for the development of a business based on sound principles and putting out a first-class product.' A new business, he suggested, would be called William P. Hartley Ltd, New York, and would be run out of his factory in Poughkeepsie. It was, he added, an opportunity that would take the firm ahead of rivals Crosse & Blackwell, who had already opened a factory in America, and Chivers, who were in discussion with local manufacturers. The visit was encouraging, but it was not enough to sway

Martha, who retained a controlling interest in the business and steadfastly held to the same reasoning William had used when it came to losing control of the manufacture of the firm's goods, and with it the possible loss of its reputation. At the age of eighty-four, she dug her heels in and refused to accommodate Delapenha's request.

Hartley's nevertheless continued to export its goods to America and extended its reach into the maritime provinces of New Brunswick, Prince Edward Island and Nova Scotia. It also extended its export trade to other countries, particularly those that were part of the British Empire. In the mid-1920s, a taste for all things British was sweeping the nation. Post-war patriotism was at a high, and events such as the British Empire exhibitions of 1924 and 1925 were at the forefront of attempts to persuade consumers to buy British. The Hartley name was both a taste of empire and a taste of home. In the 1920s, its products could be found in India, Singapore, Gibraltar, the West Indies, Bermuda, Jamaica, New Zealand, Rhodesia, South Africa, the Canary Islands and Newfoundland. The firm exported popular favourites, such as strawberry, raspberry, apricot, greengage, damson and plum jam, as well as marmalades, tinned fruits in syrup, candied peel, table jellies and sauces.

The export market, however, was less profitable than the market at home. In some countries, sales were modest in comparison with those at home. In Egypt, for instance, sales went from £927 in 1928 to £654 in 1930. Demand was lower in Europe, particularly in countries such as Italy and Spain, which had less of a cultural tradition of eating preserves. 'Italy is a useless ground for our goods, Spain is not a jam eating nation, France does not insist on our quality, Norway and Sweden only import marmalade, and Germany offers too much home grown competition,' Laurie Gibbens observed. The predominant market for the firm's products in Europe was in Holland, which was the one nation whose consumers were prepared to pay an increased amount for the higher quality article that Hartley's made.

The Rise of the Machine

William's grandsons were keen to modernise the business. Adverse trading conditions to some extent forced change upon them, but by the early 1930s the business was scarcely recognisable from that which William had started sixty years earlier. The work became more mechanised, less labour-intensive. In William's day, a small number of machines had been introduced at the factories. Gooseberries, for instance, were topped and tailed in a revolving drum that swirled them round against sides that were rough like a file,

Advertisement from *The Times* of India, 1930. Hartley's was a taste of home and a taste of empire.

while a stream of cold, clean water was poured over them. Similarly, he had introduced 'strigging' machines in which blackcurrants were trickled down a long wire tray in which hundreds of little 'fingers' snatched away the stalks while the blackcurrants fell into a receptacle below.

The purchase of new machinery served to streamline the firm's operations. In 1929, for instance, a plum-stoning machine was bought from Navarre & Co. of Paris, which replaced much of the work that had previously been done by hand. Two years later, two Paillard & Benoit table-jelly-packeting machines were installed at Aintree, whose output of 'uninterrupted work' was thirty-six packets a minute. There were machines for cleaning and sterilising the jars, machines that automatically weighed out the correct amount of sugar, label separators that could remove up to eighty labels a minute from used pots (like bottles of lemonade, pots were returned to grocers and then to the factory for a small payment), jelly-cutting machines and giant filling machines which at lightning speed filled the jars with the exact predetermined weight. In October 1930, Bobby Barkby travelled to Berlin to inspect a new orange-peeling machine. The following year, the machines, which cut the orange peel into small shreds for the various marmalades, were introduced at both factories. 'Gone are the days when most of the manufacturing processes were conducted by human hands,' he observed in a newspaper article extolling the virtues of the business.

Hartley's moved with the times. The 1920s witnessed the introduction of new scientific means of monitoring production. A laboratory was opened in each of the works, and William's method of touch tasting was replaced by a chemist at each factory who regularly tested and analysed samples of the firm's products. The chemists also analysed the products of the firm's competitors and kept copious notes on their consistency, colour and flavour. The results were then submitted to the directors, and tasting sessions were held in the boardroom in which the virtues of Aintree Seville Marmalade were compared with Chivers Olde English, or West End Marmalade was pitted against Frank Cooper's Oxford Marmalade. 'A few days ago, we bought a one pound glass jar of Robertson's Blackcurrant Jam,' Will Higham noted in January 1930. 'We have made some blackcurrant tea from it and also some from our own, and the difference is very marked. Robertson's cannot really be described as a full blackcurrant taste, but has a very watery flavour, whereas our own blackcurrant tea is both rich and well flavoured.'

The firm also moved into the use of glass jars for its smaller-weight products. In William's day, glass was not strong enough to sustain the heat of the boiling jam as it was poured into it. Developments within the business

and experimentation by manufacturers, however, had led to significant changes. In the 1920s, the firm purchased glass bottles from the United Glass Bottle Company and Forster's Glass, which both had factories in St Helens. The manufacture of the firm's distinctive stoneware pots did not cease; but in 1929, after fire completely destroyed the Melling Pottery, production of the larger seven-pound pots, which were still used in grocery stores and for larger customers (such as institutions), shifted to Pearson & Co. of Chesterfield. The same year, production ceased at the Caledonian Pottery, which William had bought thirty years earlier.

Fall and Rise

The profits of the business, however, continued to fall. In 1932, the firm made £86,375. The following year the figure was £62,802. The business was rocked both by its diminishing profits, which had steadily fallen from the mid-1920s onwards, but also by the loss of two of its key figureheads. In March 1930, Martha died at the age of eighty-eight. In her last years she had become increasingly frail, but she had kept in constant touch with the business, attending the annual profit-sharing distribution ceremony, as she had when William was alive, and making known her thoughts to the directors both in the boardroom and at home.

The part she had played in the success of the business was immeasurable. 'It is often the fate of a woman to be overshadowed in the public knowledge by the figure of her husband,' wrote Edward McLellan. 'He bulks largely in the gaze of the world whilst she stands modestly in the background, a more or less interested observer of the pageant that is being played. It sometimes happens, however, that the self obliterating figure in the shadows is a real power behind the throne with as commanding and forceful a personality as the one through which she is content publicly to express herself. Lady Hartley was such a woman.'

A little less than two years later, she was followed to the grave by her son-in-law, John Higham. In spite of his advancing years, he had not relinquished his grip on the business. Higham devoted himself to the firm from the moment William asked for his help to the very last. On Christmas Eve 1931, he collapsed on the train home from the works. He died ten days later in a Liverpool nursing home. Tributes to him flooded in from politicians and leaders of industry alike. 'Famous Firm's Loss' declared one newspaper headline. At his funeral in Southport, there were wreaths from the directors of Jacob's Biscuits and the recently merged firm of Tate & Lyle. A floral

Martha Hartley served as the balance wheel to her husband's enterprise.

wreath from Joe and Maggie Barkby was in the shape of a lighthouse, the firm's trademark.

The firm's move into new product lines had met with limited success, and as sales of preserves continued to fluctuate there was a need to find a means through which to create longer-term stability. In the event, it came from an unlikely source. Hartley's had by and large remained within its core business, but increasingly the prospect of broadening its appeal found favour in the boardroom. Plans for a vegetable cannery were discussed as early as August 1931, when the directors held talks with representatives of the engineering firm of Mather & Platt. In December 1931, talks were held with Boulton & Paul of Norwich, which had erected a number of buildings for the canning industry, notably a can-making factory for H. J. Heinz & Co. in London and a pea cannery for English Preserved Foods of Boston, Lincolnshire.

The plans met a mixed reception. William's daughters, who all held shares in the business, objected to becoming known as 'common pea canners' and for a time it looked as if the idea would not proceed. In the end, however, simple economics won out. In July 1933, *The Times* reported that a new canning factory had been opened at Aintree. It was, the paper noted, 'the

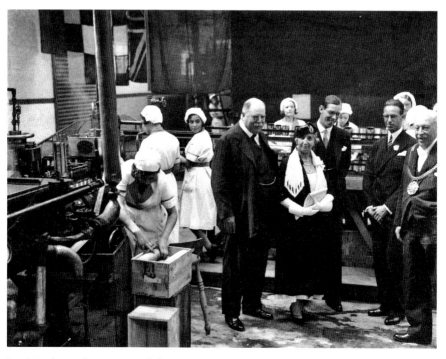

Lord Derby at the opening of the pea cannery in 1933. He is accompanied by Christiana Hartley, Bobby Barkby (to her left) and Will Higham.

first of its kind in the north of England'. The factory was erected at the side of the preserves works, with links to the railway sidings. The cost was £20,000. Touted as an 'All British' venture, it was an instant success. To householders the attractiveness of vegetables throughout the year proved irresistible. Demand was so intense that the acreage required to produce the vegetables rapidly increased, and sales expanded at such a rate that within three years the original plant was trebled in size. In the mid-1930s, a second cannery was opened at Webton Court Farm, a 430-acre farm in Madley, near Hereford. Hartley's swiftly became known as both makers of preserves and canners of vegetables.

In 1933, at the age of sixty-one, Christiana Hartley took over as the firm's chairman. In a newspaper interview, she confessed that she had never expected to 'occupy such an onerous position', but confided that when she was younger her father had told her 'all sorts of details which I have recently found of great value'. In 1934, the firm's profits rose to £85,684. The introduction of vegetable canning had been a radical step, but it was also a profitable one. In 1936, Hartley's became a public company, with share capital of £1 million. The demand for shares was oversubscribed to such an extent that each applicant was limited to 30 per cent of the number requested. The directors of the new company, William P. Hartley Ltd, were Christiana, William's five grandsons and Francis Dickens, a director of the District Bank. Dickens also became chairman. In 1937, the company posted profits of £97,910, about £3.5 million in modern values. The business was once again on the rise.

CHAPTER NINE

Food as a Munition of War

The firm, it seemed, had come through the worst of its troubles, but by the late 1930s there was a wider threat looming on the horizon. At 11.15 a.m. on Sunday 3 September 1939, Neville Chamberlain announced that the nation was once again at war. The announcement created widespread panic. In the days that followed, hospitals in London and Liverpool were emptied to make room for the expected air-raid casualties, basements and cellars were reinforced, and shelters were erected in back gardens. A blackout was imposed and thousands of schoolchildren were evacuated to the countryside to escape the expected bombing.

In the event, there followed a long period of what came to be known as the Phoney, or Bore, War. The air raids did not materialise and by Christmas many of the evacuees had returned home. It was a lull before the storm. In April 1940, the Germans invaded Denmark and Norway. The following month saw the fall of Holland, Luxembourg and Belgium. At the end of May, the British were forced to retreat from the beaches of Dunkirk. A month later, the Germans were in Paris.

In September 1940, the Blitz began. At around five o'clock on the afternoon of 7 September, waves of German bombers and fighters attacked the East End of London. In the streets below, people sheltered beneath railway arches, in churches, basements and cellars. A second attack that evening continued into the early hours of the morning. By nightfall, the Surrey Docks and the East India Docks were ablaze. Hordes of rats, forced out by the fires, roamed the rubble-strewn streets. Houses and factories lay in ruins.

The attacks continued unabated night after night. The aim of the Germans was not merely to break the will of the people, but to stifle the vital flow of food into the capital. Industry was no longer immune to enemy attack – indeed it was a priority target. 'London's Larder' felt the full force of the attacks. Bermondsey was bombed so intensively that for many of its inhabitants it was

as if the world had come to an end. The streets were scarcely recognisable as bombs destroyed houses, schools, tanneries, warehouses, factories. Churches were without roofs, shops without windows, houses without occupants. On 25 October 1940, a bomb fell through a railway arch on Druid Street, killing seventy-seven people sheltering beneath it. The town hall was destroyed, and at Stainer Street sixty-eight bodies were recovered after a high-explosive bomb crashed through a shelter.

At Green Walk, the Hartley factory swiftly moved into full wartime production, providing preserves and tinned fruits to both consumers at home and to the armed forces. The harsh lessons of the first war had been well learned. In the First World War, rationing had not been introduced until April 1918, eight months before the end of the conflict, but in 1939 the government was swift to take control of vital food supplies. A new Ministry of Food was established and Britain was divided into fifteen zones, each of which was under the control of a local authority, which managed the day-to-day administration of rationing. In January 1940, rationing was introduced throughout Britain. Householders were allowed 4 ounces of bacon or ham a week, 12 ounces of sugar and 4 ounces of butter. Meat was rationed in March and other items were steadily added to the list, including jam and marmalade, which were rationed from March 1941, at first at 8 ounces per person per month and then at 1 pound a month.

Food became a munition of war. Food Advice Centres were established around the country, staffed by home economists who dispensed nutritional advice and gave cooking demonstrations in factory canteens and department stores. The Ministry of Food encouraged the establishment of industrial canteens and lent local authorities funds to start British Restaurants for the public that opened in schools and church halls as a means of providing cheap, nutritional meals. The government was keen for householders to vary their diets, and, with a growing war machine to support, it was vital that workers were maintained in the best of health. A 'Dig for Victory' campaign was launched, exhorting householders to grow their own produce. Lawns and flower beds were swiftly turned over to the production of fruit and vegetables. Bomb sites were converted into allotments, while parks and tennis courts were dug up. At the Tower of London, the moat became an allotment, and in Pall Mall the swimming pool of the Ladies' Carlton Club was converted into a pig sty.

JAM, *real* jam on the family table just now means useful nourishment as well as delicious goodness. Hartley's Jam is *real* jam, made from the pick of the season's fruits, and with the finest pure white sugar. See for yourself the good deep orchard tones through the glass of the pots. No suspiciously bright colouring here. Hartley's is good, honest, real fruit jam, the very finest value that a housewife can find to-day.

A PROMISE

PEACE may be quick or slow in coming, but you will always be able to rely on the name 'HARTLEY'S' for Fresh Fruit Jams at the lowest price at which jam as good as Hartley's can possibly be sold. Hartley's give you their word that they will keep QUALITY UP and PRICES DOWN as long as is humanly possible. That is our determined policy.

HARTLEY'S

the greatest name in jam-making

A wartime advertisement.

Total War

The challenge for the Hartley factories, both at Green Walk and Aintree, was to meet the intense demands that were put upon them. It would prove to be a difficult time. The war brought many of the same difficulties that William had experienced twenty-five years earlier. It also brought challenges of its own. Although there was not the same enthusiasm to enlist as there had been in the flag-waving, crowd-cheering days of the First World War, the eventual loss of men to the services through conscription and voluntary enlistment was as threatening to the firm's stability as it had been when William was at its head. At the same time, there was a new threat in the loss of many of its skilled women workers.

At the beginning of the war, work in the food industry was officially classified as being of 'national importance'; but as the conflict escalated, radical changes were made. In December 1941, the government took the unprecedented step of conscripting unmarried and childless women aged between nineteen and thirty for military and industrial service. At Green Walk and Aintree, the firm lost a number of office staff and other vital workers, who joined the armed forces or went into the munitions factories.

The loss of staff put increased pressure on the remaining workforce. In the first year of the war, working hours were extended to as much as seventy a week, and while this had fallen to between fifty and fifty-five hours by 1943, the demands on workers were still relentless. Workers not only had to contend with the deprivations of the war – the shortages of food, the lack of sleep, the loss, in some instances, of home and family – but also with the task of producing enough preserves to sustain soldiers and civilians alike. In London, workers were also affected by the nightly onslaught of German bombs, which lasted almost without interruption from September 1940 until May 1941. The levels of absenteeism, nevertheless, were lower than at any time in the firm's history. The company had long maintained a unified spirit and, while it was tested to the limit, that spirit shone through.

The two factories were also affected by the reduction in supplies of sugar. In May 1940, the government purchased more than 2 million tons of sugar from overseas to boost home supplies, but the start of the Blitz and the Battle of the Atlantic meant that later supplies were restricted. After the First World War, the government had encouraged the production of sugar beet in an effort to curb reliance on overseas cane sugar. Supplies, however, could not keep up with demand. It was not only the jam makers who used large amounts of sugar, but also confectioners, cocoa makers, beer makers, biscuit

makers, bakers and distillers. At Bournville, for instance, Cadbury's turned out moulded block chocolate for consumers, together with large quantities of cocoa and chocolate for the armed forces. The soft drink manufacturers, such as Schweppes – which twenty years later purchased Hartley's – similarly demanded their share.

The reduction in both the amount and the quality of sugar impacted on production, as did the fall in supplies of the firm's other essential ingredient, fruit. In July 1941, *The Times* reported that 'fresh fruit is scarce to the general public as the Ministry of Food has so fixed prices that the bulk of the crops go the jam factories', but the amount of fruit available fluctuated, as did its quality. The result was that the firm was forced to streamline production. A lot of the products that it had introduced in the 1930s disappeared from its list for the duration of the war and the firm resorted to the manufacture of six standard flavours of preserve: strawberry, raspberry, blackcurrant, apricot, red plum and damson.

The firm also continued to make marmalade, but the disruption to supplies of oranges inevitably affected production, and by 1943 it was making its marmalade with only 50 per cent of Seville oranges, the remainder being sweet oranges. Victory in North Africa led to an increase in supplies, but the amounts coming across the Atlantic were limited. 'A recent Ministry of Food decree makes it impossible for us to continue the manufacture of our world-famous Aintree Marmalade,' an advertisement in *Picture Post* informed consumers in April 1943. 'In the meantime we have set to work to make a really first rate marmalade. Half the oranges in it are the finest that come from Seville, the other half being sweet. These blended with sugar ensure the very best product that can be made.'

In the face of a declining workforce and reduced supplies of fruit and sugar, the firm struggled to maintain its pre-war quality. Hartley's had built its reputation on the fact that its preserves were made from fresh fruit, but wartime restrictions forced the directors to make a fundamental change in production. In 1941, Hartley's became 'pulpers'. The decision was not lightly taken. The firm's entire history, indeed its legacy, was based on the fact that its products contained no preservatives and no colouring matter. The directors, nevertheless, felt there was no choice. In the First World War, William had responded to national necessities, and faced with their own set of circumstances the directors applied what seemed the most effective solution.

The change from fresh fruit to pulped fruit, however, called for a cunning conceit. At the start of the war, the firm had made a promise. 'Peace may be quick or slow in coming, but you will always be able to rely on the name

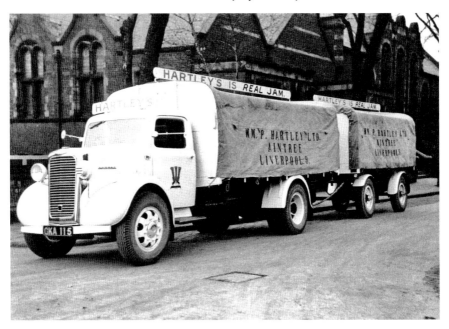

Lorries such as this Commer 6-ton and 3-ton Dyson trailer were used on the Aintree to Bolton Depot run during the war.

Hartley's for Fresh Fruit Jams at the lowest price at which jam as good as Hartley's can possible be sold,' a string of advertisements informed consumers. In order to maintain the firm's reputation, the directors thus sought to obscure the facts. The firm had always marketed its products as 'real jam', but after 1941 its advertisements noted that its products were made in the 'real jam way'. The firm was thus able to assure consumers that 'in spite of wartime difficulties and unavoidable Ministry of Food restrictions Hartley's Jam, made in the "real jam" way, still maintains the highest possible standard of purity and excellence.' In such a manner, the truth was concealed.

The Beginning of the End

The pressure on the business was intense. In October 1939, a month after the outbreak of war, William P. Hartley Ltd had posted a trading profit of £125,639. A year later, the figure was £40,241. The addition of jam and marmalade to the list of rationed items further reduced sales. In the year to October 1941, the company made a profit of £31,387, a vast drop on its pre-war figures.

Hartley's Jam, made the 'real jam' way.

The loss of many of its most skilled workers, the increased costs of manufacture, the worsening conditions in its factories – which were often left without heat and power – all took their toll.

There were additional expenses too. The division of the nation into designated zones prohibited the movement of food between them. In order to maintain the distribution of its goods, Hartley's, in common with other companies, was forced to establish depots around the country, which took much-needed funds from the business and thus reduced profits. In 1939, the company opened a depot in Bolton, which employed around sixty workers. A second was established in Manchester, and in March 1944 the firm acquired the business and assets of Davies Bottled Fruits of Madley, near Hereford.

The one saving grace was that neither factory was badly damaged, which, given the level of sustained attack on London in particular, almost defies belief. The Crosse & Blackwell factory in Bermondsey, for instance, received six direct hits, two of which exploded in the production departments. The Hartley works, on the other hand, seems to have led a more charmed existence.

In the first phase of the Blitz, from September to the end of October 1940, the factory was untouched, and it was not until the night of 8 January 1941, after four months of almost continuous attack, that it was hit. That night, a bomb burst between the factory shelter and one of the warehouses. The bomb exploded with ghastly effect. Four people were killed, twenty-three were seriously wounded and another thirty-seven sustained minor injuries. A large number of casualties were buried in the wreckage, and rescuers were forced to tunnel through a shifting mass of broken glass, rubble and metal to reach them. The damage was so severe that it took authorities many weeks to recover all the bodies.

The factory was damaged again in a short raid on 18 February, but there was no loss of life and the damage was minimal. There followed a period of intermittent raids, the heaviest of which were on the nights of 15 and 16 April when there were extensive casualties in Bermondsey and widespread damage in the streets surrounding the works. The Hartley works again emerged unscathed. A raid on the night of 10 May turned out to be one of the heaviest and most widespread of the Blitz. It also turned out to be the last raid until the Little Blitz commenced in the summer of 1944.

In the meantime, the focus of the German attack shifted and Liverpool came under attack. A series of short, sharp raids had been launched on the city from August 1940 onwards, but the main attacks came at Christmas 1940 and in May 1941. The heaviest raids were in the 'May Blitz', which began on 1 May and ran for eight successive days and nights. Mines and

incendiaries rained down on the city. Ships were sunk in the docks, railway lines destroyed, shops and offices decimated. A total of 1,453 people were killed in Liverpool alone, and more than 1,000 were seriously wounded. In the surrounding districts, over 90,000 homes were destroyed. Houses were flattened, warehouses and factories demolished. In Bootle, where William had opened his first purpose-built factory, nine-tenths of all houses were damaged or destroyed.

Aintree escaped the full force of the Blitz, but it did not escape the bombing. In the early days of the war, eighteen air-raid shelters were built for workers at the factory and residents of Hartley Village. The factory's distinctive position at the junction of the Lancashire and Cheshire railway lines was thought to make it an easily identifiable target from the air and so it was painted in camouflage colours to make it less conspicuous. The fears of an attack were widespread. In one of his broadcasts, Nazi propagandist Lord Haw Haw threatened to spread Hartley's Jam on Jacob's Crackers, a reference to the close proximity of the two factories. In the event, the works was largely undamaged. A bomb hit one of the warehouses, tumbling through six floors into the basement, but did not explode. Another bomb fell

The works' fire crew.

on the road between Hartley Avenue and the air-raid shelters on the playing field, damaging one of the houses in the village, but there were no injuries as residents were in the shelter.

A Time to Celebrate

German bombs might not have destroyed the business, but the pressure on it intensified. In 1942, the company's profits rose to £45,223, but the following year fell back once more to £33,730. The same see-saw effect was noticeable in the profits for 1944 and 1945, which rose to £43,171, before dropping to £38,212. It was an anxious time. In January 1944, the Little Blitz began and Londoners once more found themselves under attack. By then, the nation had been at war four long years. In Bermondsey, houses were demolished and lives lost. 'London can take it' had been a popular phrase in the initial Blitz, but the renewal of hostilities, after a period of relative calm, was wearing down people's resolve.

There was worse to follow. On 12 June 1944, six days after the Allied invasion on the beaches of Normandy, the first flying bomb fell on London. In the months that followed, over 9,000 were launched from bases in Holland and northern France. An estimated 2,500 of these reached London and caused considerable damage and disruption. The Little Blitz was not as extensive as its earlier counterpart, but over 10,000 people were killed in 1944, almost half the number killed in the Blitz four years earlier.

After the breakout from the Normandy beachhead in July 1944, hopes of an Allied victory were high, but faded with the failure of the airborne landings at Arnhem in September. In December, the Germans broke through in the Ardennes. The war staggered on. At the start of 1945, freezing cold winds swept across Britain. Temperatures plummeted and rivers froze. At Aintree, workers wore scarves and overcoats, and scraped the ice from the inside of the office windows. Wartime hostilities were slowly drawing to a close, but it was several months before peace was declared. The end of the war was nonetheless in sight. On 7 March, British and American troops crossed the Rhine. Two months later, Germany surrendered.

On 8 May, the streets of London and Liverpool were festooned with flags and bunting. There were parties in the streets, bonfires and fireworks. 'The best moment I remember was when all the lights started coming on,' Evelyn Creaby, who worked in the Finishing Room at Aintree recalled. A fellow worker, Muriel Hornblower, went with a group of friends to St George's Hall in the centre of Liverpool: 'It was absolutely crowded down there, right up

England still sends its fresh fruits to us and soon will send the fruits of victory to all the world

HARTLEY'S

THE GREATEST NAME IN JAM - MAKING

Wartime advertisement showing the fruits of victory.

London Road and Lime Street – singing, dancing. What touched people most was when they started singing "Land of Hope and Glory". Everybody was hugging and kissing each other. It was a night to remember.'

The nation celebrated victory, but did not forget its losses. At Bermondsey, more than one man distinguished himself in the conflict, but Hartley's would ever after remain proud of one particular member of its office staff, Lieutenant Alec Horwood, who in 1944 was posthumously awarded the Victoria Cross for outstanding gallantry in Burma. The workers too had distinguished themselves, and in speeches at both Green Walk and Long Lane the directors were swift to praise their hard work. On 1 June 1945, the company hosted a 'Victory Dinner and Entertainment' for its workers in the Aintree Institute. The war had been long and hard, but the business had survived. It was a moment to celebrate.

Regeneration

The immediate post-war years witnessed a period of sweeping social change. In July 1945, the Labour Party, under the leadership of Clement Attlee, ousted the nation's wartime hero Winston Churchill. The new government immediately nationalised major industries and public utilities. Iron and steel, coal mining, civil aviation and the railways, all fell under government control. The government created a National Health Service and promised widespread reforms in education. The first comprehensive schools were opened, and the despised 'means test' was dropped from new unemployment and sickness benefits. 'A revolutionary moment in the world's history is a time for revolution, not patching,' declared William Beveridge, architect of many of the reforms.

The revolution was slow to start. In the wake of the war, Britain faced continued austerity. Rationing did not end with the cessation of hostilities but lasted until as late as 1954 when meat, butter, margarine and cheese were removed from the list. The war had ended, but the hardship had not. In 1946, the weekly ration stood at 8 ounces of sugar per person, 4 ounces of jam, 3 ounces of chocolate and sweets, 2 ounces of tea, 2 pints of milk and an egg. The shops were bare. In 1946, bread was rationed for the first time and remained so for the next two years. Potatoes were rationed the following year. Demobbed servicemen returning home found 'nothing but queues and restrictions and forms and shortages'.

After six years of war, the nation was in a state of flux. Industry in particular was hit hard, with rising taxes and escalating fuel costs. At the Hartley

factories, workers returned to find a business which on the surface seemed little different to the one they had left behind. In the mid-1930s, Thomas Winterson had been appointed Works Manager at Aintree and his influence during the war earned him a seat on the board. The death of Rex Hartley in March 1942 had left Green Walk without one of its directors, but apart from the shrapnel marks left by the bomb on the night of 8 January 1941 (which can still be seen) there was little outward evidence of change.

The business slowly recovered. After the war, Hartley's once again made vast quantities of preserves. In 1952, the firm was making nineteen different flavours of jam, including black cherry (first made for American servicemen), four kinds of marmalade and nine flavours of table jelly. Advertisements were quick to reassure consumers that the firm's products were made from whole fruit. 'Hartley's is Real Jam' reappeared in its advertising campaigns, and the firm was touted as 'the greatest name in jam-making'. In December 1948, jam and marmalade came off rations. Sales duly boomed. The export market was reopened and crates laden with Hartley products were dispatched to America and throughout the empire.

In an attempt to reduce its transportation costs, the company opened more depots around the country. In 1953, it purchased an old cinema at 77 Wellington Road, about a mile from the centre of Leeds, which it modified so that the former auditorium became the main storage area. The foyer was transformed into the entrance and offices. New distribution depots were opened in Handsworth, an industrial area outside Birmingham, and at Winlaton, near Newcastle, which added to those the company had opened in the war in Bolton and Manchester. The directors also entered into an agreement with Blatchford's of Exeter, which stored its goods and delivered them in the Devon and Cornwall area.

At home, the firm's drivers travelled far and wide, delivering its products to the north of Scotland, the Isle of Man, the Channel Islands and Northern Ireland. An experiment in sending goods to Ireland proved to be short-lived. After the war, a number of tank landing craft were converted to carry loaded vehicles, and for a short time Hartley's dispatched its goods on its own lorries across the Irish Sea. The service, however, did not prove popular and the firm soon reverted to sending its products through the Belfast Steamship Company. The drivers (along with its salesmen) remained the public face of the company. In the war, the firm had painted its vehicles green, but after the war it opted for white, with the Hartley name written on the side in patriotic blue and red. The livery for the drivers was also changed from green to white, and each wore a shirt and tie and a peaked cap with a red badge that had Hartley's written on it.

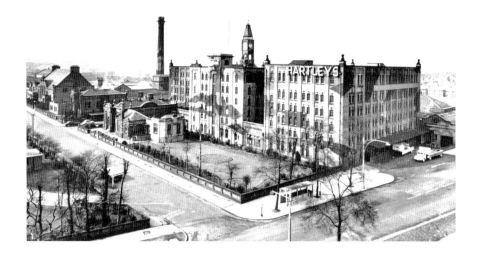

Above: A view taken from the Schweppes factory in 1952. The Hartley's factory is still in wartime camouflage.

Left: A post-war advertisement.

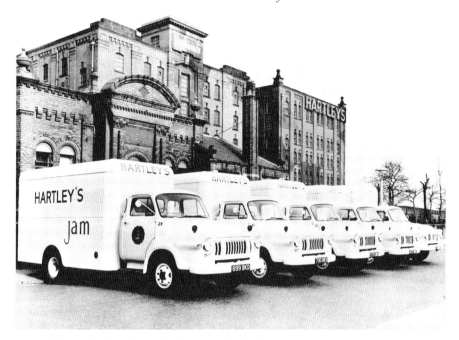

Some of the firm's fleet of vans lined up outside the factory.

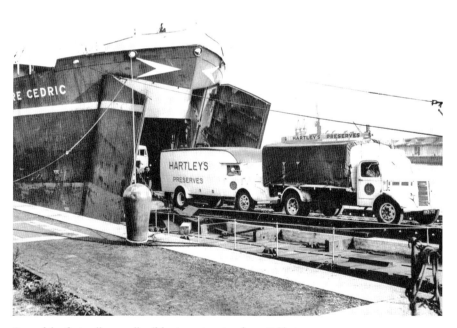

One of the first roll-on, roll-off ferries returning from Belfast.

The canning side of the business was also returned to full production. In the war, the firm had produced canned vegetables for the services; after the war, attention turned to the domestic market. The profitable vegetable canning operation, which had in effect rescued the business from collapse in 1933, proved to be as popular and as profitable as ever. As a result, the operation was expanded, and growers across Lancashire and Herefordshire lined up to produce peas and carrots for the firm. In 1940, the government had purchased 120 acres of land near the factory at Madley, which was used to develop RAF Madley, a training centre for air crew and wireless operators. After the war, the company bought back part of the land and extended the factory to include offices, a canteen and a store for the finished products. Workers slept in several of the old RAF buildings and in the eight cottages that went with the farm. The cannery was incorporated in some of the old farm buildings, and in 1955 a pea vinery was erected on the site.

The post-war euphoria, however, masked deeper underlying difficulties. In 1946, the company posted a profit of £41,665. It was a marginal improvement on the previous year and was to herald the beginning of a short-lived recovery. A year later, profits rose to £56,510 and by 1949 stood at more than £92,000, a reflection of the removal of jam and marmalade from rationing. The upward trend was not to last. In 1950, profits fell back to £54,622, and throughout the 1950s – apart from a three-year period from 1951 to 1953 – the figure was scarcely improved. In September 1953, sugar came off the ration and demand for the company's sugary preserves started to wane. In 1953, the company made a profit of £95,644, its highest since 1939. A year later, the figure was almost halved. The business faced an uncertain future.

There were other changes. In November 1943, William's oldest daughter, Maggie, died at the age of seventy-six, and in March 1945 she was followed to the grave by her sister Pollie. The girls were both shareholders in the company and to the end of their lives had taken an active interest in its future. An era was coming to an end. In December 1948, Christiana died. The only one of William's daughters to remain unmarried, she was the one who most closely followed in her father's footsteps. A Poor Law guardian for eighteen years, she founded four scholarships at Liverpool University and two at Girton College, Cambridge. In 1921, she was accorded the unique honour of becoming the first female mayor of Southport, and six years later she received the equally unique honour of being named the first Lady Freeman of Colne. In 1932, she built a maternity hospital in Southport, and on 23 February 1940 – the anniversary of her father's birthday – she added a nurses' home alongside it. In 1943, she was awarded a CBE. 'I was of course surprised and pleased to receive a letter from the Prime Minister, Mr Churchill,' she told reporters.

Christiana Hartley. Of all William's daughters, she was most like him.

Advertisement from 1953.

'What I have done has been for the love of the work and not for any reward.'

William's daughters had all grown up with the business, and it was perhaps fortunate that most of them did not live to witness its demise. In October 1955, Sallie Gibbens died two months short of her eightieth birthday, and in December the youngest of William's children, Connie, was buried. Connie's shares in the business passed to her daughter, Joy, who had been born in June 1916 at the height of the First World War and who became the family's largest single shareholder. Sallie's shares went to her six surviving children. In 1959, when the business was sold, only two of the Hartley girls were still alive, Martha and Clara. Both were old ladies – Clara a stately eighty, her sister a still buoyant 77-year-old, who in her final years took to the gaming tables of Monte Carlo.

At the same time, tastes were changing. The post-war austerity years were followed by a consumer bonanza. In September 1955, almost thirty years after Gordon Selfridge had opened the world's first television sales department, commercial television was launched in Britain. The new medium was an advertiser's dream and helped to promote a wide range of consumer products. The era of mass retail gathered pace. As wages rose, householders invested in new washing machines, vacuum cleaners, cars, refrigerators, electric toasters, electric kettles.

When William had started the company in 1871, bread and jam was an accepted part of the diet for lower- and middle-class householders. Indeed, for the poor it was the main part of their diet. The end of wartime rationing and a rise in earnings, however, meant that many people wanted to escape from the poor man's diet. In the 1950s, new self-service stores were opened around the country, the beginnings of the modern supermarket, and consumers were able to purchase a wide range of new products. At the same time, sales of bread, the staple of the working class, fell. The nation looked to the future with a renewed sense of optimism, and an aging business selling the poor man's fare suddenly looked very out of place.

The End of the Beginning

In 1959, the company was showing the well-worn lines of its advancing years. After the war, the directors had done little to modernise either of the factories, and there were few advances in terms of new product lines. The business, it seemed, was marking time. At a shareholders' meeting in May 1958, Will Higham announced that the company's profits had risen from £44,636 to £52,869, but he was quick to dismiss the improved figures as the green shoots of recovery. 'It would not be right to interpret this as indicating that conditions in the industry have become any easier than they have been in recent years,' he explained, 'because, whilst our sales in the home and export markets showed an increase, competition remains intense and we are compelled to absorb higher costs and to rely on a continuous increase in the volume of our sales to compensate for deteriorations in margins.'

When Schweppes approached the directors, the company was ripe for sale. William's grandsons had worked on the basis that the next generation of the family would take over from them, but there had been little interest shown in the business. The only member of the family to join the company after the war was Lister Hartley's son, Christopher, who started at Green Walk in the early 1950s. Hartley's remained a profitable business, but its heyday was over.

In 1959, the directors were all approaching retirement age and had few ambitions. The shareholders too considered the opportunity to be too good to miss. Schweppes was an aggressive, forward-looking company. The business had been founded in London's Drury Lane in 1792 by German-born Jacob Schweppe, whose carbonated mineral water sold well as a medicinal drink. By the 1950s, Schweppes was an international concern specialising in drinks such as ginger ale, lemonade and its famous tonic water.

In 1951, the company had built a factory on Long Lane, overlooking the Hartley works at Aintree. The following year, it signed an agreement with the Pepsi-Cola Company to manufacture and distribute its products in the United Kingdom. Pepsi similarly agreed to manufacture Schweppes products in the United States.

With the end of sugar rationing in 1953, sales of soft drinks boomed. Schweppes launched a range of products, including Kia-Ora, Suncrush orange drink and its perennially popular Bitter Lemon. The products were heavily promoted on the new commercial television stations and seduced audiences with their inventiveness. 'Schhh… you know who' and 'Schweppervescence' became popular slogans. Billboards and newspaper adverts were similarly inventive and maps of Schweppshire, featuring horse racing on Schwepsom Downs and bird watching in Schwepping Forest, could be seen throughout London and the Home Counties. In 1958, the group declared trading profits in excess of £3 million.

The following year, Schweppes sought to extend its interests into the manufacture of preserves, canned fruits and vegetables. Hartley's was a natural target. The firm had assets valued at £1.1 million, which included not only its two factories and the model village at Aintree, but also the canning works at Madley, the Aintree Institute, three depots, seven houses and a Pickers' Camp at Wisbech.

William's daughters had objected to becoming common pea canners, but by the late 1950s the vegetable cannery was the most profitable part of the business. In 1959, more than fifty growers in Herefordshire alone were under contract to Hartley's and between them produced over 1,000 tons of peas a year, which, according to the firm's advertisers, were 'picked, podded and packed in two hours', a slogan that was later adapted by one of its competitors.

When Schweppes made a bid for the whole of the 2 million shares in William P. Hartley Ltd in October 1959, there was no opposition. A few months earlier, Schweppes had purchased the firm's main competitor, Chivers & Sons of Histon, and shortly afterwards bought William Moorhouse & Sons, whose main attraction was its interests in the canteen and catering industries. The total purchase price was £5 million. Will Higham signed the documents of sale on behalf of the company. It was a sombre moment. After almost ninety years, the firm that his grandfather had founded came to an end as a family business. But a new chapter in its history was about to begin.

To Schweppshire and Beyond

Hartley's, Chivers and Moorhouses collectively became known as Connaught Food Products and, according to Schweppes chairman Hanning Philipps, 'provided considerable scope for the integration of manufacture, distribution and accounting on which Schweppes' resources in the areas of research, methods study and advertising can be profitably brought to bear'. The integration of the three businesses did not start well. The overlapping of production facilities resulted in the underemployment of workers and resources. In 1961, only Chivers (Ireland) Ltd and Moorhouses traded successfully. Chivers UK and Hartley's both reported losses.

There followed a period of reorganisation. In January 1962, a new sales team assumed responsibility for both Hartley's and Chivers products. The team was based at Green Walk. At the same time, production in Bermondsey ceased and the works became one of twenty-four distribution depots. The following year, the manufacture of preserves at Aintree ceased and the production of all Connaught food products moved to the Chivers factory

In 1964, F. G. Moorhouse (middle, front row) presented long service awards to thirty-four workers at Aintree, who between them had logged a total of 1,276 years of service to the company.

at Histon. The works, like that at Green Walk, became a depot. In the reorganisation, between 30 and 40 per cent of workers at Aintree lost their jobs, although a number were reassigned to the canning works beside the factory, which remained fully operational.

At Histon, Chivers-Hartley manufactured a range of preserves and marmalades that were separately marketed under the two brand names, as well as table jellies, bottled fruits and canned fruits. The Hartley name had lost none of its power as a popular brand, and as part of the move to Histon the company unveiled what it billed as an entirely new product using the most modern technology.

In March 1963, Hartley's New Jam was launched. The product was revolutionary. Instead of using the manufacturing process that jam makers had used for over a century, the fruit was boiled at a low temperature in sealed vacuum pans, which allowed fresh frozen or fresh canned fruit to be used without losing the quality and flavour of traditional methods. The launch was accompanied by an extensive advertising campaign and, according to the company's marketing men, was the most heavily advertised jam on television. The firm claimed that its new jam retained the 'true natural flavour of the fruit'. There were those who disagreed, but the public seemed to like it. In less than a year, the Histon factory was doubled in size to keep pace with demand.

In the late 1960s, Schweppes continued to tighten its grip on the food and drink industry. In 1968, the company merged with another household name, Typhoo Holdings, and purchased the Kenco Coffee Company, which served to extend its interests in the hotel and catering trades. Schweppes was eager to strengthen its position abroad, and in January 1969 it merged its interests with that of the Cadbury Group to form giant conglomerate Cadbury Schweppes. The match, it seemed, was made in heaven. Cadbury's by then had been in existence for more than a hundred years. The firm was one of the nation's great success stories. In 1919, the company merged with rivals J. S. Fry & Sons. Fifty years later, the business had extensive foreign holdings and, like Schweppes, was looking to expand its interests.

Merging Interests

The merger of Cadbury's and Schweppes turned out to be an awkward, albeit successful, fit that allowed the group to take the lead in both the confectionery and soft drinks markets. The creation of the group, however, led to further consolidation. In 1975, the former Hartley works at Green

Walk was closed, and shortly afterwards the Aintree factory met the same fate. At Green Walk, the main buildings were retained. The site at Aintree was less fortunate. In an act of demolition that was part of the wholesale destruction of the nation's industrial past, the railway line into the factory was pulled up and the wrecker's ball tore down the three great warehouses. Trees were uprooted and Victorian lamp-posts removed. The ornate turrets above the factory gates were sold for scrap, and the clock that had once chimed out the hours to workers hurrying across the fields disappeared from view.

There were more changes afoot. In 1979, Cadbury Schweppes decided to focus on its core businesses and to dispense with many of its more recent acquisitions. In 1981, the works at Histon was fully modernised, and following a management buyout Chivers-Hartley became part of a new company, Premier Brands UK Ltd. The business continued to thrive. In 1984, Chivers-Hartley was described by a trade magazine as 'the largest manufacturer of preserves in Europe and possibly the largest in the world'. Hartley's Pure Fruit Jams were the brand leader, commanding 20 per cent of the market. Its nearest rival was Robertson's, with a 12 per cent share. At Histon, the firm produced around 120 tons of fruit preserves a day and, unlike the business when it first started, was able to make jams and marmalades throughout the

The demolition of the works. (Liverpool Record Office, Liverpool Libraries)

All signs of the factory's former greatness have disappeared.

Hartley's Best Strawberry Jam. (Reproduced by kind permission of Premier Foods)

year. The factory also manufactured Roses and Moorhouse brands, together with supermarket 'own label' goods.

The firm's chequered fortunes continued. In January 1990, Premier Brands was sold to Hillsdown Holdings for £195 million. One of the UK's largest companies, with interests in a wide range of food and drink products, Hillsdown was a voracious purchaser of companies. After putting a quarter of its shares on the market in February 1985, the company stunned London's financial community by making forty-two acquisitions in twenty months. After the sale, Hartley's preserves continued to be manufactured at Histon, and at the end of the twentieth century included a new organic range, marketed and sold as Wm P. Hartley Organics. Hillsdown later changed the name of Premier Brands to Premier Foods, its current identity.

The face of food manufacture was changing as ownership of many of the nation's favourite brands fell under the control of a small number of companies. In 1999, Hillsdown Holdings was acquired by American private equity firm Hicks, Muse, Tate & Furst, which three years later bought Nestlé's ambient food business for £115 million. The acquisition added such well-known names as Crosse & Blackwell (once Hartley's competitors) and Rowntree's jelly to the Premier Foods stable. The acquisitions war continued. In 2007, Premier Foods purchased rivals Rank Hovis McDougall in a deal worth £1.2 billion, which widened its product portfolio to include brands as diverse as Hovis, Haywards, Bird's, Angel Delight, Mr Kipling, Marvel, Oxo, Lyons and Mother's Pride. It also included two of Hartley's long-term rivals, Robertson's and Frank Cooper.

In the early years of the new century, Premier Foods controlled the manufacture of some of the nation's best-known, longest-lasting and most well-loved products. Hartley's was prominent among them. The Hartley name remained a firm favourite with consumers, and in 2009 the directors decided to withdraw Robertson's jam from the market and to focus on the Hartley brand. The move paid off. In 2010, almost a third of all jam purchased in the United Kingdom was Hartley's, and Hartley's products were sold throughout the world, from the Middle East to the Caribbean, Africa, India, North America and Australia, which became its most successful overseas market.

The concentration of resources in the brand has led to significant changes. Hartley's jams now come in innovative squeezy pots, as well as traditional glass jars. The company has also widened its range to include sugar-free jellies and fruit fillings, and it has introduced a new 'No Bits' range of smooth jams – the exact opposite of the days when consumers liked to see an abundance of

fruit in the product. It is all a far cry from the business that William Hartley founded.

Hartley's no longer survives as a family business. It nevertheless remains Britain's favourite brand of preserves, whose products continue to excite the public palate. The business is more than a corporately owned name. It is part of a long and illustrious heritage, whose roots might lie in a small town in the Lancashire hills, but whose branches have spread its name throughout the world. Hartley's remains the market leader and its continued survival is an enduring testament to all those who helped to make it 'the greatest name in jam-making'.

The Closing of a Circle

The origins of this book lie in a chance encounter. In 1994, Christina Mungall, the youngest child of John and Pollie Higham, was living in the south of France. She was eighty-seven. Her memories of Grandpa, as she still touchingly called William, spanned the final years of his life and the early years of her own. In her advancing years, Christina was living with a companion. Unsurprisingly, her memories often drifted back to what she called 'the old days'.

One afternoon, as she spoke about William, her companion asked whether she was related to Jimmy Hartley. Christina duly sifted through her papers and found a copy of the family tree. Her finger traced the line from William to his only son Will and downwards to his son Rex, with whom she had once danced at The Savoy. In 1927, Rex Hartley had married Muriel Stewart, heiress to the fabulous Stewarts & Lloyds steel fortune. The couple had two children. The oldest was a girl, Jane, the youngest, a son, christened Ronald James Rex Hartley. Was it possible that this was Jimmy Hartley?

When Christina contacted him in the spring of 1994, my father was sixty years old. While he had been christened Ronald, after his mother's older brother who died in the Great War, he had been known as Jimmy throughout his life. The call from France took him by surprise. Although he knew he was related to William Hartley, the famous preserves manufacturer, he knew little about him. He knew there had been factories in London and Liverpool, but when it came to its founder he was virtually a blank page. Hartleys was no more than a name from a vague, unconnected past.

In consequence, I too knew little about the company and its founder. As a child, all I was told was that my great-great-grandfather first made jam in his mother's kitchen, a romantic image which even if true could never match my imagined picture of a country cottage with a sunlit orchard glimpsed through the window. I was as unenlightened about my enlightened relation

A young Christina Higham and her father, John.

as my father, and there it might have remained had it not been for a chance remark hundreds of miles from home, which produced the connection on a family tree and a breathless telephone call in which distant relations were in an instant reunited by a common ancestor.

The Search for the Past

How a family can become separated from its roots is a question that doubtless recurs throughout the generations and no doubt has many answers. In the case of my family, there are a number of reasons, the most prominent of which was the death of my grandfather and my grandmother's subsequent flight to Rome. In two quick strokes, almost all connection with the family was lost.

In March 1942, when Rex died, my father was eight. He would later describe him as 'a distant person I could not even remember properly, a father whose face I could no longer recall'. The last time he had seen him was at the start of the war when, with his mother and sister, he had headed out of London to escape the expected bombing. His parents' marriage by then was effectively over and Rex spent the last years of his life with Molly McGeachin, a pretty young socialite.

In 1944, my grandmother remarried, and after the war, faced with mounting debts, she moved to Rome, where her new husband set up business as a theatrical agent. After Rex's death, there was little reason for her to stay in contact with his family, many of whom had disapproved of his dissolute lifestyle. Her life in Rome similarly put a distance between her and the past.

In 1952, my father won a scholarship to Oxford and, three years later, at the age of twenty-one, took a job as a Promotion Copywriter at Associated Rediffusion, one of the new independent television companies. In his father's will, he had inherited shares in Hartley's, but he had no interest in joining the family business. The fast-paced world of television was more absorbing. In 1957, his mother died. Two years later, when Schweppes made its bid for Hartleys, he sold his shares in the company. The links grew thinner.

When we travelled to Cannes, I am not certain what my father or I expected to find. In the event, what we found was an open door to the past. There were considerable gaps in what Christina remembered, but there was enough to spark an overwhelming passion to find out more. Here was the life of a great Victorian industrialist and philanthropist, whose Utopian ideals had been

Jimmy heading to the Little People's Ball at the Grosvenor House Hotel, 1938.

grounded in his contributions to manufacturing, medicine, mission and ministry. In her house in the hills, Christina unveiled the outline of what has since become this book. At the time I had not even seen a photograph of William. Christina's memories would spark a fire that has not gone out.

On my return to England, I began what would turn out to be a protracted period of research as each discovery prompted the opening of new avenues, and a life, once hidden from me, slowly emerged. The company had not kept a complete archive of its history and, after the mergers, first with Schweppes and then Cadbury's, little attention had been paid to its origins. In 1975, when Green Walk was closed, most of its records were burned, like some vast incineration of the past. The same happened at Aintree, where albums of photographs, letters and other documents went up in a great pyre of flame and smoke. The past did not so much disappear, as was obliterated.

One of the great pleasures of writing this book has been in peeling back the layers of time. I have been fortunate. In the offices of Schweppes Europe I came across four leather-bound books containing William's notes on the manufacture of his preserves, as well as details of the firm in the 1920s and 1930s. The books were stored in an old tea chest. The discovery of a number of photographs that had been rescued from the fires at Aintree by one of the factory's workers (to whom I shall forever remain indebted) and of bound copies of *The Lighthouse*, which another employee had kept for over sixty years, similarly proved invaluable. At the Chivers-Hartley factory at Histon, the archive consisted of a few shelves in a storeroom behind the canteen, but it nevertheless yielded its insights into the business.

The other great pleasure was visiting the former Hartley works. At Aintree, I had the happy experience of meeting four former workers, who showed me around the remains of the works with an enthusiasm that was contagious and which has urged me forward in many a moment of despondence during the writing of this book. The great works had once been a landmark for travellers heading into Liverpool, but with the passing of the years had become a hollow relic of a forgotten age. The warehouses by then had long been demolished, and the main production area was divided into industrial units. The Dining Hall, once a source of pride at the firm, was a carpet warehouse. In William's office beside the gates, all that remained of its former occupant were his initials inlaid in wood on the back of the door and the trademark lighthouse carved into the wood above the old fireplace.

The works at Green Walk similarly had been neglected. After the factory was closed in 1975, it had been left empty and abandoned. On a cold, rainy morning I stood at the factory gates looking into a courtyard that had once bustled with activity and which now seemed desolate and forlorn. A former

employee, with whom I corresponded about the firm, had written to thank me for reminding him of the 'best days' of his life, but there were few signs of its former greatness. Not long afterward, the factory was converted into apartments, a row of penthouse suites added to the roof where girls used to sort through the fruit on hot summer afternoons.

Almost one hundred years after his death, William Hartley has left behind both edifice and ideals. In Manchester, Hartley Theological College closed in the early 1970s and became home to the Royal Northern College of Music. It subsequently became a Muslim school. At Liverpool University, the Botanical Institute still survives, although students entering it for quite different reasons are perhaps unaware of its origins. The church William built in Southport, which for years was known more familiarly as 'the jam chapel', was converted into a medical centre, though the chapel in Aintree still supports a small, flourishing congregation.

The last of his benefactions similarly became a victim of changing times. In 1948, Hartley Hospital was one of almost 3,000 institutions absorbed into the newly created National Health Service, and it continued to serve the needs of the town until the early 1980s, when it was closed in favour of larger premises in nearby Burnley. Abandoned and with no plans for its future, the hospital fell into dereliction. The grounds became overgrown and the building was vandalised, its lead roofing removed, windows smashed. The hospital was finally bought by a firm of property developers and converted into apartments, the grounds where vast crowds had gathered at its opening cleared to make way for a new housing estate. One of the few signs of its illustrious past was William and Martha's initials inscribed in the stone above the main entrance, uniting them as inseparably in death as they were in life.

The people of Colne had once stood to applaud his deeds, but by the dawn of the twenty-first century William Hartley was no more than a name on a label. History misplaced him and to some extent misjudged him. As a man of commerce, he could never have been more than a symbol of Victorian endeavour, and as a man of God he stood to be denigrated at a time when the expression of Christian values was seen more as a source of diminishment than elevation. Although the Hartley name remained well known to consumers, the roots of the business had been forgotten and it became little more than a corporate name.

The abandonment of this piece of industrial heritage has been the main reason I have pursued this project in order to record and retain what might otherwise be lost. In his day, William Hartley was as influential a figure as George Cadbury and the individualistic William Lever. However, while their

more stirring deeds have been immortalised in the long litany of Victorian achievements, those of William Hartley have largely been overlooked. In writing this book, I have unashamedly sought to champion my great-great-grandfather's vision. He is a forgotten figure who deserves a kinder fate. I hope this book might redress the balance.

Acknowledgements

I am indebted to all those who have so freely given their time and help toward the completion of this book. In particular, to the four former workers at Aintree, Charles Connor, Eric Coldwell, Harry Georgeson and Bill Hill, who shared their knowledge of the business. I would also like to give a special thanks to Jim Charters, who when the firm's past was casually being tossed onto the fires that followed the closure of the Aintree works, had the presence of mind to rescue the many photographs and other documents that he has kindly shared with me.

I would like to thank all the former workers at both factories who shared not only their memories, but sent me photographs and other items. To Marjorie Llewellyn, who kept the photos taken at Aintree in 1923, Joan Bateman, and Agnes Gallagher, who was gracious enough to let me keep the copies of *The Lighthouse*.

My thanks too to all the members of my family, past and present, who came forward to help: Penny and Richard Aikens, Ann Bowden, John and Romie English for lending me the Family Mag, Norma Hamer, Jonnie Hamer, Stephanie Hamer, Tim and Hilary Hall, Dinah Hanbury-Williams, Ann Harper, my father Jimmy Hartley, John Higham for pointing me towards the Carroll Gibbons recordings, Billie More, Christian Mungall, Joan Pearson and Sue Paz Pineiro. Also, to Gordon Hartley for locating the former Hartley works in Bootle and for much useful information on the family in Colne.

I would like to thank Nicholas Bickham for the use of his grandfather's correspondence, the archivist at the University of Liverpool and the archivists at the libraries in Southwark, Aintree, Colne and Liverpool, Kelly Davis and Piyank Dutta at Premier Foods, Richard Allan for all his help regarding the photographs, Geoffrey Milburn, Karen White and June Hill.

I would also like to thank everyone at Amberley who helped in the making of this book, especially Alan Sutton, who believed in it from the outset, and Robert Drew for his solid advice.

Finally, my love, as always, to Louise, who lived through the evolution of this book and still had the grace to smile.